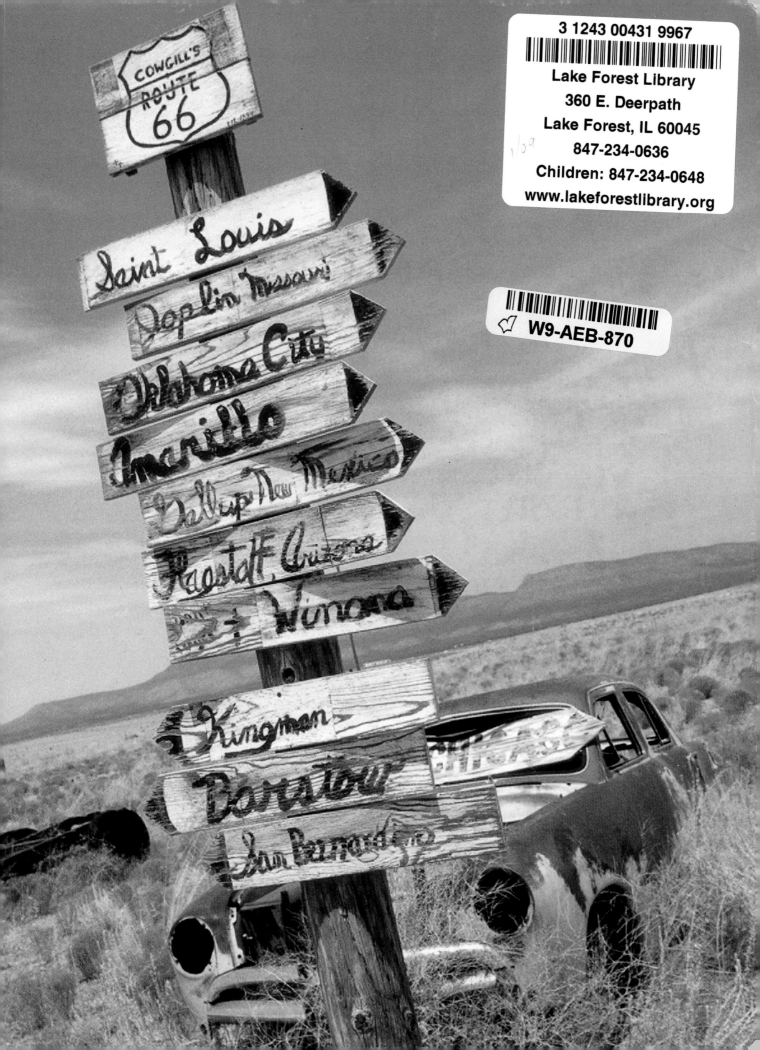

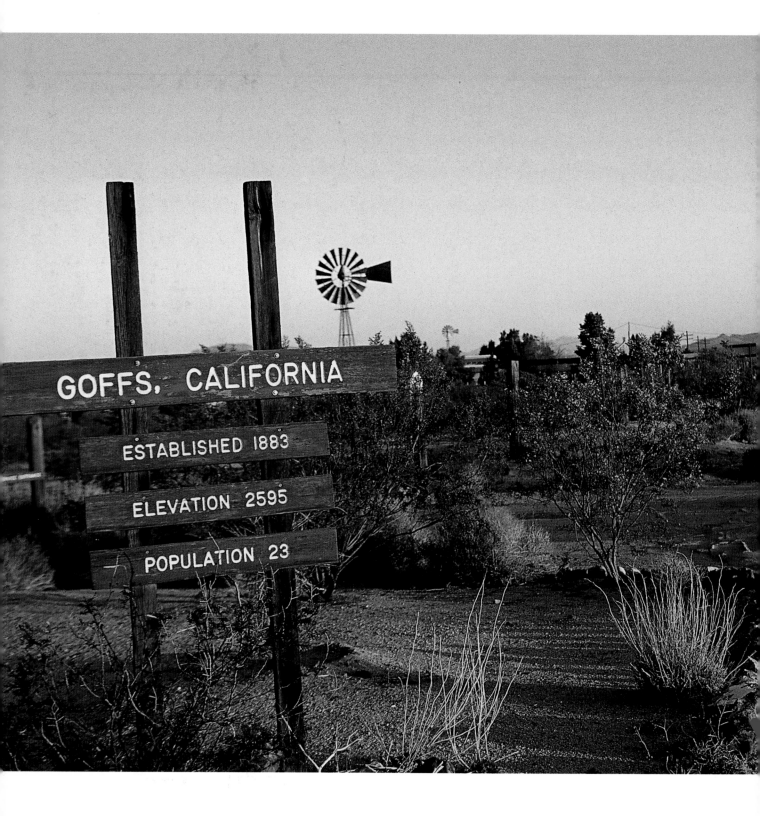

Route 66
Backroads

YOUR GUIDE TO SCENIC SIDE TRIPS & ADVENTURES FROM THE MOTHER ROAD

TEXT BY Jim Hinckley
PHOTOGRAPHY BY Kerrick James, Rick Bowers,
AND Nora Mays Bowers

Voyageur Press

ACKNOWLEDGMENTS

The list of those whose contributions made this book a possibility is a lengthy one. To every one of these fine folks I say, thank you. Josh Leventhal and those who work so hard at Voyageur Press to transform these books from idea to reality deserve a word of thanks.

To Dorothy Molstad, a special thank you. It is my sincere hope that your retirement is a lengthy and enjoyable one.

Last, but definitely not least, I say thank you to my dear, loving wife, my best friend. Without your support and encouragement, none of this would have been possible. You are a true blessing in my life.

— Jim Hinckley

First published in 2008 by Voyageur Press, an imprint of MBI Publishing Company, 400 First Avenue North, Suite 300, Minneapolis, MN 55401 USA

Text copyright © Jim Hinckley, 2008
Photography copyright © Rick and Nora Bowers, 2008, and photography copyright © Kerrick James, 2008, except where noted

Voyageur Press titles are also available at discounts in bulk quantity for industrial or sales-promotional use. For details write to Special Sales Manager at MBI Publishing Company, 400 First Avenue North, Suite 300, Minneapolis, MN 55401 USA.

To find out more about our books, join us online at www.voyageurpress.com.

Library of Congress Cataloging-in-Publication Data

Hinckley, James, 1958-
 Route 66 Backroads : your guide to backroad adventures from the mother road / text by Jim Hinckley; photography by Kerrick James, Rick Bowers, and Nora Bowers.
 p. cm.
 ISBN 978-0-7603-2817-0 (pbk. : alk. paper) 1. West (U.S.)--Tours. 2. United States Highway 66--Guidebooks. 3. Scenic byways--West (U.S.)--Guidebooks. 4. Automobile travel--West (U.S.)--Guidebooks. I. Title.
F595.3.H56 2008
917.804'34--dc22
 2007052035

Editors: Josh Leventhal and Leah Noel
Designer: Brian Donahue / bedesign, inc.

Printed in Singapore

ON THE FRONTIS: A directional marker in Truxton, Arizona, shows the way to a number of Route 66 towns. KERRICK JAMES

ON THE TITLE PAGE, MAIN: Route 66 passes through many miles of desolate country on its way west, including through the tiny hamlet of Goffs, California. KERRICK JAMES

ON THE TITLE PAGE, INSET: Eryngo, a grassland flower with a thistle-like bloom, thrives near Caprock Canyon, Texas, one of the backroad treasures found off Route 66. RICK & NORA BOWERS

ON THE OPPOSITE PAGE: The highway in California's Joshua Tree National Park winds through a fascinating landscape of oddly shaped rock formations and even more oddly shaped Joshua trees. KERRICK JAMES

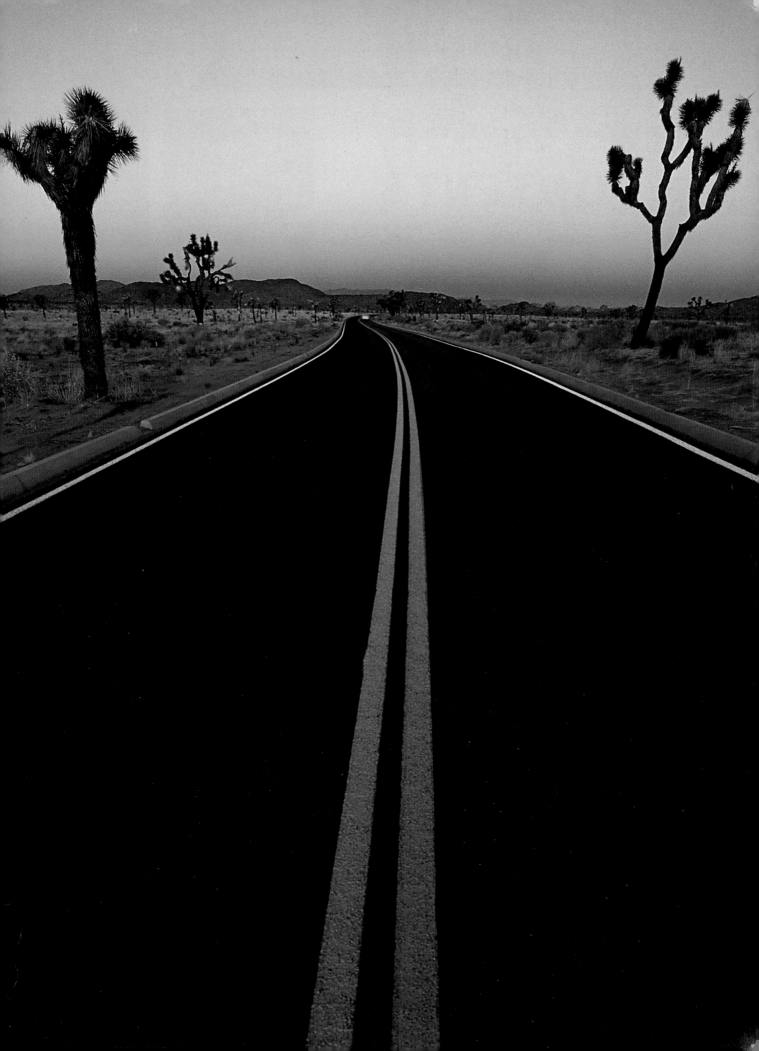

CONTENTS

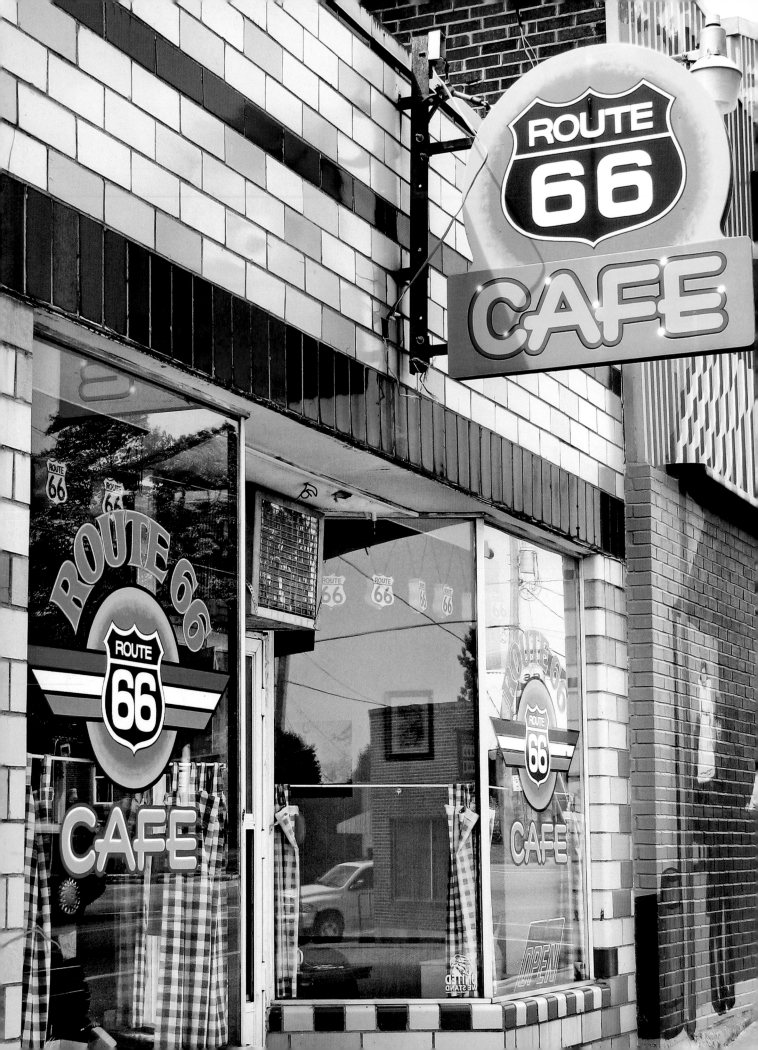

Introduction

Journeys from the Mother Road

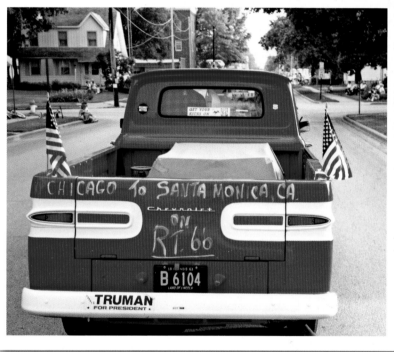

ABOVE: The markings on this old pickup truck show it is destined to follow the Mother Road's entire route.
ROUTE66PHOTOGRAPHS.COM

OPPOSITE: Route 66 Café, in Cuba, Missouri, is a tangible link to when Route 66 was the Main Street of this community and countless others between Chicago and Santa Monica.
ROUTE66PHOTOGRAPHS.COM

Route 66 is a fascinating American icon. For those fleeing the Dust Bowl of the 1930s, it was a road of hope, carrying desperate families west in search of a better life. In the era before the interstates, large portions of the iconic highway had larger-than-life reputations for white-knuckle driving, the result of narrow bridges, tiny shoulders, heavy traffic, and all manner of highway hazards. From Chicago to Santa Monica, the roadside became the world's biggest sideshow, with colorful billboards encouraging you to stop and see a live Indian or albino buffalo.

Today, the old "double six," segmented and broken, remains an American legend that lures travelers from throughout the world to experience life at a slower pace, to step back in time and rediscover the quintessential American experience that is the road trip. Minivans may have replaced station wagons, and many of the neon signs may have gone dark, but the essence of Route 66 is there to be found.

Travelers who stay tied to the original trail of old Route 66 in their quest for an America before the age of generic franchise restaurants and chain motels may see only a vestige of that bygone time. However, for those looking for the true meaning of what the old road represented, where past and present flow together almost seamlessly, the Mother Road is merely a portal. In many places, a short detour

north or south from the historic highway will take you to spots where the neon still glows and the diners still serve apple pies made with fruit picked from the orchard across the road. Explore the land beyond the stretches of the old road, and you will encounter some of the best historic, natural, and commercial attractions between the mighty Mississippi River and the great Pacific Ocean.

In Illinois, the homes of Presidents Ulysses S. Grant and Ronald Reagan are just north of the highway and that of Abraham Lincoln is but a few blocks away. In Missouri, deviate from Route 66 and you are transported to the family vacation paradise of Branson or to the literary world of Mark Twain immortalized in books such as *The Adventures of Tom Sawyer* and *The Adventures of Huckleberry Finn.*

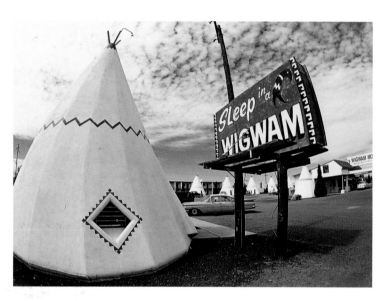

ABOVE: The recently refurbished Wigwam Motel in Holbrook, Arizona, provides a rare opportunity to experience an evening on Route 66 as it was when Studebakers still rolled out from the factory in South Bend.
KERRICK JAMES

A drive along the banks of the mighty Mississippi and its many tributaries is a journey through centuries of American history, from the world of lost Native American civilizations to that of French pioneers and explorers such as Lewis and Clark.

Oklahoma and the Texas Panhandle are a cornucopia of surprises, especially for those who envision open plains of rolling hills where the winds sweep without restriction. Lakes and scenic canyons and historic communities and the National Route 66 Museum are but a few of the treasures found here.

In New Mexico, you can spend a morning visiting a wonderful little village that has been perched on a towering monolith of stone for almost a thousand years, and you can be back on Route 66 in time for lunch. In Arizona, a journey of less than one hundred miles separates Route 66 from the Garden of Eden and a village so remote that mule trains still deliver the mail.

One of the most beautiful drives in America begins where Route 66 ends, as you explore the Pacific Ocean shoreline and beach communities that define Southern California.

Route 66 has inspired more ink to cover paper with its praises than asphalt to pave it. Yet little about the wonders waiting just a few miles north or south of the Mother Road has been published.

It is my hope that the drives in this book enhance your adventure as you explore legendary Route 66. Additionally, as you travel, plan your schedule so that you have time for side trips onto the backroads from Route 66 and rediscover the true Main Streets of America.

ON THIS PAGE: Scenes from the backroads of Route 66—at New Mexico's Bitter Lake National Wildlife Refuge (below) and Kiowa Grasslands (above). KERRICK JAMES

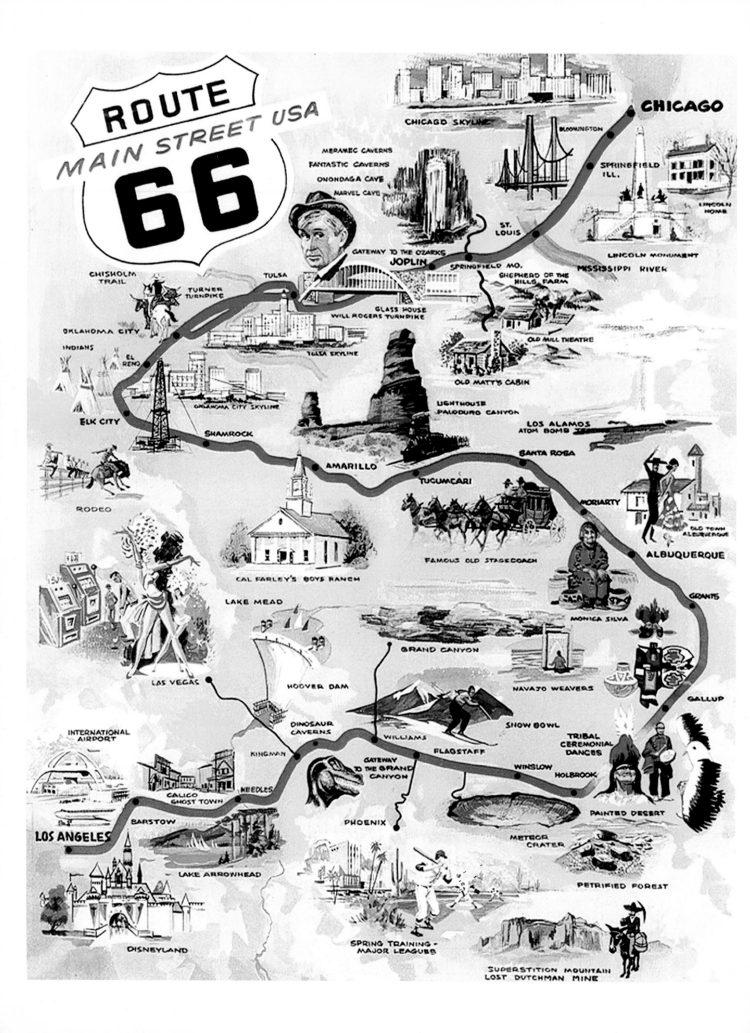

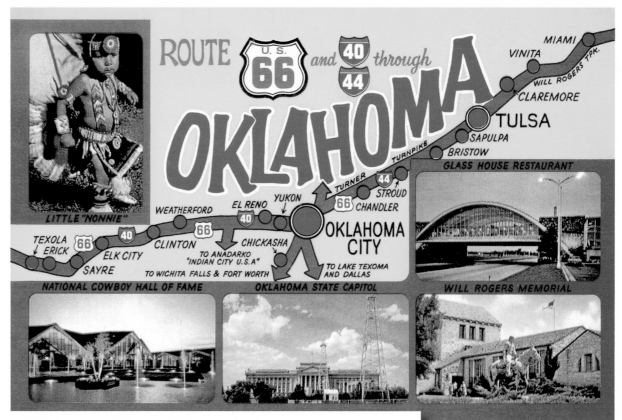

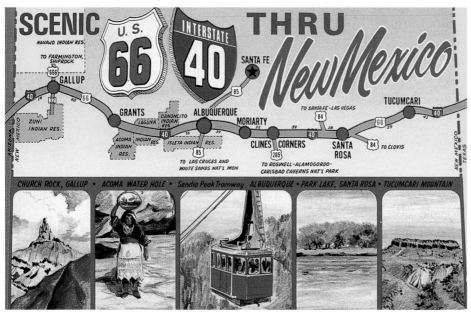

ABOVE AND LEFT: These two postcards highlight the Main Street of America as it winds through New Mexico and Oklahoma, respectively. The Oklahoma map dates from after the construction of the interstate, showing how Route 66 parallels Interstate 44 and Interstate 40.
VOYAGEUR PRESS ARCHIVES

LEFT: This 1960s-era poster shows the towns and sights to be found along Route 66 from Chicago to Santa Monica during the Mother Road's tourism heyday. VOYAGEUR PRESS ARCHIVES

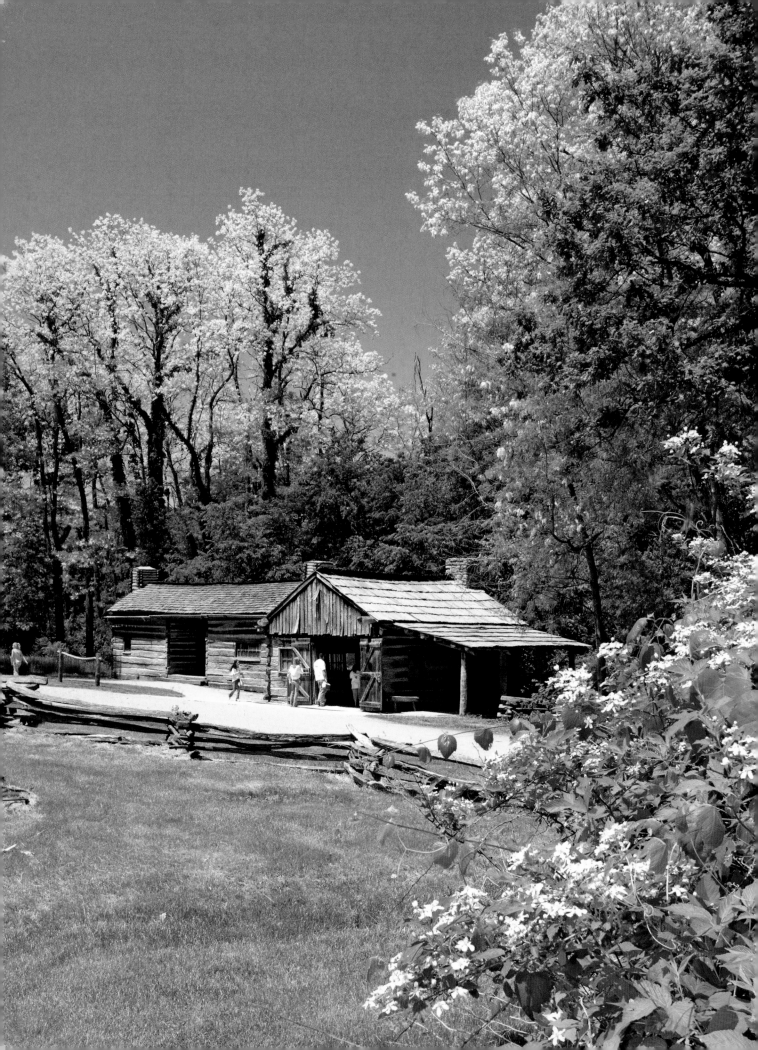

PART I

Illinois

The Beginning of 66

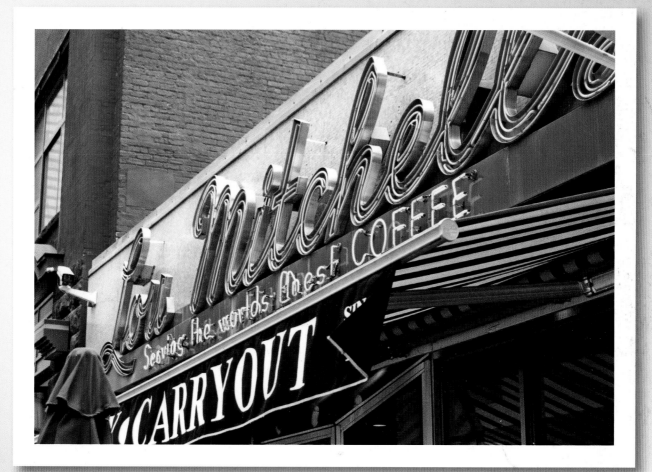

ABOVE: Lou Mitchell's began serving food to travelers and locals alike in 1923, three years before there even was a Route 66. ROUTE66PHOTOGRAPHS.COM

OPPOSITE: Visitors to New Salem State Historic Site, outside of Springfield, Illinois, savor the warm days of early spring. The stunning attention to detail here allows visitors to experience the village as it was when Abraham Lincoln lived here in 1832. RICK & NORA BOWERS

In retrospect, there could not have been a better place to locate the eastern terminus of Route 66 than Grant Park in Chicago. The excitement of this bustling metropolis fills one with anticipation and an eagerness to explore, as it has for almost two centuries.

Moreover, Illinois—with its picturesque little towns and shaded courthouse squares that evoke a Norman Rockwell print— serves as a near-perfect backdrop for what the old highway has come to represent.

The glory days of Route 66 are more than a half century in the past, but this is recent history in Illinois, as a drive south along the Mississippi River will reveal. In worn sandstone bluffs near Prairie du Rocher, you will find evidence of hunters who took cover in the Modoc Rock Shelter more than eight thousand years ago. The remnants of a culture that created towering monuments centuries before Europe emerged from the Dark Ages await discovery with a short detour along the Illinois River.

For those unfamiliar with Illinois or whose only mental picture of the state is the urban grind of Chicago, it may come as a surprise that the state is replete with such stunning natural beauty. On the drive to Galena through Mississippi Palisades State Park, you will encounter the land that inspired the poet Carl Sandburg. Traveling in the footsteps of Abraham Lincoln in New Salem and in Springfield, you will find vestiges of the frontier that nurtured his towering strength of character.

From north to south, the state stretches almost four hundred miles, and cutting diagonally across the heartland of this amazing and diverse landscape is legendary 66. As exciting as a journey along the Main Street of America may be, to truly experience the variety, the flavors, and the sights of Illinois, you will need to submit to the urge to follow the two-lane blacktop over the next hill and watch Route 66 disappear in the rearview mirror.

ROUTE 1

The Mother Road in the Land of Lincoln

ROUTE 66 IN ILLINOIS

The entrance to Grant Park serves as the starting point for this drive along the most famous highway in America and the third-largest tourism draw in the state of Illinois.

Route 1

Rerouted several times before it was decommissioned and then segmented by the interstate, Route 66 in Illinois still survives in many spots. The best place to start a tour of the beginning of the old highway is to go east on Ogden Avenue from Douglas Park and turn east on Jackson Boulevard. Follow Jackson Boulevard to Grant Park, the eastern terminus of the highway. Then head south on U.S. Highway 41 to Interstate 55 (not part of the original 66). Head west again on I-55 to the suburb of Bolingbrook, where you'll turn south on State Route 53 to Joliet. Follow Route 53 further south to Gardner, where you'll rejoin I-55. Signage makes it relatively easy to follow the remnants of Route 66 through Illinois to the Mississippi River.

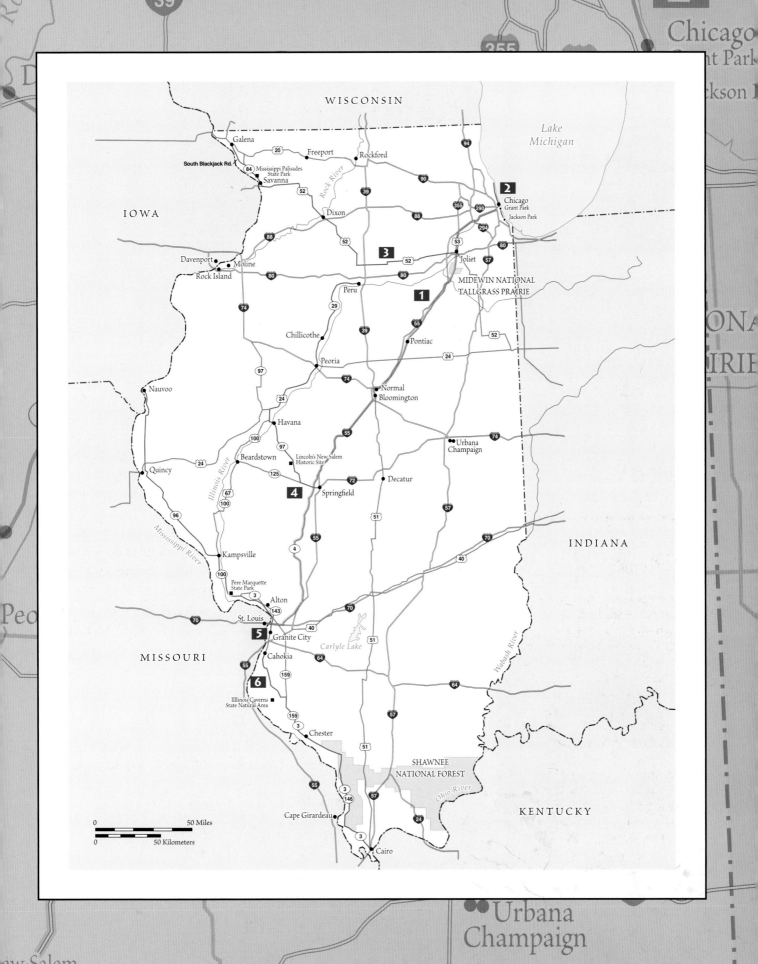

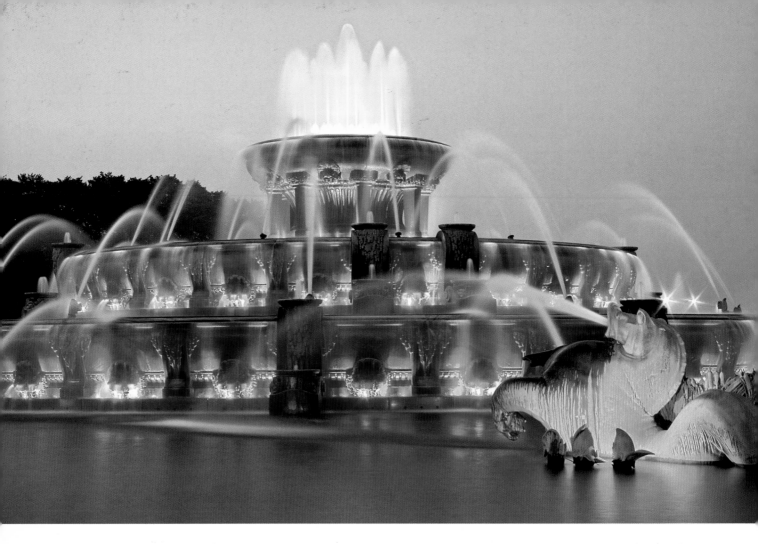

Buckingham Fountain in Grant Park has been a Chicago landmark since 1927. ©HENRYK SADURA/SHUTTERSTOCK

The fountains were modeled after the world-famous fountain of the Palace of Versailles in France. AUTHOR'S COLLECTION

Renamed for Galena, Illinois, resident Ulysses S. Grant in 1901, the park actually predated this president's administration by more than twenty years. The park was established in 1844 with the goal of preserving the land along the shores of Lake Michigan, and a city ordinance prohibited any building within the park. Developers fought to overturn this ordinance in the late nineteenth century, but they were defeated in the courts, largely through the efforts of Aaron Montgomery Ward. The first exception to the ordinance was the Art Institute of Chicago, which was built in Grant Park in 1892.

Today, one of the highlights of the park is the Clarence Buckingham Memorial Fountain and Gardens, which are modeled after the world-famous fountain of the Palace of Versailles in France. Then there is this oddity: Grant Park is home to a monument to Abraham Lincoln, while a memorial to President Grant is located in nearby Lincoln Park.

As you begin motoring west along Route 66, be sure to allow time for a stop at Lou Mitchell's, a landmark on the highway and in this city. Located at 565 West Jackson Boulevard, this wonderful eatery began serving food to travelers and locals alike in 1923, three years before there even was a Route 66.

The drive west on Ogden Avenue, through Cicero and Berwyn, is a true opportunity to experience Route 66 as it was before

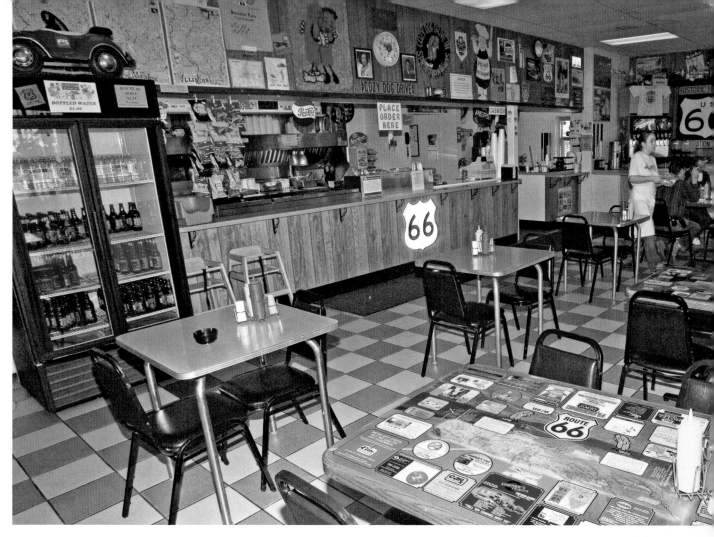

ABOVE: Route 66 souvenirs abound inside the Cozy Dog Drive In. You can still eat Cozy Dogs at the Cozy Dog Drive In, home of the batter-dipped hot dog on a stick. Cozy Dogs were first invented and sold at the Lake Springfield Beach House on June 16, 1946. RICK & NORA BOWERS

AUTHOR'S COLLECTION

LEFT AND ABOVE: The Cozy Dog Drive In in Springfield, Illinois, is a well-known Route 66 icon. RICK & NORA BOWERS

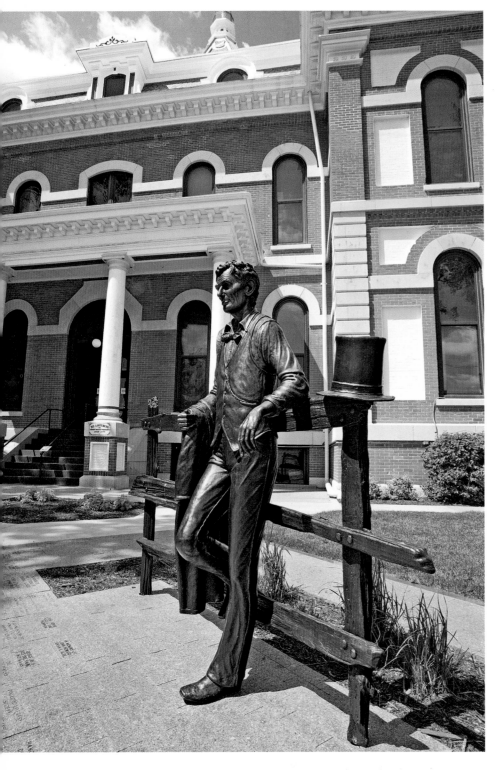

This statue of Abraham Lincoln outside of the Livingston County Courthouse portrays him as a young man, leaning on a split-rail fence. Ironically, the sign on the front column of the courthouse says, "No loitering on courthouse property."
RICK & NORA BOWERS

the interstate highway—with traffic, and lots of it. The city of Chicago and its neighbors have experienced a great deal of sprawl since the christening of Route 66 in 1926, but here and there, remnants of the prairies, the farms, and even the coal mines that once lined the highway can be seen.

The old highway, now designated as Illinois State Route 53, follows the west bank of the Des Plaines River into Joliet. There are enough attractions in and around Joliet to keep one occupied for days on end, but if time is limited, save some to explore the historic and beautiful Rialto Square Theatre.

Listed on the National Register of Historic Places, the Rialto was built in 1926 as a "palace for the People"; it underwent an extensive restoration in the 1980s. Its intricate plasterwork, ornate ceilings, historic organ, and other period features make the Rialto an architectural gem.

Other Joliet gems include the Billie Limacher Bicentennial Park, along the old commercial center of the city. This delightful river walk features a visitor's center, performing arts center, fountain, and band shell in a parklike setting.

Farms and all that they entail may dominate the landscape along much of Route 66 in Illinois, but interspersed among them are icons of the old highway. In Wilmington, there is the Launching Pad, with its notable Gemini Giant astronaut statue, where since the 1950s good food has welcomed weary travelers. In Odell, the local, federal, and state governments as well as private businesses joined forces to preserve and restore the historic Odell Station, a service station that first opened in 1932.

The Old Log Cabin Restaurant in Pontiac, another Route 66 landmark, opened its doors in 1926. The original building was constructed of cedar telephone poles and seated forty-five customers. Farther down the road, in Lexington, an original, narrow alignment of the highway is preserved as a walking trail known as Memory Lane.

Buried but not lost among the modern urban landscape of Bloomington are the 1903 courthouse, now a museum, and the Beer Nut Factory. The latter is a family-owned business that has sold the famous red-skinned nuts since the 1930s, and today it offers a fascinating tour that culminates with a beer-nut tasting.

South of Bloomington is a true national treasure, a roadside stop that has been serving Illinois travelers since 1824: Funks Grove. This century-and-a-half-old farm, nestled in a natural stand of maples and

The three swinging wooden bridges over the Vermilion River in Pontiac, Illinois, add a thrilling touch to a peaceful hike among the towering trees.
RICK & NORA BOWERS

ancient white oaks, is famous for its maple syrup, but you'll find other attractions as well, including a gem and mineral display.

In McLean, the Dixie Truckers Home opened its doors in 1928 and became the site of the original Route 66 Association of Illinois Hall of Fame Museum (now located in Pontiac). For years, Broadwell was home to the Pig-Hip Restaurant, which opened in 1937 and was a museum until fire destroyed it in 2007.

Between McLean and Broadwell, the city of Lincoln, Illinois, has numerous remnants from the glory days of Route 66. As an interesting historical footnote, on August 27, 1853, Abraham Lincoln christened this namesake community with the bursting of a ripe watermelon.

This is but one Abraham Lincoln–related site found in this part of Illinois. Springfield is overflowing with Lincoln history, from the shrine that is the only home Abraham Lincoln ever owned to his solemn tomb in Oak Ridge Cemetery.

The prairie metropolis of Springfield also boasts a wide array of Route 66 attractions, including the legendary Cozy Dog Drive In. This venerable establishment is the birthplace of a true American institution: the corn dog. Renowned artist Bob Waldmire is the son of Cozy Dog founder Edwin Waldmire.

From Springfield, the prairie quickly gives way to limestone bluffs, thick forests, lush farms built on rich bottomlands, and wide savannas. Then, almost as quickly, the landscape becomes an urban one, and the road twists and turns through Maryville, Granite City, and Madison to the banks of the Mississippi River and a Route 66 icon, the Chain of Rocks Bridge—one of the longest continuous steel-truss bridges in the country.

BEFORE ROUTE 66

BEFORE THE ADVENT of Route 66 and the national highway system, early Illinois motorists had to deal with roads that were often primitive, unpaved tracks, little improved since the time of Abraham Lincoln. Community or commercial interest determined the route as well as condition.

Another concern for early motorists was that route names depended upon whom you asked, what community you were in when you asked, or how old your map was. In 1915, on the roads between Chicago and St. Louis, this issue was addressed by linking them with the designation Pontiac Trail, and appropriate signage provided

by the Goodrich Tire Company was placed on posts at one-mile intervals.

In 1921, surveys, a bond issue, bids, and preliminary planning marked the beginning of transforming the Pontiac Trail into an all-weather road. By 1926, the entire route had been paved with concrete, just in time for inspection by the newly created American Association of State Highway Officials. By 1930, Illinois and Kansas had become the first two states that could proudly proclaim Route 66 paved with asphalt from border to border.

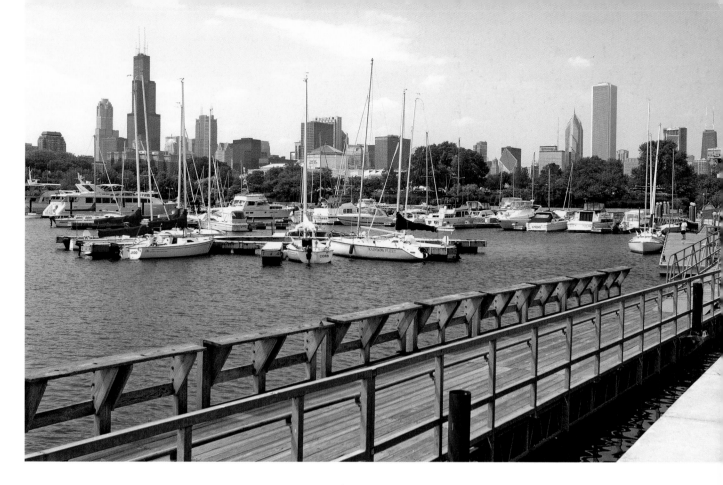

ROUTE 2

The Chicago Coast

LAKE SHORE DRIVE

For those unfamiliar with the "Windy City," Lake Shore Drive from Jackson Park to Lincoln Park is a wonderful introduction to all that makes Chicago one of the most beautiful cities in America. Moreover, it is an opportunity to experience the rarity of an urban vacation in a city that masquerades as a small town.

This tour begins with lovely Jackson Park and the nearby Museum of Science and Industry. For those with even the faintest interest in the evolution of technology or industry, this museum should be at the top of the list of Chicago attractions. Displays run the gamut from an operating coal mine shaft elevator to the aerodynamic 1934 *Pioneer Zephyr* locomotive, from a Boeing 727 to an Aurora 7 Mercury spacecraft. The crown jewel of the museum's extensive collection is a fully restored World War II German submarine, a U-505 captured in 1944, and a corresponding multimedia display. The museum also features an Omnimax theater.

The drive continues north on one of the busiest and most scenic thoroughfares in the city. Lake Michigan, more an inland sea than a lake, sits on one side and the skyline of towering steel and concrete looms on the other.

Burnham Park Yacht Harbor near Lakeshore Drive is located within walking distance of the Chicago downtown area on the Museum Campus. The Museum Campus is home to the Field Museum, the Shedd Aquarium, and the Adler Planetarium.
RICK & NORA BOWERS

Route **2**

Lake Shore Drive is also U.S. Highway 41. For this route, follow U.S. 41 north for 15.8 miles from Marquette Drive to Hollywood Avenue.

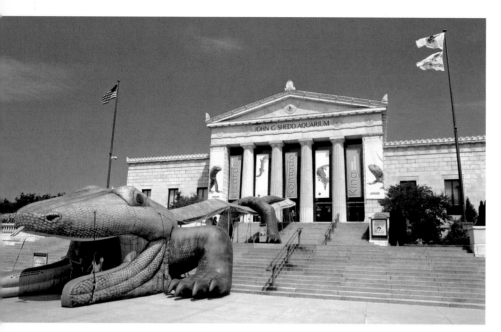

ABOVE: A komodo dragon appears to be swallowing visitors into the Shedd Aquarium in Chicago. From tropical coral reefs in the Caribbean to the Amazon River, and from coldwater shores to freshwater wetlands and the Great Lakes, the Shedd Aquarium holds ninety aquatic habitats.
RICK & NORA BOWERS

BELOW: The Shedd Aquarium houses thousands of unique animals, including clownfish, sharks, coral shrimps, giant octopus, blue iguanas, bluegills, sunfish, moon jellies, and sea stars in exhibits that re-create the animals' natural habitat.
RICK & NORA BOWERS

Further north on Lake Shore Drive, turn onto Museum Campus Drive and enter a world of surprising serenity. Burnham Park, Twelfth Street Beach, and Northerly Island Park are a rich tapestry of green (or white, depending on the season) on the lakeshore. The centerpiece of this urban paradise is the Museum Campus, which consists of three astounding museums set against the backdrop of Lake Michigan.

The Field Museum began as a showcase for an extensive biological and anthropological collection during the Columbian Exposition of 1893. The collection has since grown to proportions befitting its prize exhibit: the largest and most complete *Tyrannosaurus rex* skeleton in the world.

The second museum in the complex is the Adler Planetarium and Astronomy Museum. When its doors opened in 1930, this was the first planetarium in the western hemisphere. The planetarium is still an exciting stop on any tour along Lake Shore Drive, and the Astronomy Museum, with interactive digital StarRider theater, is nothing short of stunning.

As noteworthy as these museums are, they pale in comparison to the wonders of the Shedd Aquarium. A massive Pacific Northwest exhibit; the three-million-gallon Oceanarium containing everything from Beluga whales to dolphins; and the wild coral and shark reef are but a few of the awesome displays in this attraction, the world's largest indoor aquarium.

A few blocks west of Lake Shore Drive, the Prairie Avenue Historic District is a welcome respite from the hustle and bustle of a major modern metropolis. A walking tour of the neighborhood takes you to historic homes, including the oldest house in Chicago, architectural gems from the Gilded Age, and quaint museums, while also giving you a break from the traffic.

As Lake Shore Drive continues north, it swings closer to the lakeshore and traverses the green expanses of Grant Park. Bordering this wonderful park are such diverse attractions as the Sports Museum, Chicago Cultural Center and Visitor Information Center, the Symphony Center, and several theaters.

After crossing the Chicago River, turn east on Illinois Street to reach Navy Pier, a Chicago landmark. Navy ships docked here during both world wars, but by the 1970s, it, as well as the surrounding area, was rapidly becoming a blight on the city.

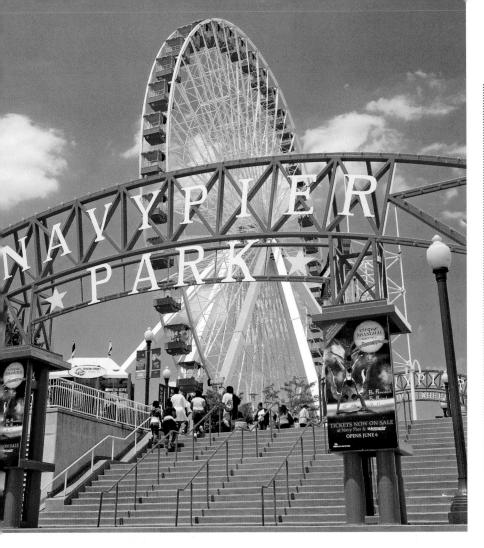

This all changed in the 1990s thanks to a multimillion-dollar cooperative effort between the city and private investors. Today acres of parks, an IMAX theater, a towering Ferris wheel that offers awe-inspiring views of the lake and the city, fireworks, and free live music during the summer make Navy Pier another ornament of the city's historic lakeshore.

The twelve-hundred-acre Lincoln Park is the next stop on the northward journey on Lake Shore Drive. Squeezed between North Avenue and Hollywood Avenue, this lovely park features beaches, picnic areas, a free zoo, a conservatory, the Theater on the Lake, and an almost-overwhelming collection of statuary.

The length of Lake Shore Drive, as well as short detours off its path, is dotted with many other exciting attractions. At 1524 North Lake Shore Drive, the International Museum of Surgical Science is the most complete collection of medical artifacts in the world. Other one-of-a-kind museums in the vicinity of this drive are the Museum of Contemporary Photography, the Museum of Holography, the National Vietnam Veterans Art Museum, and the Hellenic Museum and Cultural Center.

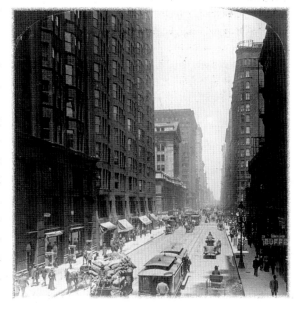

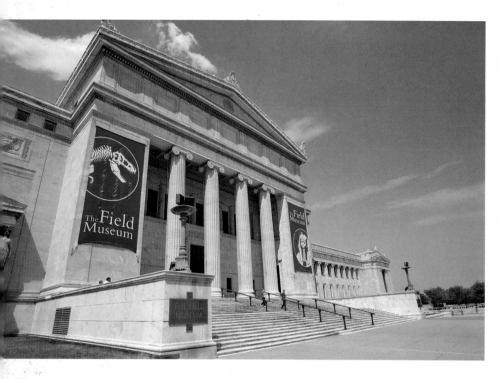

The Chicago Field Museum, located on Lake Shore Drive, holds the largest and most complete skeleton of a *Tyrannosaurus rex*, as well as numerous exhibits of cultural, historical, natural history, and global interests.

RICK & NORA BOWERS

Chicago's rich ethnic heritage can be explored at such destinations as the Ukrainian National Museum (located at 2249 West Superior Street), the Balzekas Museum of Lithuanian Culture (6500 South Pulaski Road), the Swedish American Museum Center (5211 North Clark Street), and the Polish Museum of America (984 North Milwaukee Avenue).

Sports fans will want to check out the renovated Soldier Field, located at 1600 South Lake Shore Drive. Originally opened in 1924 as a memorial to fallen American soldiers, the stadium has been the home of the NFL's Chicago Bears since 1971. It received a major face-lift in 2002 and 2003, with the modern glass-and-steel structure contrasting with the Greco-Roman design of the original structure.

Because Lake Shore Drive encompasses such a rich diversity of attractions, it serves more as a series of adventures than an actual drive, and you can spend days, weeks, or even a lifetime experiencing all this city has to offer.

Route ③

Begin in Joliet at the intersection of U.S. Highway 52 and Interstate 80 and drive west on U.S. 52 142 miles to Savanna. In Savanna, turn north on State Route 84 and drive to the junction with South Blackjack Road. Follow South Blackjack Road north about another 25 miles to Galena.

ROUTE 3

Destination 1890

JOLIET TO GALENA

If you were to drive the nearly two hundred miles from Joliet to East Dubuque in a single day, you would surely miss some of the best that Illinois has to offer. This is an adventure where a weekend excursion merely whets the appetite, and even a week can leave you hungering for more.

The highlight of this scenic drive is not just a mere destination; it is the stuff of dreams, an almost magical place known as Galena. The prelude is the drive from Joliet, which provides an increasingly rare opportunity to enjoy the bucolic American heartland dotted with family-owned farms, orchards, and wilderness preserves that are a window into the Illinois of centuries ago.

Galena, Illinois, on the banks of the Mississippi River, is known for its many recreational opportunities, including fishing, boating, and hiking. ©TIM BIEBER/GETTY IMAGES

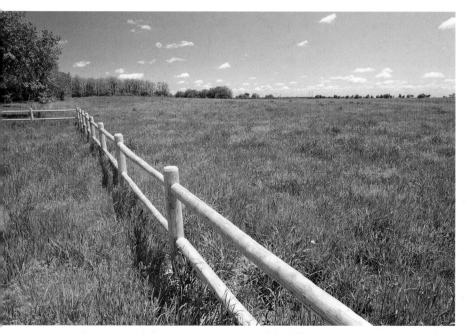

Once part of the sprawling Joliet Army Munitions Plant, the restored Midewin National Tallgrass Prairie is dotted with remnants of munitions, bunkers, and over 200 miles of roads and railroads. RICK & NORA BOWERS

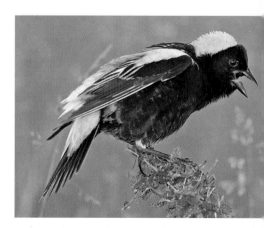

A bobolink male displays his colors at Midewin National Tallgrass Prairie, a preserve of a prairie ecosystem for grassland birds, such as the upland sandpiper, bobolink, and loggerhead shrike.
RICK & NORA BOWERS

Joliet, Illinois, was first settled in 1834 and originally was known as Juliet. Some historians believe the town's original name was in honor of settler James B. Campbell's daughter. LIBRARY OF CONGRESS

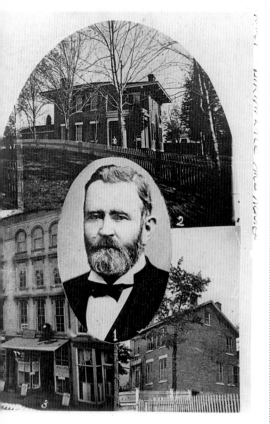

This 1879 composite image with Ulysses S. Grant's portrait in the center shows the home where he grew up in Galena at right, his adulthood home at top, and his family's store.
LIBRARY OF CONGRESS

The landscape abruptly turns from urban to rural on the roll west on U.S. Highway 52 out of Joliet.

The quaint community of Norway and the nearby Norwegian Settlers State Memorial are clear indications of which country the first immigrants to this area hailed from. After passing through the tiny community of Troy Grove, the highway rolls across the prairie to the community of Mendota. Mendota is home to several small museums that pay homage to the rich agricultural heritage of these prairies and to one of the area's most famous residents, Wild Bill Hickock.

If but two words were allowed to describe the almost thirty miles of countryside between Mendota and Dixon, they would be rural and agricultural. An island in this rural landscape is Amboy, with its vintage railroad depot built in 1876, now a museum, and the Amboy Pharmacy, where soda jerks still work the fountain behind the counter and the penny will still buy candy—a snapshot of Americana oft overlooked by travelers.

Amboy is also home to another unique attraction, the woodcarvings at Amboy City Park. Standing tall in this community park are tree trunks transformed into fine art, including the sculpture of three presidents associated with Illinois: Ronald Reagan, Abraham Lincoln, and Ulysses S. Grant.

Though Dixon, the "Petunia Capital of the World," is a bit too big to be a small town, something about it just makes one want to walk the shade-dappled streets, stroll along the banks of the Rock River, or enjoy the colorful foliage in autumn. There are a number of points of interest here that, like the town itself, are too small to be considered major attractions but that are nonetheless memorable.

On South Galena Street, the Dixon Theatre has served the community since 1922. The theater was built on the site of the Dixon Opera House, which was destroyed by fire in the winter of 1920. The Dixon was recently restored through volunteer and community efforts.

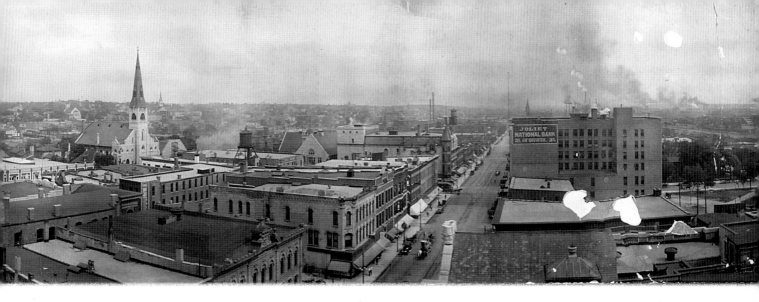

Lincoln Statue Drive boasts the only statue of Abraham Lincoln in military uniform, a tribute to the time he served during the Black Hawk War of 1832. On South Hennepin Avenue, a simple two-story house, now a museum, was home to the community's favorite son, Ronald Reagan.

The landscape between Dixon and Savanna is one of transition, as rolling prairie, rocky knolls, and farms dotted with stands of forest gradually give way to heavily forested bluffs. On this drive, basking in the tranquil beauty, rather than reaching a destination, becomes the priority.

BELOW: The Italianate Belvedere Mansion was built in Galena in 1857 for J. Russell Jones, who built a fortune with steamboats and served as the American ambassador to Belgium.
©APPLEMAN52/DREAMSTIME.COM

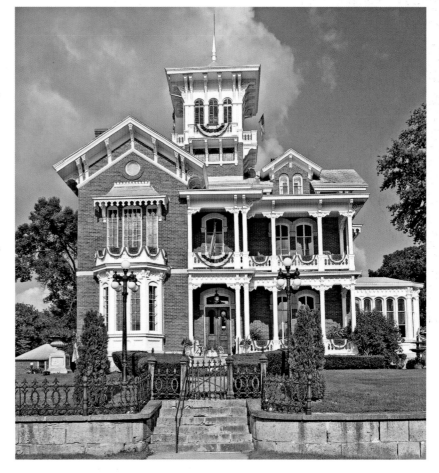

At the riverside town of Savanna, continuing west on U.S. 52 will take you into Iowa across a historic bridge that has spanned the Mississippi River since 1932. For this journey, however, turn north on Illinois State Route 84 toward Galena. When you reach the turnoff for South Blackjack Road, take it. Frequent stops to enjoy the overlooks, to stroll along shaded hiking trails, and to break for a picnic lunch under the towering trees will enhance the drive through the 2,500-acre Mississippi Palisades State Park and the Hanover Bluff Nature Preserve.

After turning west on South Blackjack Road, you arrive at the crown jewel of this drive, Jo Daviess County and Galena. Named for the type of lead ore mined from rich deposits in the area, Galena is a popular destination for both its history and its outdoor recreational

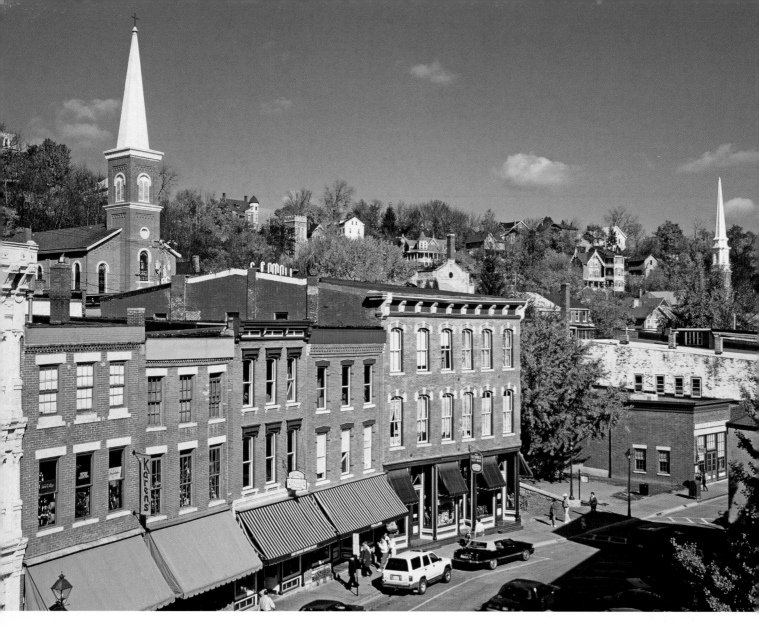

Downtown Galena is full of architectural gems, historic buildings, and national landmarks.
©PETER PEARSON/GETTY IMAGES

activities. The historic business district is a treasure box of late-nineteenth-century architecture, and the side streets present a stunning array of ornately trimmed homes built more than a century ago.

History is found at every turn in Galena, from the home of President Grant to a complete, authentic 1897 blacksmith shop, located on Commerce Street. Indeed, in a town famous for its historical preservation, it is difficult to single out specific sights or attractions, but a few, in particular, highlight Galena's role as a portal to the past.

The Galena Post Office and Customs House is the second oldest continuously operated post office in the United States. This fortress-like structure built of limestone by General Eli Parker has been in operation since 1857.

Other fascinating structures include the Galena Public Library built in 1907; the 1845 Old Market House; and the Italianate Belvedere Mansion, built in 1857. The most famous building in Galena is rather unimposing compared to its neighbors: the Ulysses S. Grant Home State Historic Site on Bouthillier Street. Beyond the charm of its most renowned town and county seat, much of Joe

Daviess County is a magic kingdom of wineries, spas, and challenging golf courses set against scenic woodlands and rolling hills. Bed and breakfast accommodations in historic mansions, fine dining, galleries, and museums add to the joys of the region.

ROUTE 4

In the Footsteps of Lincoln

SPRINGFIELD TO PERU

Illinois is the Land of Lincoln, and this route begins at its heart. At 112 North Sixth Street in Springfield, the Abraham Lincoln Presidential Library and Museum serves as a gateway to the life and times of this larger-than-life man. Historical artifacts and detailed exhibits blend seamlessly with state-of-the-art special effects to immerse the visitor in the world of Abraham Lincoln.

The nearby depot, on the corner of Tenth Street and Monroe, has been restored to how it was when Lincoln boarded the train in early 1861 for his journey to Washington, D.C., as the nation's sixteenth president. At Sixth and Adams Street in Springfield, the Lincoln-Herndon Law Offices have been refurbished to such a degree that you will almost expect the great man to walk through the door at any moment.

The only home that Abraham Lincoln ever owned stands at the corner of Eighth and Jackson streets. Today the modest home, built in 1839, is the centerpiece of a four-block historic park. A few blocks to the north, at 1500 Monument Avenue, the somber and stirring Lincoln Tomb towers over his final resting place.

Springfield has many attractions beyond those associated with Abraham Lincoln. There are several excellent Civil War museums, most notably the Grand Army of the Republic Memorial Museum and the Daughters of Union Veterans of the Civil War Museum, and related sites such as Camp Butler National Cemetery. Other attractions of note include the Air Combat Museum, the Illinois State Museum, and the unique Museum of Funeral Customs.

The journey in Lincoln's footsteps continues with a stop at the New Salem State Historic Site, twenty miles northwest of Springfield. With painstaking attention to detail, this village is a near-perfect re-creation of the 1830s trading town where Lincoln worked as a postmaster and began his formal education.

At Havana, the drive takes a turn along the Illinois River Road: Route of the Voyageurs. As this byway is a celebration of Illinois' rich diversity, natural as well as human, two wonderful stops serve as an

Route 4

Start at the intersection of Ninth Street and East Clear Lake Avenue (State Route 97) in Springfield and drive west on Route 97. Follow this highway north across the Illinois River at Havana and then turn north on U.S. Highway 24. At War Memorial Drive in Peoria, turn north on State Route 29 and continue along the river to Peru. The approximate distance is 165 miles.

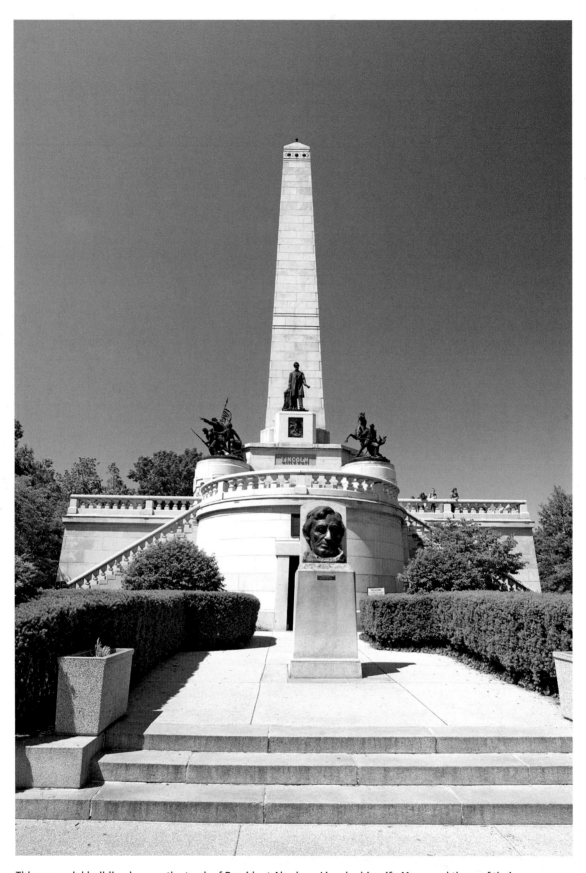

This memorial building houses the tomb of President Abraham Lincoln, his wife Mary, and three of their four sons, Edward, William, and Thomas. Around the statue of Lincoln, four bronze sculptures represent the infantry, artillery, cavalry, and navy of the Civil War. RICK & NORA BOWERS

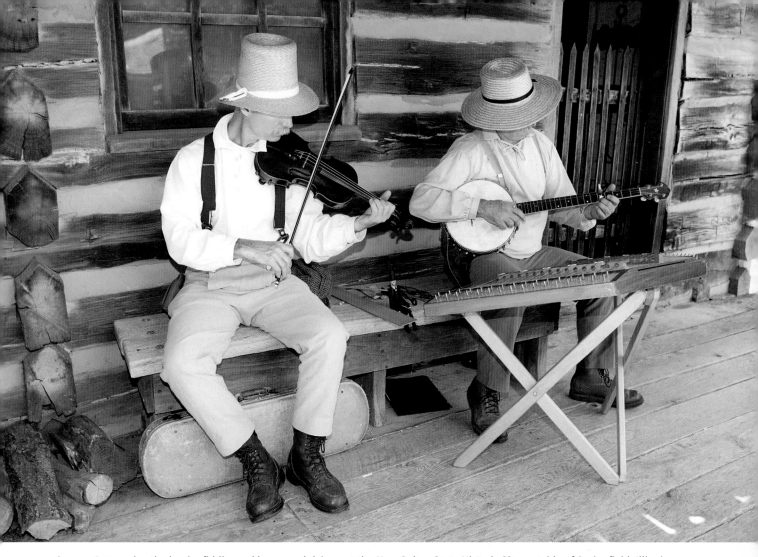

ABOVE: Actors play the banjo, fiddle, and hammer dulcimer at the New Salem State Historic Site, outside of Springfield, Illinois. They are among the many re-enactors who show visitors what life was like during Lincoln's time in New Salem.
RICK & NORA BOWERS

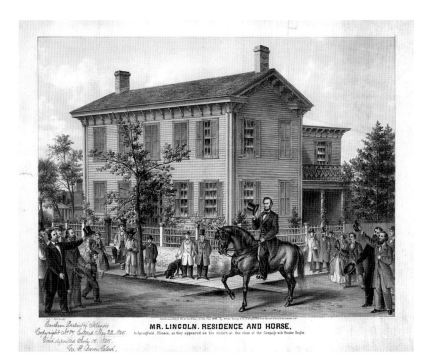

MR. LINCOLN. RESIDENCE AND HORSE,
In Springfield, Illinois, as they appeared on his return at the close of the Campaign with Senator Douglas.

LEFT: This sketch of Lincoln astride a horse outside of his Springfield residence dates back to 1865.
LIBRARY OF CONGRESS

Maple leaves frame a lazy summer river scene in Emiquon National Wildlife Refuge near Havana, Illinois.
RICK & NORA BOWERS

introduction to both: Emiquon Preserve and National Wildlife Refuge and Dickson Mounds.

Initiated as a pilot project to restore the wetlands of the Illinois River, the Emiquon Preserve has become a window onto Illinois as it was before the arrival of European settlers. The best way to experience this turn-back-the-clock experiment is to hike the Frank C. Bellrose Nature Trail.

Dickson Mounds, a premier on-site archaeological museum, preserves and re-creates the world of the region's original human inhabitants through restoration of the surrounding environment, interpretive exhibits, and audiovisual programs covering almost 12,000 years of Native American history. A highlight of any visit is the hands-on discovery center.

From Dickson Mounds, the drive along the Illinois River is dotted with opportunities to stop, stretch your legs, and take in the beauty of the river valley. This is especially true south of Peoria.

Peoria itself is, perhaps, one of the most overlooked and undervalued urban areas in America. The River Front District is the heart of the community. Festivals and fairs attract thousands to the shores of the Illinois River; thousands more are lured by the cultural, dining, and entertainment opportunities.

The city of Peoria features a series of lakeside and riverside parks, intriguing historic sites, and fine art museums as well as unique, informative museums such as the African American Museum Hall of Fame.

A favorite for all ages is Peoria's Wheels O' Time Museum. This fascinating, hands-on museum offers a mechanical menagerie of vintage automobiles, all manner of gasoline engines, airplanes, trains (the real thing as well as toys), jukeboxes, and even a miniature circus.

North of Peoria, a number of small communities represent stereotypical small-town America. One in particular should not be missed, so be sure to take the time to seek out Chillicothe, where the city streets are lined with buildings featuring architectural styles that span more than a century.

The remainder of this drive toward Peru is much like the first section along the river south of Peoria: scenic views of the river and lakes, rich agricultural lands, and alluring parks that almost beg one to stop for a picnic lunch.

Two parks found along the Illinois River Road deserve special mention. Starved Rock State Park, east of Peru near Utica, is stunning. Here you can enjoy a series of deep glacier-carved canyons, trails of varying lengths through the wondrous landscape, and scenic overlooks.

The 104-mile-long linear Hennepin Canal Parkway State Park is a delightful woodland laced with trails and ample opportunities for outdoor recreation. The centerpiece of the park is a monument to folly. The Hennepin Canal was conceived in 1890 as part of a plan to connect the Great Lakes with the Gulf of Mexico. Seventeen years into the project, the railroad and increased barge sizes made the canal obsolete. The canal begins at the Illinois River, north of Hennepin, and reaches the Mississippi River at Rock Island.

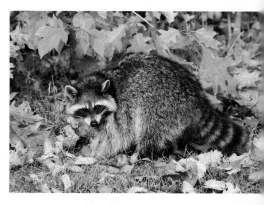

Raccoons searching for mussels and crayfish are frequent visitors to rivers throughout the Midwest.
RICK & NORA BOWERS

ROUTE 5

North to Adventure

GRANITE CITY TO NAUVOO

This drive is but a small portion of the Great River Road that follows the Mississippi River through the heart of America. The scenic byway is marked with signage that bears a ship's pilot wheel, a testimonial to the steamships that played a crucial role in the development of the continent's interior.

The journey begins at the Chain of Rocks Bridge, a historic Route 66 river crossing that was converted to a pedestrian bridge in the late 1990s. From there, you will battle traffic through Granite City, catch glimpses of the mighty Mississippi thick with barges and commerce, and break into a brief clearing of suburbia interspersed with urban sprawl—though this is not to say that this portion of the trip is without its charm or points of interest.

At Hartford, the Lewis & Clark Interpretive Center stands at the location of the launching of the famous duo's western explorations. This facility opened in 2002 as a living history complex introducing

Route 5

Begin at the historic Route 66 crossing of the Mississippi River, Chain of Rocks Bridge, in Granite City. Follow State Route 3 north under Interstate 270 and continue north to Wood River. Here, follow State Route 143 west to Alton. In Alton, turn north on State Route 100 and drive to Kampsville, and then turn west on to state Route 96. Continue north on this highway along the river to Nauvoo. The approximate distance is 180 miles.

Winged Liberty marks the gravesite in the Alton National Cemetery of Elijah Parish Lovejoy, a newspaper editor and Presbyterian minister shot to death by an angry mob in Alton, Illinois, for his stand against slavery.
RICK & NORA BOWERS

Bald eagles, the nation's symbol, soar over the 8,050-acre Pere Marquette State Park, Illinois' largest state park.
RICK & NORA BOWERS

visitors to the world of Camp River DuBois, the original training center for the Lewis and Clark Corps of Discovery expedition.

Alton, a few miles to the northwest, includes an amazing array of forgotten architectural landmarks as well as historic sites. The National Great Rivers Museum presents a fascinating, thumbnail history of the Mississippi River's role in the history of the region. On Market Street at Broadway, Lincoln Douglas Square commemorates the last debate between two of the nation's greatest orators, Abraham Lincoln and Stephen Douglas, which took place in Alton in 1858. A walking tour of the historic district features numerous buildings that served as important stops for fugitive slaves seeking refuge as they headed north along the Underground Railroad.

As the urban landscape gives way to the rural, you will encounter an increasing number of glimpses into the Mississippi River Valley of more than a century ago. At various locations between Alton and Grafton, bald eagles nest and roost.

The quaint community of Elsah, nestled in a scenic, wooded valley, appears to be the land where time stood still. The entire town is listed on the National Register of Historic Places. The distinctive stone construction of the buildings in this community presents a timeless feel that makes it difficult to find a seam between the past and present.

Short detours provide endless opportunity to experience historic and scenic attractions often missed. An excellent example of what awaits the adventurous explorer is found on a drive south of Hardin to Brussels, home of Wittmond Restaurant. The former hotel and stage station, built in 1847, also houses a general store.

When was the last time you heard of a game show or contest offering a trip to Quincy as the grand prize? While this lack of attention ensures that the crowds are not overwhelming here, Quincy is one of those places that is too big to be considered a small town but which offers all the charms and appeal of small-town America.

Victorian-era homes and businesses are scattered through Quincy's older districts, and the city boasts a number of interesting cultural and historic sites. The Dr. Richard Eell House, at Jersey and Fourth streets, is an unassuming two-story brick home built by a leading abolitionist. Eell's home served as a stop on the Underground Railroad in the 1830s.

This city on the river is also home to the Mississippi Valley Historic Antique Car Museum, the World Aerospace Museum, the Gardner Museum of Architecture & Design, the Quincy Art Center, and the All Wars Museum. For a quiet getaway, seek out the solitude of Quinsippi Island, a delightful respite from the modern era with cabins, a harbor, and a beach.

The drive north from Quincy reveals a surprisingly rural landscape, with long stretches where the asphalt cuts through thick

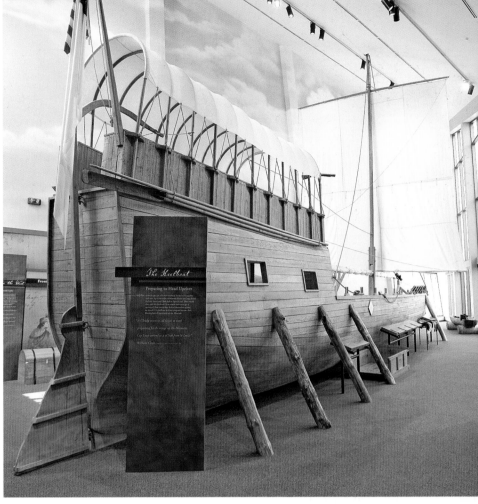

stands of forest and follows the contour of steeply rolling hills. All of this sets the stage for our final stop, Nauvoo.

Restored or rebuilt homes and business act as a window into the world of the 1840s and form the core of the Nauvoo community. The city's main claim to fame is its connections to Joseph Smith and the Church of Jesus Christ of Latter-day Saints. In 1839, Smith and a group of his Mormon followers who were forced to flee Missouri settled in the mostly vacant community of Commerce in Hancock County, about fifty miles north of Quincy on the Mississippi River. Smith renamed the town Nauvoo, after the Hebrew word for beautiful, and the Mormon settlement quickly grew. Animosity with the surrounding non-Mormon communities eventually led to the exodus of most Mormons from the city in 1846. Today, the Joseph Smith Homestead and other sights stand as monuments to the Mormon founder, and a new LDS temple was completed in Nauvoo in 2002. The temple replicates the community's original temple, which was built in 1841 but was burned by arsonists in 1848.

This thirty-five-foot keelboat is a re-creation of the one Lewis and Clark hauled, rowed, and sailed up five hundred miles of the Missouri River on their historic expedition to discover a waterway to the Pacific.
RICK & NORA BOWERS

ROUTE 6

The Illinois Wilderness

CAHOKIA TO CAIRO

In Cahokia, urban sprawl and trappings of the modern era often give the wrong impression to the casual visitor. Numerous attractions here attest to the age of this community and the important role it played when this was the nation's western frontier.

At First and Elm Street, the Cahokia Courthouse, built circa 1730, stands in a parklike setting. Nearby is the Holy Family Log Church, a unique structure in that it was built in the late 1700s with upright logs and a historic one in that it is the oldest standing church

Route **6**

In Cahokia, follow State Route 3 south about 150 miles to Cairo.

Stone replaced wood in the construction of Fort de Chartres in the 1750s. This massive stone fortress served as the seat of French colonial government in the area and was abandoned in 1771.
RICK & NORA BOWERS

between the Allegheny Mountains and the Mississippi River.

At Columbia, to the south, the road turns inland, away from the river and into a more pastoral landscape. Views from the car window or even short strolls from the main road offer little hint of the beauty and wonder that lies underfoot. The Great River Road takes you from Columbia to Waterloo, where the nearby Illinois Caverns State Natural Area allows visitors to see these down-under wonders, including whimsical cave formations and a small underground river. Tours of this cave complex require a hardhat and lantern.

At Ruma, travelers who choose a side trip west on Illinois State Route 155 will be richly rewarded. The scenic cemetery, with graves dating to 1731, and the name of the small town, Prairie du Rocher, reveal the region's French history.

Nearby, overlooking the river, is Fort de Chartres State Historic Site. This imposing stone edifice became the seat of French colonial government in the area in 1753 and today offers visitors a chance to learn about the French perspective on settling the new world. Rolling south, the road draws closer to the mighty Mississippi, providing beautiful views of the river from bluff tops framed by towering trees and lush landscapes. At Chester, where State Route 151 crosses the river, there is a park dedicated to a man whose contributions to pop culture span several generations: Elzie Segar, the creator of Popeye.

From Chester, the highway ventures into a land of forest deep and dark, steeply rolling hills, and quaint communities where time just does not seem to move quickly. Campgrounds, recreation areas, and hiking trails by the dozens leave little excuse for a rushed trip.

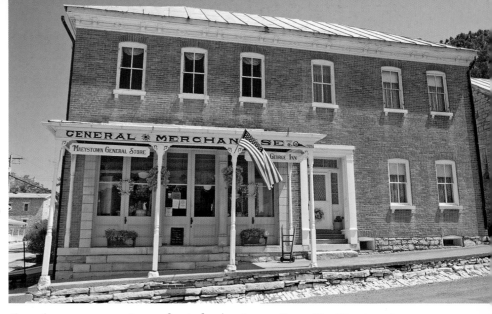

History abounds here in the wooded, rugged Shawnee Hills. In quiet Thebes, the towering hand-hewn stone courthouse, built in 1845 on a bluff above the river, is where Abraham Lincoln allegedly honed his oratory skills while practicing law. Dred Scott—the plaintiff of the notorious 1856 Supreme Court decision—was held overnight in the courthouse jail.

The Horseshoe Lake Conservation Area appears transplanted from some Louisiana bayou, with its bald cypress, tupelo gum, and swamp cottonwood trees. For bird-watchers, this is a wintering place for Canada geese, bald eagles, and numerous other northern species.

The current size of Cairo, at the southwestern tip of Illinois, belies the city's important role in the American Civil War. At the tip of the peninsula at the confluence of the Mississippi and Ohio rivers just south of Cairo is Fort Defiance State Park. Fort Defiance was crucial in defending this strategic location for the Union during the war, and for a time the fort was under the command of General Ulysses Grant. Today, the site of the historic fort and the surrounding area includes hiking trails and secluded picnic areas.

In the decade that followed the Civil War, Cairo rose to prominence as a river port. Attractions in the city today include the 1872 customhouse, completed after Congress named the community a port of delivery; Magnolia Manor, an 1869 residence that is currently on the National Register of Historic Places; and Riverlore, a breathtakingly beautiful home built in 1865 and nestled in a parklike setting across the street from Magnolia Manor. Both homes are open to the public for tours.

This is a drive to be savored rather than followed on a strict course from beginning to end. As you make this drive, ask the locals about other attractions and lay plans for a return visit.

ABOVE: Opened in 1884 as a saloon and hotel, the Maeystown General Store has been renovated to appear as it was when it served as a mercantile in 1904.
RICK & NORA BOWERS

BELOW: The native prairie at the 120-acre Illinois Caverns State Natural Area awash with blooming spring wildflowers.
RICK & NORA BOWERS

PART II

Missouri and Kansas

Ozark Wonderland

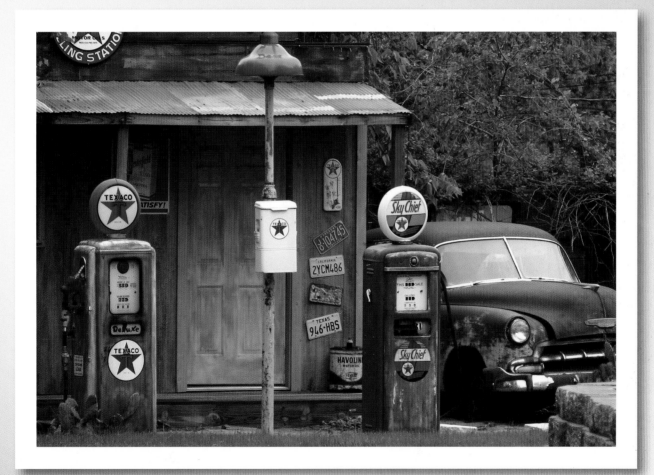

ABOVE: This vintage Texaco service station in Springfield, Missouri, hints of a time when Route 66 was the Main Street of America. ROUTE66PHOTOGRAPHS.COM

OPPOSITE: Lake of the Ozarks in Missouri's Ozarks State Park is a serene inland sea surrounded by a picturesque landscape of forested bluffs and vistas. ©CHARLEY GURCHE

The Missouri landscape is largely one of rolling, forested hills dotted with lakes and cleaved by streams, brooks, and rivers. That is, however, only the surface beauty, as more than five thousand caves filled with spectacular formations are scattered throughout the state.

That's Missouri in a nutshell. Behind every attraction, scenic view, or wooded park there is another story, another vista of even more stunning beauty.

The eastern border of the state, the Mississippi River, is one of the busiest shipping lanes in the world. However, a drive along the bank, north or south of St. Louis, is a journey through historic communities and pristine woodlands.

Today, Missouri's rural landscape includes sleepy farming communities and hamlets nestled among towering forests, all laced with miles of scenic trails. Historic markers and quiet cemeteries are tangible reminders that this seeming paradise was once the front line in our nation's most brutal conflict, the Civil War.

Missouri has a long association with larger-than-life figures of history. Frank and Jesse James, Mark Twain, Harry Truman, and even Winston Churchill and Jacques Cousteau are but a few. Many lesser-known individuals associated with Missouri made contributions that were just as wide reaching. James Cash "J. C." Penny launched his empire in Hamilton, and Joyce Hall of Kansas City made a fortune with a little card business called Hallmark.

From Missouri, your journey along Route 66 takes you briefly into a state that is often passed through to get somewhere else. In the sixteenth century, Francisco Vázquez de Coronado, the legendary conquistador, was in search of the fabled Quivira when he came through the land that is now Kansas. Pioneers crossed the territory on their way to the promised lands of the West. Pony Express riders crossed the Kansas plains carrying news from east to west and back again. In the closing decades of the nineteenth century, the American version of the *vaquero*, cowboys, drove cattle north to the railheads in Kansas or to the fertile grasslands of Wyoming and Montana.

Even Route 66 enthusiasts often rush through Kansas, perhaps not entirely surprising since this state has the shortest portion of the legendary highway. But to do so may cause you to miss some real treasures, manmade as well as natural.

Mention Kansas and the first thoughts that often come to mind are rolling hills of amber grain; Dorothy, Toto, and *The Wizard of Oz*; and tornados. This is the illusion. The reality is that this state has award-winning wineries and historic forts, buffalo herds, and the world's largest ball of twine. It's also home to world-class symphonies among the flowers on the prairie, the world's largest hand-dug well, and plenty of friendly folks.

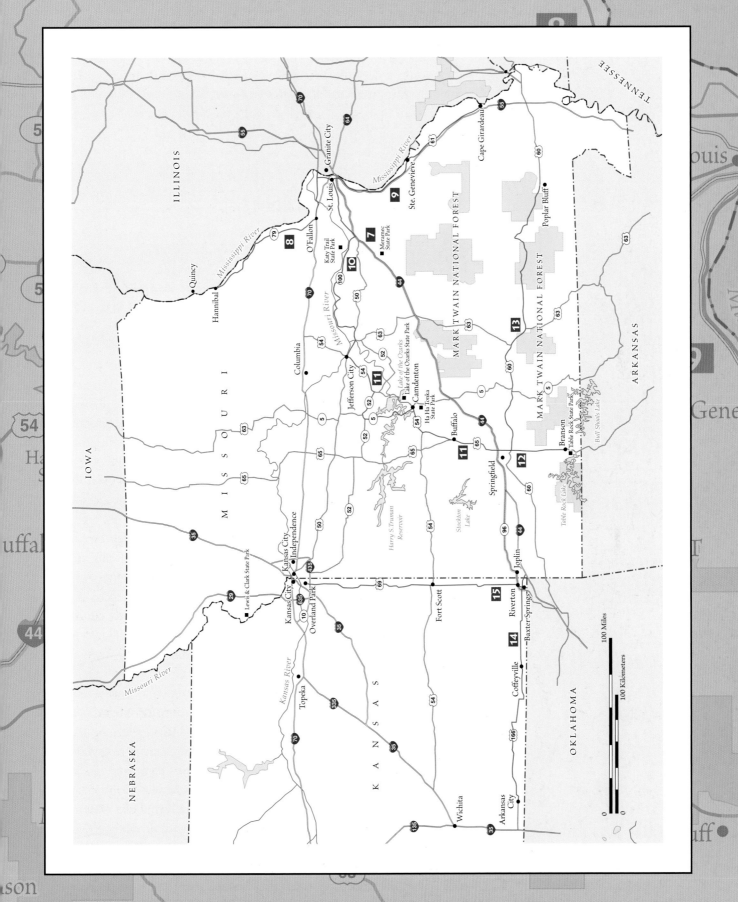

Though this visit to Kansas is a brief one, the rich diversity and multitude of surprises will most likely encourage future visits and even greater adventures.

As you travel the Main Street of America and its side streets through Missouri and Kansas, be sure to savor the beauty and history found here. Then slow the pace and discover even more beauty and history.

ROUTE 7

The Mother Road in the Show Me and Sunflower States

ROUTE 66 IN MISSOURI AND KANSAS

Over the years, the Route 66 shield has appeared on many different streets in St. Louis, so it's hard to know for sure that you are driving the Main Street of America when passing through the "Gateway City." The road's initial entrance into St. Louis was on the recently renovated McKinley Bridge from Venice, Illinois; it then followed Salisbury to Florisant Avenue, headed south along Tucker and then west on Manchester Avenue to Manchester.

A highway realignment in about 1934 moved the river crossing south to the Municipal Free Bridge, and then the road ran along Twelfth Street to Gravois Avenue, and west on Chippewa Street. Later in the 1930s, the highway again was realigned, this time to the Chain of Rocks Bridge crossing, from which it turned south near Lambert Field (now Lambert–St. Louis International Airport) and continued west through the suburb of Kirkwood.

Regardless of the alignment, landmarks from the pre-interstate era are plentiful in the city of St. Louis. A few—such as two veterans found along Chippewa Avenue, Ted Drewes Frozen Custard and Garavelli's Restaurant—have transcended the realm of mere roadside eateries to become classic destinations on the legendary highway.

West of the city, much of old Route 66 serves as a frontage road for Interstate 44. Other portions serve as the business loop through small towns decorated with remnants from when this was the main route, at times presenting the illusion that you have stumbled into a lost world.

Enhancing this illusion are the dense stands of native hickory, oak, sycamore, and dogwood that border the road and drape the

Route **7**

Begin at the west end of Chain of Rocks Bridge. Drive south on Riverview Drive to Broadway. Missouri takes great pride in its association with Route 66; as a result, the Mother Road is well marked throughout the state with large portions serving as the access road for Interstate 44.

OPPOSITE: The 630-foot-tall Gateway Arch in St. Louis, Missouri, the city's most prominent feature, and the surrounding Jefferson National Expansion Memorial were built to commemorate the Louisiana Purchase. RICK & NORA BOWERS

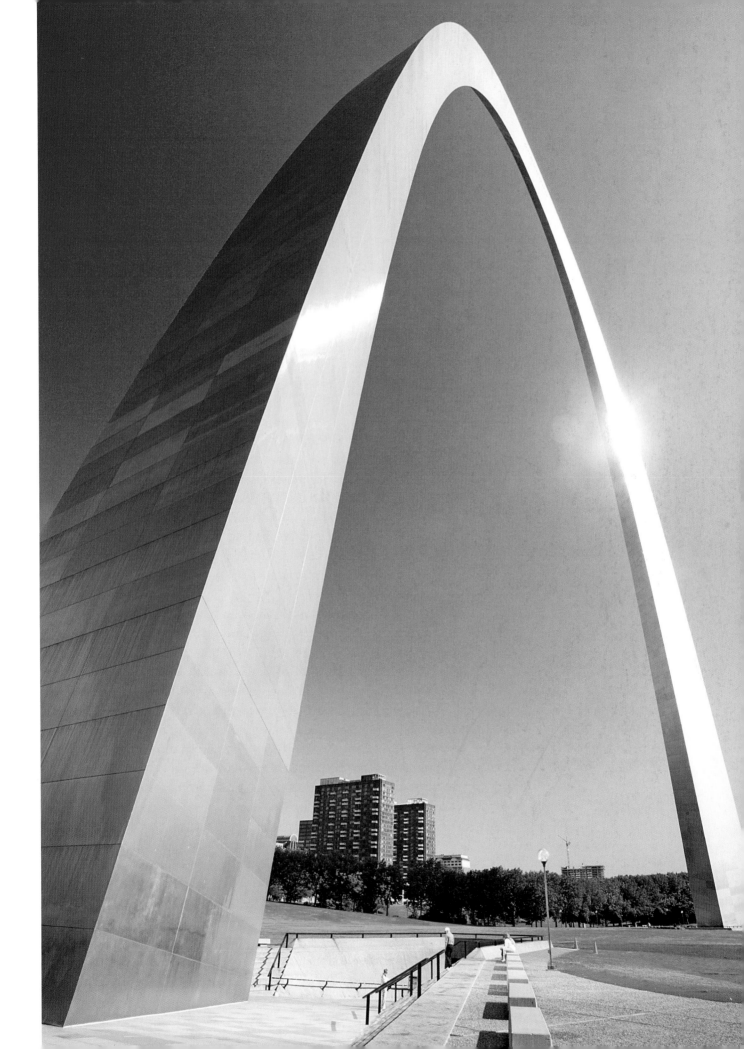

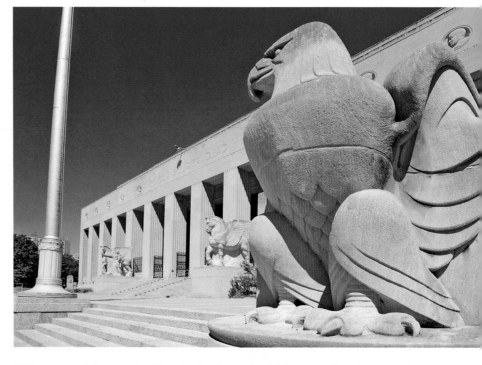

The Veterans Memorial building with its surrounding monuments in downtown St. Louis honors the brave sacrifices of men and women from all branches of service and all U.S. wars. RICK & NORA BOWERS

BELOW: This vintage postcard from Route 66's Coral Court Motel in St. Louis notes that the motel's accommodations are "exclusive, not expensive. The finest in the Midwest." AUTHOR'S COLLECTION

hills west of St. Louis. Shortly before World War II, for thirty miles west of the city, the state planted these and other native trees and shrubs along the Henry Shaw Gardenway, a highway named for the founder of St. Louis' famous Missouri Botanical Gardens.

Near the old railroad town of Pacific, a quiet community that was nearly erased from the map by Confederate raiders in 1864, the Jensen Point scenic overlook provides a panoramic view of the forested hills that border the wide Meramec Valley. The strip of asphalt that is Route 66 and the railroad that parallels it stand in contrast to the rich greens of the countryside.

Leaving Pacific, old 66 noticeably begins its climb from the valley toward Gray Summit. In the 1920s, here on the banks of the Meramec River, the Missouri Botanical Garden Arboretum and Nature Preserve (now known as the Shaw Nature Reserve) was established. The Missouri Botanical Garden sought out the site as a new home for much of its collection, including the garden's impressive orchid display, free from the pollution of urban St. Louis.

Ancient cemeteries with fences that serve as trellises for honeysuckle vines, old roadside business with glassless windows that blend with the shadows under ancient trees, and vintage bridges dot the drive west toward Rolla.

About midway between Gray Summit and Rolla, near Stanton, is a true Route 66 icon, Meramec Caverns. Found about three miles off the highway, the caverns have been an attraction for centuries; legend claims that one of the first European visitors was Hernando de Soto in 1542.

However, it took the traffic of Route 66, the desperation of the Great Depression, and the showmanship of Lester Dill to give Meramec

Caverns worldwide recognition. To entice tourists and travelers from the highway during the bleak days of the Depression, roadside promotions encouraged visitors to park their cars in the cool of the cave, and in the evenings, dances were held in one of the cavern's great rooms.

During the war years, soldiers from Fort Leonard Wood bivouacked in the nearby river bottoms during maneuvers and were entertained with lavish dances in the cave. Postwar prosperity and the height of the family vacation on the open road kicked promotion into high gear. Free weddings were offered for any couple who would tie the knot underground. A decrepit old log cabin, torn down and reconstructed in the cave, was heralded as the hideout of Jesse James. When the Cold War made concerns about nuclear war a national paranoia, Meramec Caverns proclaimed itself the "Safest Bomb Shelter in the World."

As with Tennessee's famous Rock City, Meramec Caverns was promoted on barns along Route 66 and in surrounding states. Further advertising was achieved by tying large cardboard signs to each bumper in the parking lot.

Between Stanton and Springfield, like a necklace of tarnished beads, little communities lie nestled among the hills and valleys. You

The Backyard Garden is a small portion of the seventy-nine-acre Missouri Botanical Garden, one of the oldest botanical gardens in the United States. The St. Louis–area institution was founded by botanist Henry Shaw in 1859.
RICK & NORA BOWERS

IN THE BEGINNING THERE WAS . . .

FOR THE COMMUNITIES situated between St. Louis and Springfield, the opening of Route 66 in 1926 was anticlimactic. Much of the highway's route through the Ozarks followed a road that had been established by the government some twenty years before the Civil War. Even this road was a relative newcomer, as it followed the Great Osage Trail, a major trade route used by Native tribes.

During the Civil War, the road was an important link in the supply chain for both Union and Confederate troops. During this period, a telegraph line was strung along the road, with primary stations at St. Louis, Rolla, Lebanon, and Springfield, and the old trail became known as the Old Wire Road.

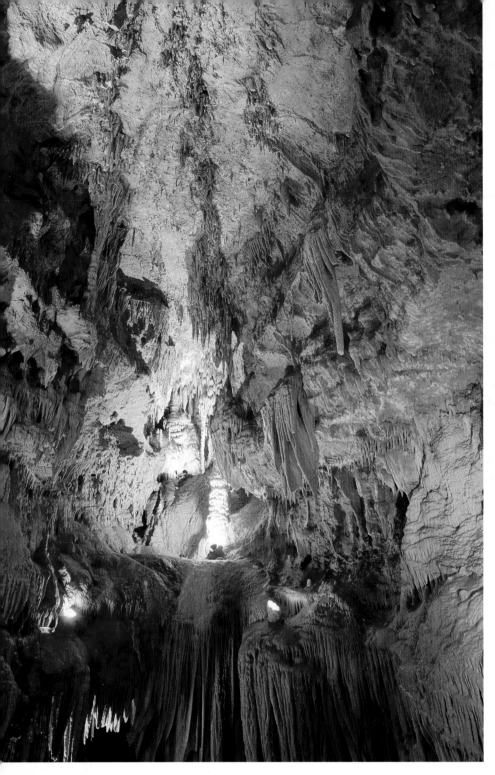

On tours, trained guides share the natural and varied human history of Meramec Caverns, the state's largest commercial cave.
RICK & NORA BOWERS

will find vestiges of the highway's glory days in each, but it often takes a stop to discover the shine beneath the tarnish.

Sleepy little Sullivan is the hometown of George Hearst, father of publishing czar William Randolph Hearst. Rosati and St. James are home to several fine wineries. Martin Springs is where The Old Homestead, one of the nation's first truck stops, opened in 1925.

The beauty of Devils Elbow at a bend of the Big Piney River contrasts with the horrendous accidents that made this a dreaded part of any drive on old Route 66. The lay of the land forces the highway into a series of twists and turns over hills and through scenic hollows on the way to the "Queen of the Ozarks," Springfield.

For decades, this small city has served as a base camp for those seeking the wonders of the Ozarks. Today it is also a mecca for the Route 66 enthusiast, as scores of vintage eateries and motels, garages, and other roadside businesses await rediscovery.

After Springfield, the landscape takes on a distinctly different look as the highway rolls out onto the Springfield Plateau. Again, a string of small roadside and farming communities with long, rich histories are easily overlooked on the drive west.

Carthage, the county seat of Jasper County, is probably best known for its association with Route 66. This now-quiet community, however, has a long and dark history.

Carthage was almost erased from the map in guerrilla raids during the Civil War, and the community suffered greatly throughout the war. On July 5, 1861, the Battle of Carthage took place in the surrounding fields and woods. This was sixteen days before the Battle of Manassas, making this the first land battle of the Civil War.

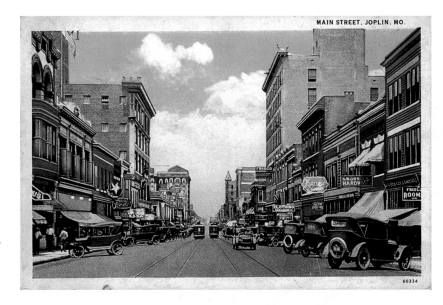

MAIN STREET. JOPLIN, MO.

60334

The city was also the birthplace of bandit queen Belle Starr. The notorious outlaw aided the Confederate troops in Carthage during the war, and later she was affiliated with the James and Younger gangs.

In the years following the war, lead and zinc mining brought prosperity to Carthage. This, as well as quarrying Carthage gray marble, resulted in a city of fine homes and substantial public buildings.

With this history, Carthage is a community that deserves more than a quick drive through.

Then there is dusty, all-American Joplin, long the jumping-off point for folks headed out to the plains and points west. Here, the town's Main Street was also, fittingly, Route 66, and though the old business district is a bit down at the heels, it is a diamond in the rough awaiting rediscovery.

ROUTE 8

In Search of Huck Finn and Becky Thatcher

CHAIN OF ROCKS BRIDGE TO HANNIBAL

Though the drive from Chain of Rocks Bridge to Hannibal is a relatively short one, you can easily spend several days exploring this area—and the memories will last a lifetime. For those who value sights seen and wonders discovered more than miles covered, a visit here offers many rewards. Time, lots of film, and comfortable walking shoes are all you will need.

Route 8

From Chain of Rocks Bridge, continue west on Interstate 270 to Interstate 70. Follow I-70 west to O'Fallon; then turn north on State Route 79. Continue north on Route 79 just over 100 miles to Hannibal.

The *Mark Twain*, named for Hannibal, Missouri's most famous son and a former riverboat pilot, plies the waters of the mighty Mississippi River. RICK & NORA BOWERS

The Becky Thatcher House in Hannibal, Missouri, is the "home" of the fictional character of the same name in Mark Twain's classic *The Adventures of Tom Sawyer.* RICK & NORA BOWERS

Mark Twain moved to Hannibal in 1839 and left in 1853 but never completely cut his ties with his hometown. LIBRARY OF CONGRESS

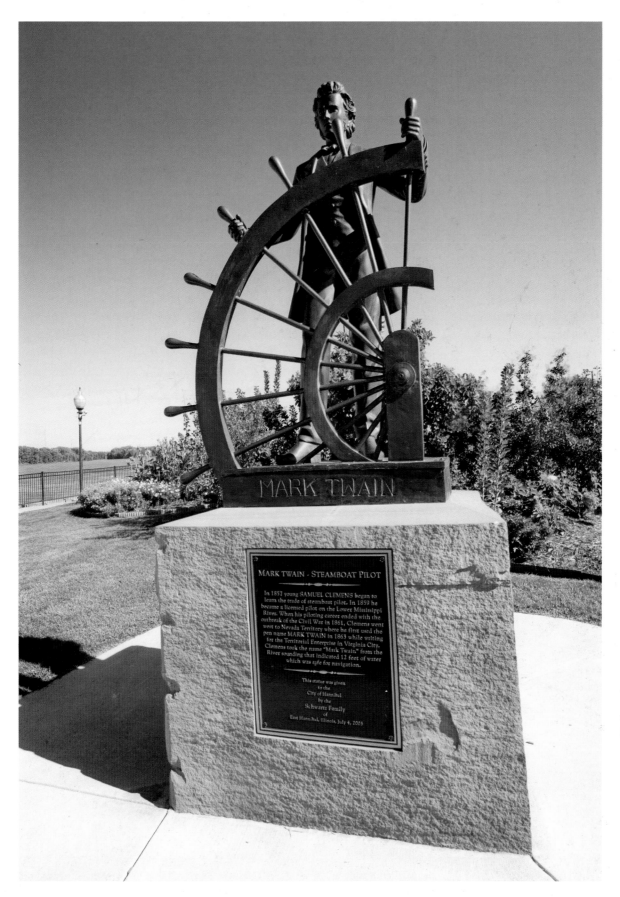

MARK TWAIN

MARK TWAIN - STEAMBOAT PILOT

In 1857 young SAMUEL CLEMENS began to learn the trade of steamboat pilot. In 1859 he became a licensed pilot on the Lower Mississippi River. When his piloting career ended with the outbreak of the Civil War in 1861, Clemens went west to Nevada Territory where he first used the pen name MARK TWAIN in 1863 while writing for the Territorial Enterprise in Virginia City. Clemens took the name "Mark Twain" from the River sounding that indicated 12 feet of water which was safe for navigation.

This statue was given to the City of Hannibal by the Schwartz Family of East Hannibal, Illinois, July 4, 2003

This statue commemorates the three-year riverboat piloting career of Samuel Clemens, aka Mark Twain, in his boyhood hometown. RICK & NORA BOWERS

SLOWING THE PACE IN MISSOURI

ONE OF THE GREAT UNDISCOVERED treasures of Missouri is the KATY Trail system, the largest rails-to-trails project in the nation. This trail follows the old rail beds of the defunct Missouri-Kansas-Texas Railroad from Machens, near St. Louis, to Clinton, east of Kansas City.

In between these cities are 225 miles of some of Missouri's finest scenery. Stony bluffs along the Missouri River, deep and primeval forests, rolling hills, and vast farmlands are the centerpieces.

The old railroad towns along the route, many with refurbished lodging and dining establishments, cater to travelers on the trails as they did for those who rode the rails.

The drive begins at Chain of Rocks Bridge (which is now limited to bicycle and pedestrian traffic), quickly becomes a battle with modern urban congestion, and then almost as quickly enters an earlier era at St. Charles, across the Missouri River. A visit to this amazing riverside community can absorb a weekend or a full week, especially for those who walk its streets in search of hidden treasures.

Exemplifying these treasures is Boone's Lick Trail Inn, at 1000 South Main Street, which provides lodging as it has for over a century and a half. Keeping it company are more than ten full blocks of lovingly restored buildings that constitute the state's largest historic district. Fine dining, antique shops, cobblestone streets, and even wine tasting, all on the banks of the Missouri River, present a rich tapestry of sights, sounds, and flavors.

Rolling north from O'Fallon on Missouri State Route 79, the Great River Road seems almost like a dark stream dappled by shadows from the towering trees. Through it all, one thing remains constant: the Mississippi River. On occasion framed by twisted trees, the views are most spectacular from the heights of a rocky bluff or county lane.

Clarksville, usually home to less than five hundred residents, becomes a small metropolis every year during the last weekend in January when thousands gather to see the wintering bald eagles. Further upriver, the town of Louisiana's entire business district is on the National Register of Historic Places. The town boasts lavish antebellum homes, many overlooking the river, as well as antique stores and intriguing gift shops.

Not all of the wonders found along this drive relate to human history and endeavors. There are several excellent opportunities to experience the mighty Mississippi as it was when Missouri was the western frontier. The most notable among these is at the Clarence Cannon National Wildlife Refuge near Annada. Here you'll find two hundred species of migratory birds, including bald eagles, waterfowl, shorebirds, and songbirds. Many birds also nest on the refuge, including the king rail (a Missouri state endangered species) and a pair of bald eagles.

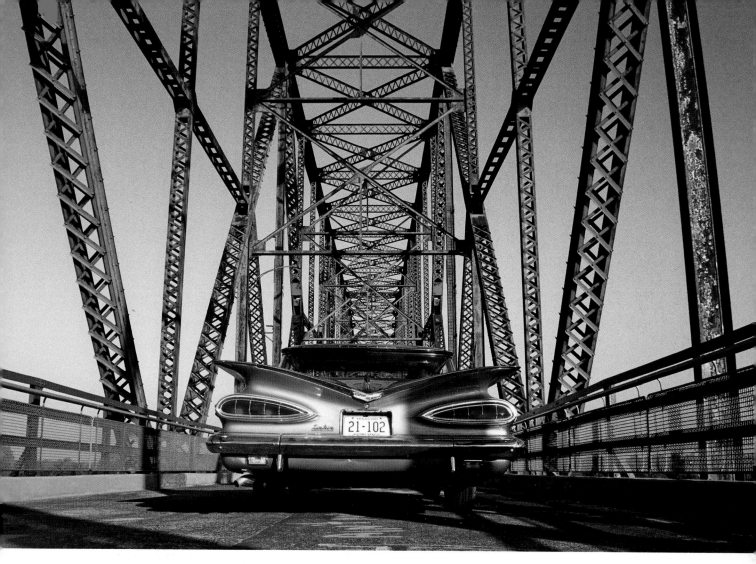

The crown jewel of the small riverbank communities north of St. Charles may not be as quiet or even as historic as most, but through the prose of Mark Twain, the community of Hannibal is forever immortalized. As a result, much of the community centers around Samuel Clemens, aka Mark Twain, and the characters he created.

There is the Becky Thatcher House, which is actually the home of Laura Hawkins, who lived here in the 1840s and who was the inspiration for the fictional character in Twain's *The Adventures of Tom Sawyer.* The Garth Woodside Mansion, set in thirty-nine acres of gardens and woodlands, was frequented by Mark Twain on his many visits to Hannibal. This lovely home was built in 1871 and is famous for its three-story "floating" staircase, which seems to defy all principles of construction.

There is also the Mark Twain Cave, described in the classic *The Adventures of Tom Sawyer,* and the Planters Barn Theater, built in 1849. There are even worthwhile places in Hannibal that are not associated with the legendary storyteller. The Molly Brown Birthplace and Museum honors the woman who came to be known as the "Unsinkable Molly Brown" after she survived the tragedy of the *Titanic* in 1912. The museum celebrates Brown's rags-to-riches story and provides a window into the Hannibal of the 1870s and 1880s.

The historic Chain of Rocks Bridge with its unique mid-river bend was recently reopened as a pedestrian-only bridge.
ROUTE66PHOTOGRAPHS.COM

ROUTE 9

The Legacy of a River Named Mississippi

ST. LOUIS TO CAPE GIRARDEAU

This grand adventure along the mighty Mississippi begins at the Jefferson National Expansion Memorial in St. Louis. In addition to the arch that provides stunning views and that has come to symbolize the city as a gateway to the West, this beautiful park on the banks of the Mississippi River is home to the Museum of Western Expansion, located under the arch, and the old St. Louis courthouse nearby.

After leaving the city, your first stop on this drive of discovery is Jefferson Barracks Park and National Cemetery, just south of St. Louis on the banks of the river. Established in 1826, Jefferson Barracks was the nation's first "Infantry School of Practice." It was a major military post during Indian conflicts, the Mexican-American War, and the Civil War and continued to serve as a training site through World War II. Among the notable soldiers who served at Jefferson Barracks were Ulysses S. Grant, William T. Sherman, Jefferson Davis, and Robert E. Lee. Today the park is relatively quiet and somber, with rows upon rows of white stone markers standing as mute testimony to those who served their nation in times of crisis.

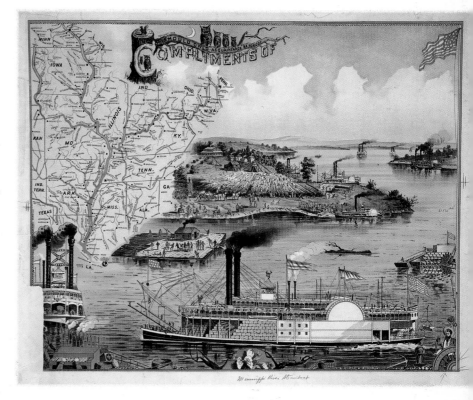

Taking a step even further back in time is as easy as a visit to Mastodon State Park and the Kimmswick Bone Bed near Imperial. An enthralling visitor's center, life-size dioramas that capture the thrill of the hunt of some ten thousand years ago, and the most extensive Pleistocene fossil beds in the country make this a fascinating stop for young and old alike.

The vast urban landscape of St. Louis gives way to an increasingly rural one as you continue south. The Governor Daniel Dunklin's Grave State Historic Site offers a beautiful overlook of the Mississippi River at Herculaneum.

ABOVE: This Mississippi River steamboat scene, completed in 1885, shows African-Americans on a raft picking cotton and playing instruments. LIBRARY OF CONGRESS

OPPOSITE: Tower Rock on the Mississippi River has served as a landmark and directional milepost for riverboat traffic for more than a century. ©CHARLEY GURCHE

Route **9**

From Jefferson National Expansion Memorial, drive south on Memorial Drive to Interstate 55. Continue south on I-55. At Weber Road, Exit 201B, drive east to Broadway and then turn south. Broadway is also State Route 231. Continue south on Route 231 to Jeffco Boulevard, U.S. Highway 61. Turn south on U.S. 61 and continue to Jackson. In Jackson, follow East Jackson Boulevard southeast to Cape Girardeau. This entire route is approximately 150 miles.

The 1821 courthouse in Sainte Genevieve, Missouri, provides a rare glimpse into a time when this was the western frontier. ©CHARLEY GURCHE

The halfway point between St. Louis and Cape Girardeau is lovely Sainte Genevieve. Established as a French colonial outpost more than a decade before Thomas Jefferson penned the Declaration of Independence, this charming community is now famous for its wineries.

The pinnacle of a wine-tasting tour of the area has to be the Sainte Genevieve Winery and Inn. The heart of the winery is its inn, a stately five-thousand-square-foot mansion built around 1900. Flower gardens, flower boxes, and a shaded grape arbor embrace the visitor with genteel charm and warmth. Only the occasional hint of a southern accent breaks the illusion that you are sampling hand-crafted wines in a remote valley in southern France.

Rolling with the river, and twisting and turning with the gentle flow of the land, the drive continues south. Wonders abound on the last leg of this drive, so take the time to stop for a cup of coffee and ask the locals for tips.

In little Perryville, there is the St. Mary of the Barrens Church, opened in 1827. A quick detour east on County Route A provides another opportunity to experience a little touch of Europe; the

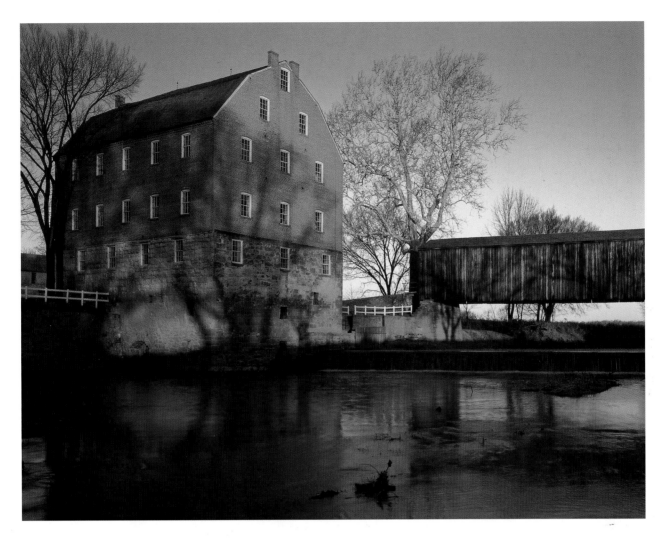

The covered bridge and grist mill at Bollinger Mill State Historic Site make this attraction seem timeless.
©CHARLEY GURCHE

towns of Frohna, Altenburg, and Wittenberg all reflect their German heritage. Nearby is Tower Rock, an 85-foot monolith standing in the deep waters of the Mississippi River.

Back on the main route, U.S. Highway 61, Jackson is another Missouri gem. Quaint bed-and-breakfast inns, historic homes, and good food are available for those in need of a little rest and relaxation; the Iron Mountain Railway is a destination for those who hunger for history and adventure.

The historic tourist railway is a railfan's dream, with its steam locomotive and vintage rolling stock, but it is also a fun-filled adventure for the whole family or an opportunity for a romantic evening for two. Strolling magicians, an occasional train robbery, a dinner train, and a murder mystery run are just some of the attractions here.

Detour west on Missouri State Route 34 to reach Bollinger Mill State Historic Site and another rare treat. Located on the Whitewater River, this imposing stone and brick edifice has been in continuous operation as a mill since the mid-nineteenth century. You can also walk across the oldest of Missouri's four remaining covered bridges, the Burfordville Covered Bridge. Built in 1858, the bridge is now open to pedestrian traffic only.

Cape Girardeau has preserved its long, colorful history with loving attention to detail. The "modern" era for this history dates to the establishment of a trading post on a nearby bluff overlooking the river in 1733. Historic homes that look like architectural jewel boxes, dining options that run from gourmet to Cajun and burgers, and the ever-present Mississippi River make Cape Girardeau a richly rewarding destination.

Although you could get from St. Louis to Cape Girardeau in less than two hours on Interstate 55, this is a drive that offers so much more if you take the roads less traveled and explore Missouri's hidden treasures.

ROUTE 10

On the Trail of Lewis and Clark

KIRKWOOD TO JEFFERSON CITY

On the map, Kirkwood blends with St. Louis as a suburb, but even a cursory visit shows this community has its own individual personality. Just explore the downtown Kirkwood Junction Special Business District, or check out the National Museum of Transportation.

Following the sun on its westward trek, the drive on Missouri State Route 100 and its attractions are primarily urban. Then, at Wildwood, everything changes. The Rockwood Reservation, a conservation education center, encompasses two thousand acres of woods and prairies with hiking trails and babbling brooks. The Hidden Valley Ski Area offers year-round outdoor adventure, with skiing in winter and a private golf course when the snow thaws.

Just west of Wildwood on Route 100, turn onto County Route T (St. Albans Road). Deep forest, scenic views of the Missouri River, and the little town of Labadie do not foster the urge to hurry or rush.

The next stop, perhaps for a day or two, is Washington, on the banks of the Missouri River. Located on the east end of town, the Fort Charrette Historic Village is a re-created late-eighteenth-century French frontier trading post that provides insight into the area's initial settlement by Europeans.

At Loaves and Fishes Bulk Foods on Front Street in Washington, all manner of Amish-produced foods are sold in a circa-1850 freight depot, giving the impression of a general store as it would have been around 1900. Another interesting attraction in the Washington area

Route 10

Begin in Kirkwood at the junction with State Route 100 and U.S. Highway 67. Continue west on State Route 100 to Linn and the junction with U.S. Highway 50. Turn west on U.S. 50 and continue to Jefferson City. This drive is approximately 155 miles.

OPPOSITE: Sunrise on the Missouri River is an unforgettable experience and delightful way to start a day of adventure in the Show Me State.
©CHARLEY GURCHE

Pelican Island Natural Area is but one of the many scenic wonders found along the Missouri River.
©CHARLEY GURCHE

is the Missouri Meerschaum corncob pipe factory and its corresponding Corn Cob Pipe Museum.

As you continue the drive along the Missouri River, there is ample opportunity to stop and stroll to work up a thirst for what awaits in New Haven and Hermann. The claim to fame for both communities is an array of fine wineries and wonderful views of the Missouri River Valley.

After Hermann, the highway twists and turns along the river and through quaint, almost-forgotten towns not much larger than the dots that represent them on maps. Still, those with an interest in photography will find near-limitless opportunities to capture the dramatic scenery.

Jefferson City, a truly beautiful little city on the banks of the Missouri River, offers numerous attractions, although some of the most interesting are rather somber in nature. During the Civil War, more than one hundred thousand Missouri men enlisted with the Union army, another thirty thousand enlisted with the Confederacy, and the state was the site of the third-highest number of combat engagements. Confederate guerilla activity in Missouri also worked to deprive Union forces of support and supplies.

In Jefferson City, several fine museums and sights pertain to this chapter as well as others in the state's rich history. Topping the list would be the Missouri State Museum in the state capitol, the Museum of Missouri Military History (at 2007 Retention Drive), and Jefferson City National Cemetery (1024 East McCarty).

ROUTE 11

Into the Heart of the Ozarks

SPRINGFIELD TO JEFFERSON CITY

Bring your hiking boots, your camera and, in the summer months, a bathing suit for this journey into the Ozarks. Most importantly, bring a sense of adventure.

This route begins in Springfield, a cornerstone of the state's Route 66 legacy and a city full of surprises. Imagine a community with a population under 170,000 that has a wonderful zoo, a vibrant arts district, an excellent air museum (the Air Combat Museum), beautiful parks and gardens, restaurants to please any appetite and palate, and even ballet. You'll find it all here.

You likely will find your speed dropping as you drive north into the Ozarks, as the astounding natural beauty causes you to slow the pace. Forest, rolling hills, rocky ridges, and streams blend into an entrancing tapestry.

With all due respect to the folks at Disney, the real magic kingdom is not in California or Florida but in the heartland of Missouri, at the Lake of the Ozarks. To locals, this huge, sprawling body of water is known simply as "the lake."

Bordered by towering cliffs and deep forests, the Lake of the Ozarks was created by the damming of the Osage River in 1931. With a shoreline longer than California's Pacific Coast, this manmade reservoir offers many opportunities for boating and other water sports. There is, however, more, much more, to a visit to the lake. There are

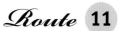

Route **11**

Begin at the junction of U.S. Highway 60 and U.S. Highway 65 in Springfield. Follow U.S. 65 north through the city and continue to Buffalo. There take State Route 73 north to U.S. Highway 54. Follow U.S. 54 north to Camdenton. In Camdenton, follow State Route 5 north to the town of Gravois Mills and Versailles. In Versailles, follow State Route 52 east to U.S. 54 and Jefferson City. The drive is approximately 160 miles.

Arches in Ha Ha Tonka Castle, part of Ha Ha Tonka State Park, create one of the many whimsical formations that make this park a true treasure. ©CHARLEY GURCHE

Ha Ha Tonka Spring in Ha Ha Tonka State Park hints of the serenity that abounds along the trails in this park. ©CHARLEY GURCHE

outlet shopping centers, lodging from rustic to resort, and amusement parks. The possibilities for camping, horseback riding, and hiking are nearly limitless. And then there is golf, miniature as well as premier courses that challenge the pros. Osage Beach, located on the north side of Lake of the Ozarks State Park, is packed in summer with crowds exploring the numerous roadside craft shops, souvenir stands, and flea markets, as well as eateries, art galleries, and amusement centers.

On the flip side of the coin, Ha Ha Tonka State Park, just south of the lake near Camdenton, has natural bridges, sink holes, caves, streams, and a wonderful seven-mile hiking trail. The bluffs give breathtaking views of Lake of the Ozarks and the surrounding countryside.

For the next stop on this route, take Missouri State Route 5 north from Camdenton to Versailles and then follow State Route 52 east to U.S. Highway 54. In addition to great views and fewer crowds, the journey will take you to the nifty oasis of Gravois Mills, near

the northern tip of the lake. This Ozark gem offers an almost overwhelming number of dining choices, but if you have time for but one, try the Olive Branch, located in an old church.

In Versailles, take the time for a stop at the Morgan County Historical Museum. Fascinating exhibits profile the area's rich history, and the building itself–a hotel built in 1853–is a real treat as well.

The voyage north from the lake to Jefferson City on U.S. 54 is less charming. Still, there are some wonderful spots to pull over, break out the picnic basket, and have a quiet brunch.

Overall, this drive is easily enjoyed in a weekend, though it can become a week-long vacation unto itself, as so many have discovered.

ABOVE: This Missouri postcard boasts that "every mile of Ozark highway . . . means a new thrill, a new enchanting view of the age old Ozarks . . ." AUTHOR'S COLLECTION

ROUTE 12

Missouri's Glitter Gulch

SPRINGFIELD TO BRANSON

Take the glitter and shows of Las Vegas, make them family friendly, add the best of Nashville, stir in the cornucopia of activity that is the Wisconsin Dells, and you have an idea of what to expect from Branson, Missouri. With the exception of crowds (the city draws some four million visitors annually) and the resultant traffic, this may be the ultimate family-friendly vacation destination.

If you enjoy music, you will relish the twenty-seven theaters in a five-mile strip. If swap meets are your thing, five downtown and several others along the highway will keep you busy. If your cup

BELOW: Branson, named after a former postmaster and general store owner, Reuben Branson, is often referred to as a "family-friendly Las Vegas" because its glitzy neon strip has one hundred live daily all-ages shows.
RICK & NORA BOWERS

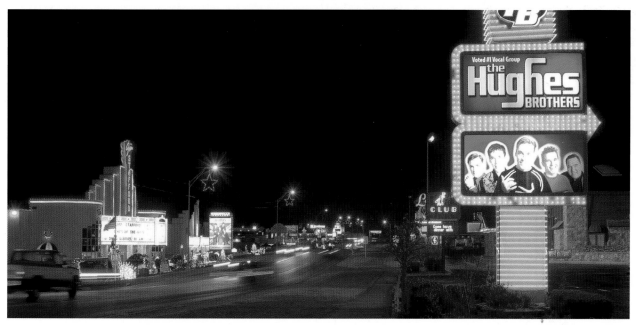

The Butterfly Palace and Rainforest Adventure in Branson, Missouri, provides visitors a rare opportunity to walk among one thousand live tropical butterflies, including the rice paper butterfly.
RICK & NORA BOWERS

||

Route 12

From Springfield, drive south on U.S. Highway 65 approximately 50 miles to Branson.

of tea is miniature golf or some other simple fun, rest assured that there is plenty of this as well.

Branson is located on the banks of the Taneycomo River, a linchpin for the current renaissance on the riverfront and in the historic district. Belying the glitter that has become Branson's trademark, the downtown is full of fascinating shops and even a quaint, old-fashioned café or two.

A great way to beat the traffic and take in the beauty of the southern Ozarks is to take the Branson Scenic Railroad. The fully restored rolling stock dates to the 1940s and 1950s and makes for a wonderful setting for the Saturday evening dinner trains. Reservations are necessary, so it is best to make plans a few weeks in advance: start with a visit to the railroad's Web site (www.bransontrain.com).

Another way to beat the traffic is the trolley system that runs along the main portion of the Branson strip. For those who want something a little different in their transportation, there are the duck tours. These vintage World War II amphibious vehicles—the military acronym is DUKW—cruise a portion of the strip, pass through an

outdoor military museum, and then drive right into the lake.

Though Branson is a major tourist attraction, much of the surrounding area is remarkably pristine. The Mark Twain National Forest is scattered over twenty-nine counties in eight distinct parcels through southern and central Missouri, and it takes up a large section of real estate just to the west of Branson. For a birds-eye view of a few of the park's wonders, take a short detour west on Missouri State Route 76 to the Shepherd of the Hills. At 230 feet high, the Inspiration Tower is the highest point in the tri-lakes area (which includes Table Rock Lake, Lake Taneycomo, and Bull Shoals Lake).

A variety of short trips from Branson will enhance any visit to this Missouri wonderland. The Arkansas state line is just a spit and jump to the south, and the first thirty miles of U.S. Highway 65 in Arkansas offer a scenic drive, as do several smaller highways that connect with that section. Continuing another thirty miles south on U.S. 65 provides access to the incredible wonders of the Buffalo National River, the fascinating Bechtel Cave complex, and first-rate lodging built into a natural cavern near Parthenon.

Even though crowding is a common problem in Branson proper, the city as well as the wonders that surround it may just be among the greatest undiscovered vacation getaways in America. A trip to Branson is more than a detour; it is an adventure unto itself.

Deer are a common sight along the highways and in the meadows near Branson, Missouri.
RICK & NORA BOWERS

Missouri Backroads Adventure

SPRINGFIELD TO POPLAR BLUFF

Route 13

From Springfield, drive south on U.S. Highway 65 to Battlefield Road. Then head west on Battlefield Road and follow County Route FF south to the town of Battlefield. To reach Wilson's Creek, go west on Third Street to a right turn on Old Wire Road, then make a quick left on Farm Route 182 (Elm Street). Continue west on Farm Route 182 to U.S. Highway 60 and take it east back through Springfield and on to Poplar Bluff.

On this tour of roads less traveled, the best has been saved for last. The drive from Springfield east to Poplar Bluff brings you back to a time when the interstate highway system was only a distant vision of the future. It is also a fascinating journey through more than a century and a half of tumultuous American history. This adventure begins at the Gray/Campbell Farmstead, the oldest-standing house in Springfield. The circa 1856 farm, now located in Nathanael Greene Park, is locked in a pocket of the timeless, rural beauty of the Springfield Plain. From the farm, head to the town of Battlefield and the nearby Wilson's Creek National Battlefield.

The serene riding trails, shade-dappled hiking trails, and quiet picnic areas provide little hint of the tragedy that took place here on August 10, 1861. Before taking to the trails, stop by the interactive visitor's center and pick up a battle map, which will enable

you to follow in the steps of the Confederate troops as they rolled back Union forces in this, the first major Civil War battle fought west of the Mississippi River.

From Wilson's Creek, roll east on U.S. Highway 60 into a delightful blend of forests, worn rocky outcroppings, farms, and small streams. Many of the little roads that branch like tendrils from our main route are well worth a detour.

Consider Ava, a small community nestled in the Ozark hills less than fifteen miles south of Mansfield. This quaint mountain community is home to Assumption Abbey, one of only eighteen Trappist monasteries in the nation. The abbey has become self sufficient through the sale of mouth-watering fruitcakes.

Mansfield itself has a treasure that is too easily missed if you are in a rush to get somewhere else. Laura Ingalls Wilder, author of the classic *Little House on the Prairie* series, moved here with her husband and daughter in 1894 and remained until her death in 1957, at the age of 90. It was at the Mansfield home, Rocky Ridge Farm, that Wilder wrote all nine books in the *Little House* series. Today, the Laura Ingalls Wilder Home and Museum is preserved as she left it.

Further along on U.S. 60, in Mark Twain National Forest, the town of Winona provides a great jumping-off point for exploring the natural beauty of the area. Small detours north and south on scenic State Route 19 will take you to some of the state's finest landscapes.

Alley Spring Mill—just north of Winona and a couple of scenic miles west of Route 19 on State Route 106—is consistently noted as the most picturesque spot in the state. The current mill, built in 1894, was considered a technological wonder in comparison to its predecessor, built in 1868.

A few miles further north on Route 19 is Round Spring and the cave with the same name. The fact that this area is the heart of the Ozark National Scenic Riverways, an innovative initiative by the state of Missouri to preserve some of the state's most pristine waterways, speaks volumes about the beauty found here and in the surrounding hills.

A drive south from Winona on Route 19 takes you to Thayer and the nearby Grand Gulf State Park, Missouri's version of the Grand Canyon. The collapse of large caverns and subsequent erosion left a chasm almost a mile wide in some locations with walls over one

ABOVE AND BELOW: Rocky Ridge Farm in Mansfield, home to Laura Ingalls Wilder, is where the pioneer-era author wrote all nine of her famous *Little House* books. The open woodlands around the farm are a perfect habitat for an array of wildlife, including the state bird of Missouri, the eastern bluebird.
RICK & NORA BOWERS

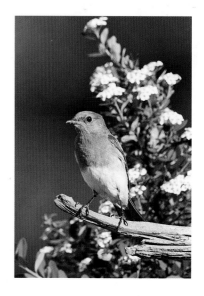

FAR LEFT: In Missouri, weathered barns have long been a common roadside sight on a drive along old Route 66.
ROUTE66PHOTOGRAPHS.COM

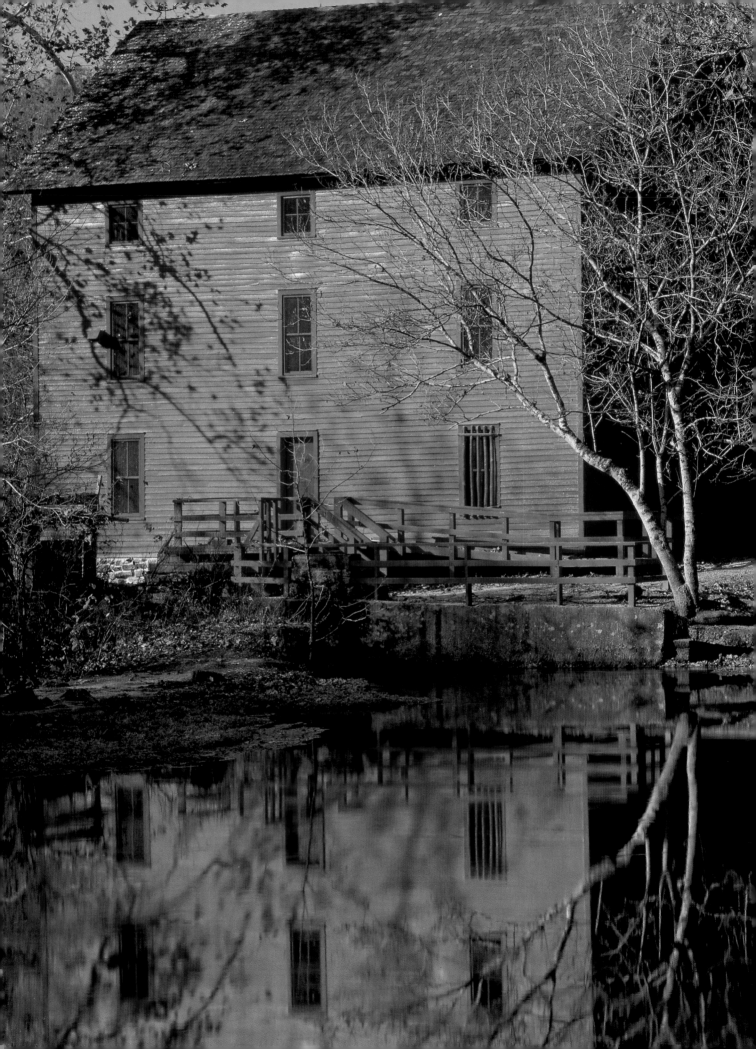

hundred feet in height. A section of the roof that did not collapse is now the state's largest natural bridge.

Back on U.S. 60, you will drive through the Mark Twain National Forest on your way to Poplar Bluff. The city features a thriving arts community centered around the Margaret Harwell Art Museum as well as quaint cafés, quiet parks, and streets lined with century-old homes that reflect quintessential small-town America.

ROUTE 14

Outlaws and Kansas Boomtowns

RIVERTON TO ARKANSAS CITY

The drive along old Route 66 in Kansas is a short one, but there are some wonderful remnants from that lost world. In Riverton, the Old Riverton Store has been in operation since 1925, before the official birth of the famous highway. The store was purchased by the Eisler Brothers in 1973, and it continues to operate as a grocery store and repository of Route 66 souvenirs. The nearby Marsh Rainbow Arch Bridge, built in 1923, is the only one of its kind that can still be driven on anywhere on Route 66.

About five miles further along the storied route, Baxter Springs has been slow to join the parade in capitalizing on the highway's popularity. This is not to say there is a shortage of landmarks here. Indeed, many of the attractions predate the highway by decades, providing links to an even earlier time.

Café on the Route is well on its way to becoming an icon for Route 66 enthusiasts. Good food and a front-row seat for all that passes by on the Main Street of America often overshadow the story behind the historic red brick edifice in which it is located, the Crowell Bank Building. Built in 1870, the Crowell Bank was robbed by Jesse James in 1876.

The Baxter Springs Heritage Center & Museum preserves the history of Route 66 in this part of Kansas as well as that of Baxter Springs and the surrounding area. Exhibits showcase the community's role in the Civil War, as a mining center, and as a cattle town.

The next stop on this drive though the rolling green hills of southeast Kansas is Coffeyville, a delightful little town rich in history. There is the Midland Theater, built in 1928 and currently undergoing an extensive renovation; colorful murals that honor local celebrities; the Aviation Museum, housed in a 1933 hangar; and the

Route **14**

From Riverton, take Kansas State Route 66 to Beasley Road/Old U.S. Route 66. Follow Route 66 as it turns south toward Baxter Springs. From Baxter Springs, head west on U.S. Highway 166 for approximately 135 miles to Arkansas City.

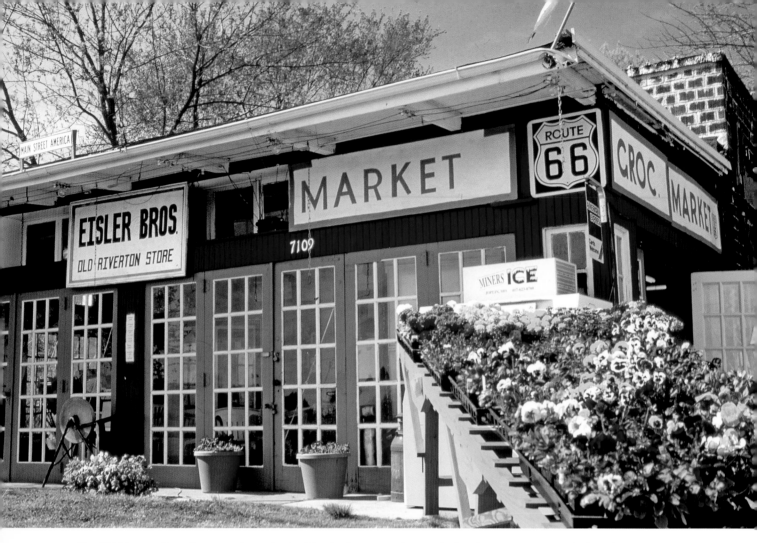

The Old Riverton Store has served travelers and locals since 1925, the year before Route 66 was commissioned.
ROUTE66PHOTOGRAPHS.COM

BELOW: Outlaw Jesse James became famous in 1869, when at age twenty-two he helped rob the Daviess County Savings Association in Gallatin, Missouri.
LIBRARY OF CONGRESS

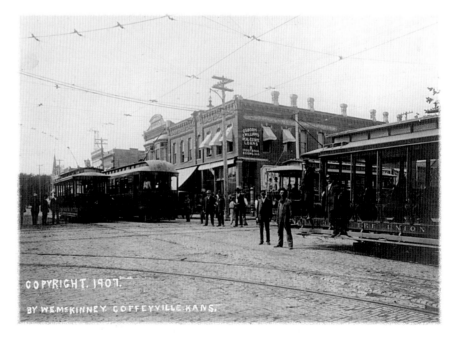

ABOVE: A 1907 downtown scene of Coffeyville, Kansas, with four street railroad cars at an intersection. LIBRARY OF CONGRESS

EARLY SITE
C.M. CONDON & CO.
BANK
CONSTRUCTED IN 1890

ON OCTOBER 5,1892 THE DALTON GANG RODE INTO
COFFEYVILLE, KANSAS, TO ROB THE CONDON AND FIRST
NATIONAL BANKS. FOLLWING A 12-MINUTE GUN BATTLE, FOUR
MEMBERS OF THE DALTON GANG WERE KILLED- BOB & GRAT DALTON
BILL POWER AND DICK BROADWELL. EMMET DALTON SURVIVED
FOUR COURAGEOUS CITIZENS ALSO LAY DEAD- GEORGE CUBINE,
CHARLES CONNELLY, CHARLES BROWN AND LUCIUS BALDWIN.

DON SPRAGUE 1988

In Coffeyville, Kansas, on October 5, 1892, an attempt by the Dalton Gang to rob two banks simultaneously left four of the five gang members dead or dying along with four townsfolk.
RICK & NORA BOWERS

imposing beauty of the Brown Mansion, a lavish home completed in 1907 and now open for public tours and private parties.

Coffeyville was not always the peaceful, quiet place it is today. On the cool fall morning of October 5, 1892, the Dalton brothers, Bob, Grant, and Emmett, and two accomplices, Bill Power and Dick Broadwell, attempted the simultaneous robbery of two banks. An armed populace responded, many with guns supplied by the local hardware store. Decimation of the infamous outlaw band took less than fifteen minutes. In addition to the outlaws, the marshal and several citizens lay dead in the street. The memory of this historic shootout is preserved at the Dalton Defenders Museum and in the alley where the running gun battle culminated.

As you head west from Coffeyville, the plains take on a more arid, open feel. Still, there are landscapes, such as the southern tail of the Flint Hills west of Peru, that are surprisingly picturesque.

The final destination on this drive is Arkansas City. Along with the city's array of vintage architecture and pleasant parks, the Cherokee Strip Land Rush Museum will open the door to much of the area's fascinating history. Museum exhibits explore the region before the arrival of Europeans up through the massive land rush of 1893, when tens of thousands came to southern Kansas and northern Oklahoma to stake their claims on lands once held by the Cherokee.

ROUTE 15

Adventures on the Border

BAXTER SPRINGS TO OVERLAND PARK

The state of Kansas designates the route from the Oklahoma border to Leavenworth, north of Kansas City, as the Frontier Military Scenic Byway. All along this drive you'll see vestiges from when this was the frontier of an expanding nation locked in clashes with the native inhabitants and remnants from when it was the front lines in the tumult of civil war.

In Pittsburg, an old mining town, a battle of another kind rages to this day. This one is over good down-home cooking. In 1934, Annie Pichler, faced with the need to support her family after her husband was injured in a mining accident, turned to preparing lunches for miners and serving Sunday dinners of fried chicken out of her home. In time, the business thrived, and soon people were driving from miles around to partake of Chicken Annie's fried chicken.

A decade later, Mary Zerngast faced a similar crisis when her husband, also a miner, developed a heart condition that prevented him from working. In the hope of emulating Annie's success, Mary also turned to selling fried chicken, but with a twist of special spices. The competing establishments each had their supporters, and a rivalry emerged. The families of Annie and Mary eventually assumed the reins of their respective dining establishments, and the feud continues. In this part of Kansas, you are either a Chicken Annie's or a Chicken Mary's fan.

Like Pittsburg with its two types of fried chicken, Fort Scott has two equally good offerings that visitors should sample: Fort Scott National Historic Site, a frontier outpost established in the 1840s, and the city of Fort Scott, with its attractive Victorian homes.

Route **15**

From Riverton, follow U.S. Highway 69 north to Overland Park, approximately 150 miles.

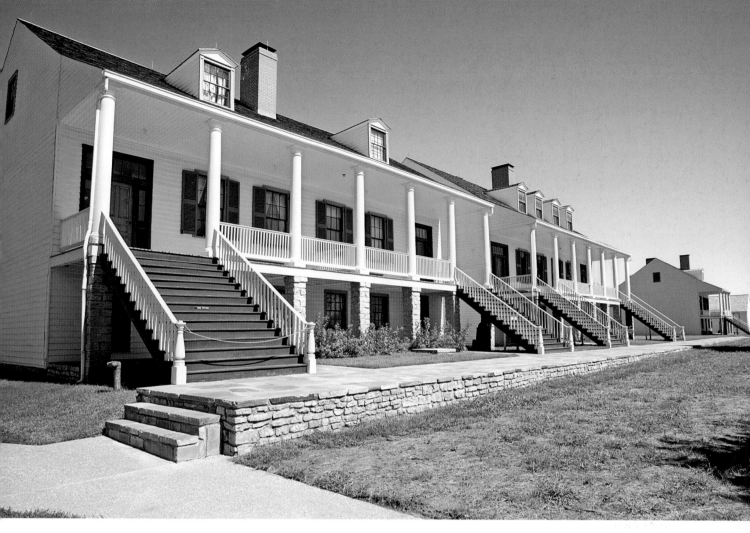

Above: Fort Scott National Historic Site chronicles the Indian Wars, the Mexican-American War, the Civil War, and finally the railroad expansion that opened the West. RICK & NORA BOWERS

Below: The sparse nature of the 1870s infirmary at Fort Scott, Kansas, attests to the rudimentary medical care of the period. RICK & NORA BOWERS

In Kansas, larger swaths of rolling prairie give way to fields of wheat that seem to stretch to the horizon.
©ALEKSANDER BRACINAC/SHUTTERSTOCK

At Fort Scott National Historic Site, nineteen timber and limestone buildings have been restored and re-created to present the look and feel of military life on the frontier in the years preceding the Civil War. Enhancing the time-capsule effect, interpreters dressed in period costume drill on the parade grounds, and officers' wives greet visitors.

The charming community of Fort Scott grew in the fort's shadow as a thriving rail center in the 1850s. To experience the best sights, the narrated trolley tour is highly recommended.

If you are looking to immerse yourself in the past on your visit to Fort Scott, look no further than the Courtland Hotel for lodging. Built in 1906, the hotel offers modern amenities amidst a classic setting.

The drive north from Fort Scott is a delightful one through rolling hills, meadows, and deep stands of broadleaf forests. Two somber but scenic historic sites, Mine Creek Battlefield and Marais des Cygnes, commemorate key and bloody engagements of the Civil War on the western frontier.

Natural wonders frame the next leg of this drive. La Cygne Lake and Marais des Cygnes National Wildlife Refuge are two of the best destinations for slowing the pace and for long walks on shady streamside paths.

Wheat, sunflowers, and cattle are the agricultural products most associated with the state of Kansas, but a wide variety of fruits and vegetables also grows in its rich, fertile soil. You-pick orchards and farms dot the landscape and allow you to discover the pleasures of gathering your own produce. The Louisburg Cider Mill, on State Route 68 in Louisburg, offers several kinds of vegetables and fruits for picking, but apples are the farm's claim to fame. An on-site mill transforms the apples into fresh cider.

The Ciderfest and Crafts Fair in late September is a rite of passage marking the end of another summer for local residents. Additional draws for the event include a petting zoo, barbeque, and pumpkin harvesting.

In many metropolitan areas, communities flow together, and Overland Park and Kansas City are no exception. There is, however, a unique place in the former that sets it apart from the latter: Overland Park Arboretum and Botanical Gardens. The centerpiece of this three-hundred-acre urban paradise is a prairie restoration project. Exploring the park and botanical gardens is an excellent way to pass a summer's afternoon.

Garter snakes are a common and harmless resident of the Kansas plains.
©RUSTY DODSON/SHUTTERSTOCK

PART III

Oklahoma

Where East Meets West

ABOVE: In Sayre, Oklahoma, wall murals commemorate the community's colorful history and long association with Route 66. ROUTE66PHOTOGRAPHS.COM

OPPOSITE: In Guthrie, the Centennial Parade in 2007 commemorated this community's long history of contributions to the state of Oklahoma. ROUTE66PHOTOGRAPHS.COM

For those who aren't frequent visitors to the Great Plains, Oklahoma is known simply as the place where the wind comes sweepin' down the plain and gusts again after the rain. However, the Sooner State has much more to inspire visitors than the lyrics to the famous song of the same name. Oklahoma is a cornucopia of unimaginable diversity. Whatever your taste, budget, or interest, there is something here for everyone.

Oklahoma's terrain runs the gamut—from looming mesas to cypress swamps, from pine-covered hills to acres of tall grass prairies. The Sooner State has fifty state parks; forest covers almost a full quarter of its area; and herds of bison still roam the Wichita Mountains.

Oklahoma has Native American cultural festivals and Asian festivals, fiddle contests and operas, bluegrass concerts and jazz clubs. It is home to fine dining, barbeque, Amish delicacies, and historic diners. The Sooner State also is home to world-renowned ballet companies, vibrant county fairs, and rodeos where local cowboys show their skills.

To explore Oklahoma, you can drive over four hundred miles of historic Route 66 or follow the legendary Chisholm Trail. Take a boat and explore 2,500 miles of shoreline and more than 200 lakes. Then slow the pace and float the Illinois River as eagles soar overhead.

If you cannot find something in Oklahoma to please your palate or interest, check your map: you must be in another state.

ROUTE 16

The Main Street of the Sooner State

ROUTE 66 IN OKLAHOMA

The change is not discernable as the green, rolling hills and mine tailings of southeastern Kansas continue into Oklahoma. Then you roll into the town of Quapaw, with its colorful murals and strong Native American traditions, and you get a strong hint that you're not in Kansas anymore. Quapaw is the site of the oldest gathering of native tribes in the nation.

The next town on your Route 66 journey is Commerce, another small, mining-based community. Do not let the size of this dusty little town fool you, however, for legendary things have happened and come from here. This was the hometown of baseball legend Mickey Mantle. It is also where Bonnie and Clyde gunned down Cal Campbell and another lawman.

Route 16

Though the old highway is broken and segmented in Oklahoma, the portions that remain are well posted with large sections serving as access roads for Interstate 44 and Interstate 40.

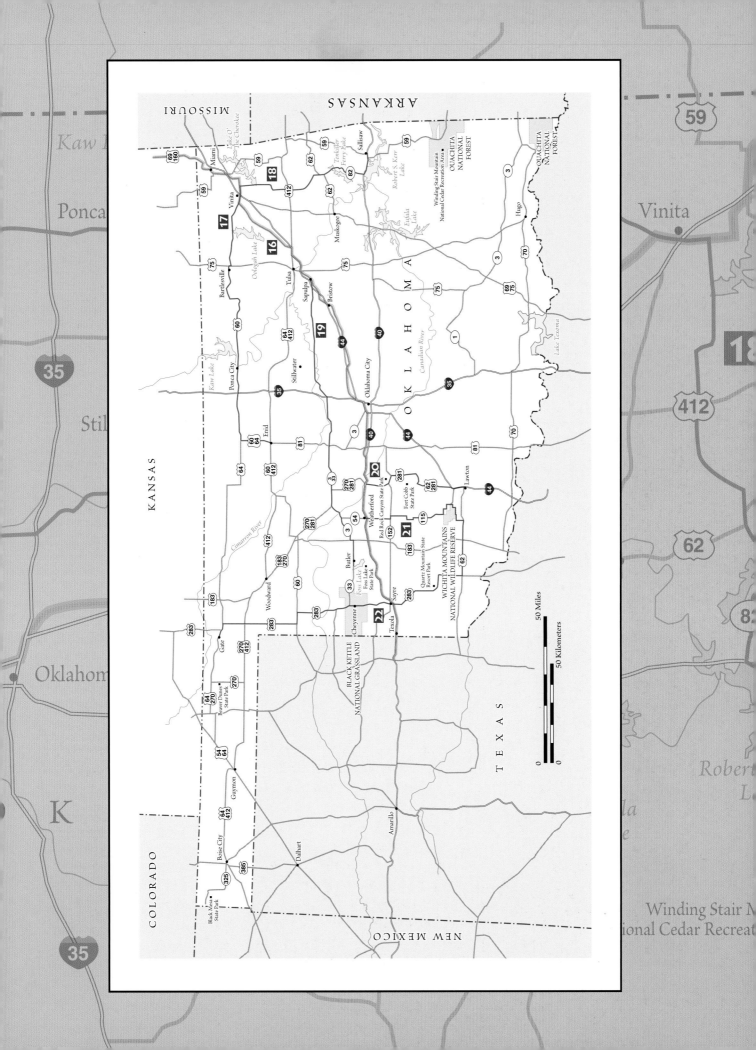

Above: As they have for more than three quarters of a century, storm clouds gather over Route 66 in Oklahoma.
ROUTE66PHOTOGRAPHS.COM

Left: The Oklahoma Route 66 Museum in Clinton, chronicling more than six decades of Route 66 history, opened September 23, 1995.
RICK & NORA BOWERS

Opposite: The field of 168 empty chairs at the Oklahoma City National Memorial & Museum represent those killed in the bombing of the Alfred P. Murrah Federal Building in Oklahoma City on April 19, 1995.
RICK & NORA BOWERS

Miami, Oklahoma, has more than its share of tarnished gems from the glory days of the highway. For fans of Route 66, the most notable association with this highway is two sections of the original nine-foot-wide alignment, one leaving town and the other just south of nearby Narcissa.

The opening of Route 66 is a comparatively recent event in several of the communities that follow Narcissa. Afton dates to 1886, Chelsea to 1870, and Bushyhead, named after a Cherokee chief, to 1898. Traces of the frontier era blend with classic icons of the Mother Road here, often with little more than a thin veneer on the façade that separates one from the other.

If you are mesmerized by obscure tidbits of Route 66 history, do not overlook little Foyil. On the west side of town, Route 66 becomes Andy Payne Boulevard and the pavement takes on a pinkish hue. This is a portion of the original Portland Cement concrete paving.

Claremore was hometown to Oklahoma's favorite son, Will Rogers. Therefore, it should be no surprise to find the Will Rogers Memorial, the Will Rogers Hotel, and other similarly named sights here.

In Tulsa, Route 66 is little more than a thread in the city's colorful history. Still, finding the riches of Route 66 is surprisingly easy,

ABOVE: Claremore, Oklahoma's most famous onetime resident, Will Rogers, first became well known because he was listed in the *Guinness Book of World Records* for throwing three lassos at once.
LIBRARY OF CONGRESS

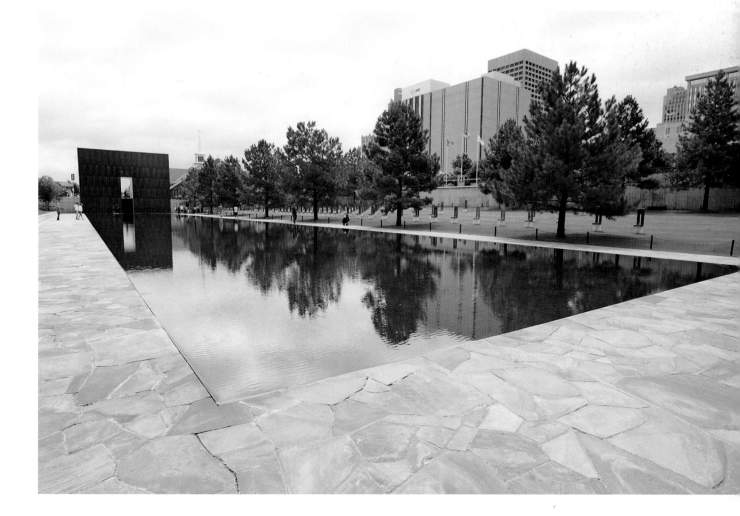

This re-created Phillips 66 service station stands on the grounds of the National Route 66 Museum in Elk City. RICK & NORA BOWERS

from the old motels on Tenth and Eleventh streets to the Art Deco Bridge on Eleventh Street, and from Mingo Circle, site of the Cyrus Avery (father of Route 66) service station, to the Metro Diner.

On a smaller scale, the towns between Tulsa and Oklahoma City along the old highway have a long history that predates Route 66, and each offers a little something special for those who take the time to seek it out.

Bristow has more brick-paved streets than any community in the state. The Bristow Historical Museum, housed in a restored 1923 railroad depot, has wonderful exhibits on local history. In Stroud, the Rock Café has been serving great pie and coffee since 1939. Just west of Chandler, where a gunfight claimed the life of fabled lawman Bill Tilghman in 1924, is the last remaining Meramec Caverns barn advertisement in Oklahoma on Route 66. Arcadia is home to the now-famous round barn, an icon for fans of Route 66, constructed in 1898.

Oklahoma City, as with Tulsa, is a modern metropolis with a long and rich history. Route 66 time capsules are easily found on Britton Road and Kelley Avenue. Keep your eyes open for gems such as Kamp's Grocery, built in 1910.

Rolling west on Route 66, the landscape takes on a more arid, prairie appearance with the passing of every mile. For those who prefer to drive by night, the communities that line the highway

THE FATHER OF ROUTE 66

CYRUS AVERY IS OFTEN heralded as the father of Route 66, but the designation—as well as the routing of this highway—is actually a small portion of his legacy. His interest in the development and promotion of good roads began with the Ozark Trails, a system of roads that connected St. Louis, Missouri, with Amarillo, Texas.

In 1912, as Tulsa County Commissioner, Avery initiated programs to maintain the roads in that county. His efforts garnered the attention of William Harvey, who invited him to help "organize a delegation of commercial clubs, good roads, and automobile associations" that could form a new Ozark Trails Association.

The organization was a resounding success and brought fresh signage, regularly scheduled maintenance, and national recognition to the road system, as well as to the men on the committee.

Avery built upon this success with an appointment to the Northeast Oklahoma Chamber of Commerce that was followed by an appointment to the Albert Pike Highway Association. His work in the development and promotion of good roads with these organizations led the Associated Highways of America to elect him president in 1921. In 1924, he accepted the position of state highway commissioner from Governor Martin E. Trapp of Oklahoma.

On February 26, 1925, Avery began work on his crowning achievement as one of the twenty-one members of the U.S. Department of Agriculture's "consulting highway specialists." This was the committee assigned the task of planning, coordinating, and establishing a system of highways, with respective signs and markers, for a national highway system. One of those highways was Route 66.

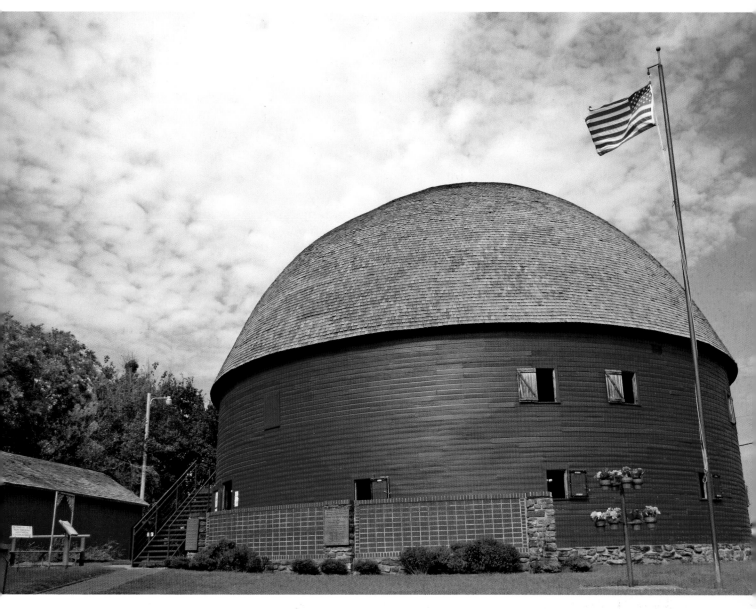

beckon like lighthouses with a neon glow, as they have for more than a half century. By day or by night, treasures abound.

Bethany is an antique shopper's paradise. Yukon hosts a wonderful annual Czech festival. Fort Reno in El Reno is a step back in time to when this was the western frontier of a nation consumed with the concept of Manifest Destiny. Fittingly, El Reno is also the headquarters for several tribes, including the Cheyenne and Arapaho.

Picturesque bridges, drive-in theaters, frontier-era jails, and museums with NASA memorabilia give a hint of the diversity of attractions found on the remainder of the drive west. However, if your schedule allows for only one stop, it must be Elk City, home of the National Route 66 Museum and Old Town Museum Complex.

ABOVE: The round barn in Arcadia, Oklahoma, is one of many roadside icons that predate the Mother Road by many years.
ROUTE66PHOTOGRAPHS.COM

A Treasure Box of Unexpected Pleasures

VINITA TO ENID

Route 17

From Vinita, follow U.S. Highway 60 west, approximately 160 miles, to Enid.

The drive from Vinita to Enid is best when taken as a weekend adventure. Moreover, when planned around one of the many festivals held in the communities along the way, it can easily be transformed into a memorable vacation.

Motoring west from Vinita, you'll pass through a varied landscape with farms, forested rolling hills nestled among terraced stone ridges, and grasslands. The history of the area is just as varied.

The town of Vinita offers resplendent Victorian architecture. It is also home to the world's largest McDonalds. Bartlesville, fifty miles to the west, is home to the Price Tower, the only skyscraper designed by Frank Lloyd Wright.

Continuing west from Bartlesville, the highway enters the Osage Indian Reservation. Osage Hills State Park is a wonderful escape from summer heat, with miles of streams that trickle over time-worn stones.

The heart of this extraordinary region is Pawhuska, home to the Osage Tribal Museum and gateway to the Tall Grass Prairie Preserve, an ancient ecosystem of the eastern Great Plains. As a historical footnote, in 1909 America's first Boy Scout troop was organized in Pawhuska.

Other attractions found here include the Conception Catholic Church with breathtaking, century-old German stained-glass windows and a delightful historic district.

THE OTHER DETROIT

THOUGH OKLAHOMA NEVER presented a threat to Michigan's dominance in automotive manufacturing, there was a brief moment early in the twentieth century when it looked as though the state might offer a bit of competition.

In late 1917, several businessmen in Enid pooled their resources and knowledge and formed an automotive manufacturing enterprise. The Geronimo Motor Company showed great promise with an annual increase in production before a fire shut down operations in 1920.

Enid was not alone in trying to break into the auto industry. In El Reno, three companies—Bonebrake-Roberts, Pioneer, and W.R.C.—were formed to build automobiles. Other communities that jumped on the bandwagon included Manchester, Muskogee, Tulsa, and Oklahoma City. The latter was home base for six automobile manufacturers.

If the charms of Pawhuska were an unexpected surprise, wait until you begin to explore Ponca City. The first of Ponca City's treats is a terrific array of art, from private as well as public collections, displayed in several museums and in almost every public building.

The community's love of art extends far beyond oils and canvases. The historic Poncan Theatre is a restored survivor of the vaudeville era now used as a venue for classic films and community theater.

ABOVE: An American bison bull stands among the remnant prairie at the Nature Conservancy's Tall Grass Prairie Preserve near Pawhuska, Oklahoma.
RICK & NORA BOWERS

LEFT: A male dickcissel, an abundant grassland bird, scans its domain from atop a dead thistle stalk in the Nature Conservancy's Tall Grass Prairie Preserve.
RICK & NORA BOWERS

Capturing the rich legacy and history of the western frontier is the 101 Ranch Museum complex and arena. In addition to extensive collections of memorabilia from the Wild West, the annual PRCA 101 Ranch Rodeo brings the best professional cowboys together in competition.

The legacy and culture of these lands' original inhabitants is also preserved in Ponca City. Standing Bear Park is a scenic outdoor

Above: The Railroad Museum of Oklahoma in Enid contains an extensive indoor collection and library of railroad artifacts, as well as a yard with historic rolling stock.
RICK & NORA BOWERS

interpretive center representing six area Indian nations: Kaw, Osage, Tonkawa, Pawnee, Ponca, and Otoe-Missouria.

Plentiful opportunities for hiking and camping under the stars can be found in the surrounding areas. Lake Ponca and nearby Kaw Lake offer more than seventeen thousand acres for boating, swimming, fishing, and all manner of water sports.

The next stop on the drive west is Tonkawa. The highlight of a visit here is the Tonkawa Tribe of Oklahoma Tribal Museum.

Last, but not least, on this tour of northeastern Oklahoma is Enid. Miniature golf and wineries, the Railroad Museum of Oklahoma, and the Museum of the Cherokee Strip are just a few of the many things to see and do in Enid.

ROUTE 18

Oklahoma's Aquatic Wonderland

VINITA TO SALLISAW

Cast aside all preconceived notions you may have about Oklahoma before beginning this drive. The central theme here is water and picturesque shorelines.

An excellent starting point for this adventure is the Eastern Trails Museum at 215 West Illinois Street in Vinita. In addition to presenting an excellent overview of the area's history, the museum offers numerous guidebooks, including a map to historic homes in the immediate area.

Vinita brims with unexpected attractions. The Little Cabin Pecan Farm is a well-known attraction on Route 66 that has served generations of travelers, providing highway souvenirs, delicious pecans, jams, and jellies. At the Cabin Creek Vineyard and Summerside Winery, you can take a tour as well as enjoy wine tasting. More somber attractions include the Cabin Creek Battle Site, commemorating a pivotal Civil War battle, and the burial site of Kate "Ma" Barker and her sons Arthur, Fred, and Herman—members of the

Route **18**

From Vinita, drive east on U.S. Highway 60 to the junction of State Route 82. Follow Route 82 south, and at the junction with Interstate 40 turn east and drive 20 miles on I-40 to Sallisaw. The approximate distance of this drive is 65 miles.

Seminary Hall, built in 1887 on the campus of Northeastern State University in Tahlequah, Oklahoma, replaced the Cherokee National Female Seminary—the first institution of higher learning for women west of the Mississippi. RICK & NORA BOWERS

notorious crime family that ravaged the country from the early 1920s through the mid-1930s.

Between Vinita and Vian, Oklahoma, State Route 82 is like a string threading several lakeside state park pearls together. In the town of Disney, just east of Route 82 on State Route 28, two state parks lie on the shores of Grand Lake. Cherokee State Park, just below the Grand River Dam on the west side of town, features a nine-hole golf course, beach, and playground; and Disney/Little Blue State Park, on the east end of town, offers delightful campsites and opportunities for water sports.

Spavinaw State Park, on Spavinaw Lake, has eighty-six primitive campsites, many with views of the lake. Snowdale State Park, across Lake Hudson from the town of Salina, offers additional opportunity for camping, picnics, and swimming.

Be sure not to miss Salina, with its great little cafés, such as the Salina Hilltop Café, and the Chouteau Museum, which profiles the area's history.

About ten miles south of Salina, the highway swings away from the lakes and river into forested, picturesque hills. At historic Tahlequah, scenic waterways again become a central theme.

Nestled in the Cookson Hills between the Illinois River and Lake Tenkiller, the community of Tahlequah offers modern amenities in a small-town package. This is the home base for numerous float trip companies that capitalize on the popularity of the nearby

This sign on the grounds of the Cherokee National Museum in Tahlequah has, from top to bottom, the following languages displayed: Cherokee, the phonetic pronunciation of Cherokee, and English. Tahlequah is the headquarters of the Cherokee Nation.
RICK & NORA BOWERS

river. It is also home to the Cherokee Heritage Center, a poignant, fascinating, and enlightening look into the culture and history of the Cherokee people.

The drive from Tahlequah south is a photographer's paradise. To experience some of the best vistas, stop at Cherokee Landing State Park and Tenkiller State Park.

Tenkiller State Park, with its worn limestone cliffs reflected in the crystal waters, offers numerous activities. Perhaps the most surprising is a scuba diving park.

The town of Sallisaw, the ending point of this drive, features attractions of its own. There is the intriguing Fourteen Flags Museum. It includes outfitted cabins that date to the 1840s and a re-created 1930s general store. Sequoyah's Cabin is the exhibit-filled home of the nineteenth-century Cherokee leader. Often overlooked is the Overstreet-Kerr Historical Farm. Additionally, Sallisaw has ample dining options, an award-winning golf course, and the largest sand beach in the state, at Kerr Lake.

For those who enjoy quiet, scenic backroads salted with history, much of this drive fits the bill. If you enjoy camping along the shores of beautiful lakes and rivers, then this adventure will merely serve as an introduction for return visits.

ABOVE: The longest multiple-arch bridge in the world and the historic Pensacola Dam were built between 1938 and 1940.
RICK & NORA BOWERS

OPPOSITE: These columns are all that remain of the Cherokee National Female Seminary. The seminary site is now the Cherokee National Museum.
RICK & NORA BOWERS

ROUTE 19

Oklahoma Backroads

SAPULPA TO FOSS LAKE/WASHITA NATIONAL WILDLIFE REFUGE

Route **19**

From Sapulpa, follow Route 66 west to the junction of State Route 33, about 10 miles. Follow Route 33 west approximately 130 miles to the junction of U.S. Highway 281 and turn southwest on Route 33 toward Custer City, Butler, and Foss Lake/Washita National Wildlife Refuge.

The town of Sapulpa, like many communities in Oklahoma, derives its name from a Native American—in this case, Chief Sapulpa, a Creek from Alabama. The town was founded as a shipping center for the Frisco Railroad in 1886, and it easily morphed into a service center for Route 66 travelers. Several cafés hearken to those times and still serve hearty fare.

In Cushing, the next stop on the drive west, a downtown historic district has five antique malls interspersed with quaint restaurants. There is also a superb golf course and the informative Dodrill's Museum of Rocks, Minerals, and Fossils. For the daring soul who wants a bird's-eye view of the landscape, Cushing is home to the Oklahoma Skydiving Center.

The oasis of the Cimarron River valley accentuates the transition toward a more arid landscape as the road climbs toward the high plains of western Oklahoma. Guthrie, your next stop, highlights the area's territorial history.

Founded in the land rush of 1889, the town of Guthrie began as fields of prairie grass and grew to become one of the nation's largest cities between the Mississippi River and the Rocky Mountains in the span of one day. Mere months later, the town known as the Queen of the Prairie was a solid community of brick and stone construction with a municipal water system, electricity, underground parking for carriages, and even a public transportation system. Guthrie became the capital of the Oklahoma Territory.

With the coming of statehood in 1907, Guthrie was transformed from territorial capital to state capital. Its fame soon faded, however, when the capital was relocated to Oklahoma City in 1910, sending the community of Guthrie into a downward spiral.

Today, the modern city of Guthrie has an unparalleled historic district as its heart. The district contains an incredible 2,169 buildings and covers 1,400 acres, or 400 city blocks.

With all this history, it should be no surprise that the city boasts numerous museums: the Oklahoma Territorial Museum, the Oklahoma Frontier Drugstore Museum, the International Model Railroad Museum, the National Four String Banjo Museum, and the Oklahoma Sports Museum are just a few.

From Guthrie, the climb from the prairie to the high plains is almost imperceptible. There is, however, no mistaking the change in landscape.

Black-tailed prairie dogs were once common on the grasslands of central Oklahoma, but poisoning by ranchers and large-scale farming have reduced their numbers significantly. RICK & NORA BOWERS

Grasslands, marshes, and upland woods, as well as the open water of Foss Reservoir, give Washita National Wildlife Refuge near Butler, Oklahoma, a unique character. RICK & NORA BOWERS

For fans of western history, Kingfisher is much more than a wide spot in the road on the drive west. To discover the pivotal role this area played in western expansion, be sure to explore the Chisholm Trail Museum at 605 Zellers Avenue.

By the time you roll into Watonga, the land has taken on a noticeably western feel, something the Roman Nose Golf Course capitalizes on. Unlike more traditional golf courses, there are no water hazards or sand traps here. Instead there are small, tree-lined canyons and mesas to challenge the golfer.

As you continue the drive toward Butler, you will encounter small communities along the way that are reminiscent of travel before 1960, with limited services after dark and small cafés.

The Canadian River, Foss Lake, and the Washita National Wildlife Refuge provide brief respites to the arid rolling plains.

ROUTE 20

Ghosts of the Frontier

BRIDGEPORT TO LAWTON

Route **20**

This drive begins at Exit 101, the junction of Interstate 40 and U.S. Highway 281. Continue south 80 miles on U.S. 281 to Lawton.

Though officially listed by the Oklahoma Route 66 Association as a ghost town, Bridgeport, established in 1895, is still home to 109 residents, according to the 2000 census. Even fans of Route 66 often overlook this small community, located just south of the Canadian River.

The land in this part of Oklahoma is reminiscent of that featured in countless epic films about the Wild West. In fact, Red Rock Canyon State Park is like a movie set for those films.

Dry, rolling hills cut by deep, narrow-walled canyons and densely wooded hollows that shade babbling brooks are the backdrop. Wildlife, in particular a diverse array of birds, is a popular subject for photographers here.

As the drive continues south, the rolling hills stretch toward the horizons, broken only by the highway, gullies, and the occasional small town such as Lookeba, Binger, or Gracemont. Anadarko provides more than a stop for fuel, food, and drinks.

Anadarko epitomizes the wonders and surprises that make backroad traveling so rewarding. First and foremost, the town is the unofficial "Indian Capital of the Nation," with attractions that include guided tours of seven authentic villages of the Wichita, Caddo, Apache, Kiowa, Pawnee, Navajo, and Pueblo tribes. The National Hall of Fame for Famous American Indians is also located here, and you are certain to find surprises among the inductees.

Several other museums in Anadarko are well worth a visit. Topping the list would be the Southern Plains Indian Museum and Oklahoma Indian Arts & Crafts Center and the Philomathic Pioneer Museum, which boasts an extensive collection of railroad memorabilia and well-designed displays of frontier life on the plains.

Lake Ellsworth, about twenty miles to the south, provides a delightful respite to the arid landscape. The drive along the shore is a scenic one, and there are ample pullouts, so be sure to bring lots of film.

Lawton and Fort Sill are both steeped in history. An excellent introduction to this rich past is the Museum of the Great Plains at 601 Ferris Avenue in Lawton. From well-detailed exhibits that chronicle the life of the Apache, Kiowa, and other plains tribes to a re-created fur-trading post, the museum deserves more than a passing visit.

Fort Sill played a pivotal role in the war against the tribes of the southern Great Plains. It was also home to the now-legendary Buffalo Soldiers, troops of African-Americans who continued their

ABOVE: Red Rock Canyon State Park in west central Oklahoma is home to an interesting mix of eastern and western wildlife.
RICK & NORA BOWERS

WINDOW TO THE PAST

OKLAHOMA WAS FOR A BRIEF TIME listed on maps as Indian Territory, a sterile term that belied the tragic relocation of tribes from throughout the United States to this region. In addition to the newcomers, sixty-seven tribes were native to the area.

As a result, Oklahoma has the second largest Native American population in the United States. A large number of cultural centers preserve native customs as well as history. Additionally, thirty-nine tribes maintain tribal headquarters in the state.

Scheduled for opening in the spring of 2009 is the American Indian Cultural Center and Museum in Oklahoma City. Upon completion, it will present the rich diversity of Native American culture through both traditional and contemporary exhibits, storytellers, lectures, and performances.

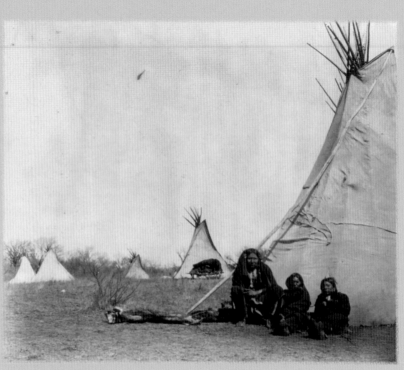

Comanche Indians at Oklahoma's Ta-Her-Ye-Hip or Horse-Backs Camp in 1873. LIBRARY OF CONGRESS

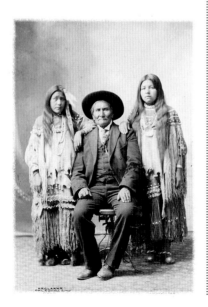

military service after the Civil War. It currently serves numerous field artillery units of the U. S. Army.

Commemorating the post's long association with artillery is the Cannon Walk, an outdoor collection of vast proportions spanning more than a century of artillery development. Students of nineteenth-century history will remember this fort as the place where Geronimo was held after his surrender, and there are numerous sites associated with this Apache warrior, including the guardhouse and his grave in the post's cemetery. This is also the final resting place for other famous Native American leaders, among them Quanah Parker, Setanek, and Satanta.

Attractions abound on this short but scenic drive. Take your time, discover lost chapters in our history, and learn about those who first called these plains home. Savor the sights and do not forget to seek out the good food, such as the enchiladas at Sala's Mexican Restaurant at 111 Southwest Lee Boulevard in Lawton.

LEFT: The legendary Apache warrior Geronimo sitting with two nieces in a 1909 portrait. LIBRARY OF CONGRESS

ROUTE 21

Hidden Gems of the Plains

WEATHERFORD TO SAYRE

In Weatherford, it is difficult to tell where the glory days of Route 66, the generic world of the interstate off-ramp, and the closing years of the western frontier begin or end. The secret is to look beyond the surface.

Crowder Lake State Park, eight miles south of town, is a blue gem in an arid sea of grass. Excellent camping sites offer relaxing, quiet evenings under the stars.

From Mountain View south to U.S. Highway 62, the highway is among the scenic drives listed in the *Southwest Oklahoma Great Plains Country 2006 Travel Guide*, and for good reason. With the hills seeming to roll south to the Wichita Mountains, you get the sense of being pulled by the tide on a sea of grass toward a distant island.

BELOW: In 1946, Rexall Drug Company launched the Owl Drug Superstores, like this one in Sayre, Oklahoma, located on Route 66.
RICK & NORA BOWERS

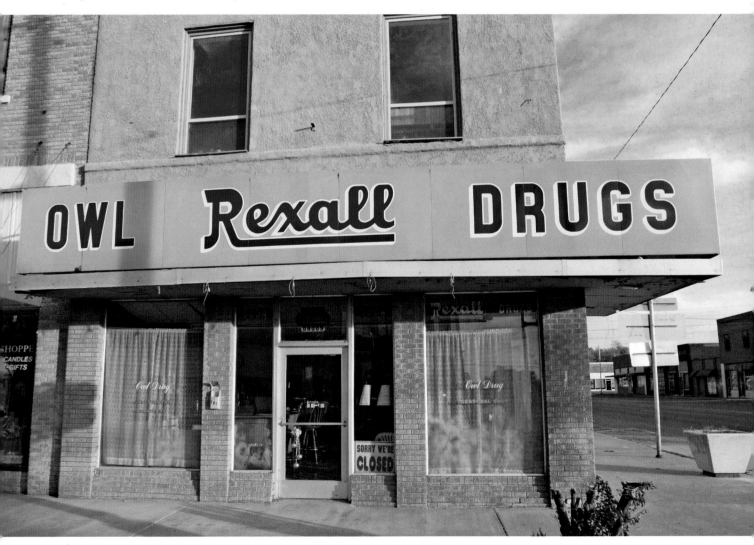

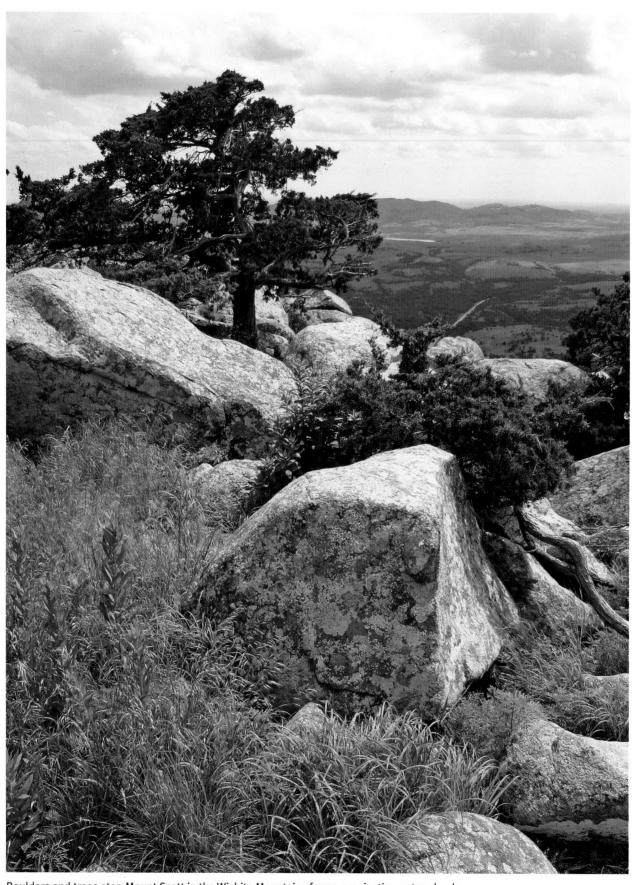

Boulders and trees atop Mount Scott in the Wichita Mountains frame a majestic western landscape.
©CHRIS TIDMORE/ISTOCKPHOTO.COM

The Wichita Mountains National Wildlife Refuge is the oldest managed wildlife refuge in the nation and a window into the Great Plains of more than a century ago. From the 2,400-foot summit of Mount Scott, the beauty of the refuge fans out below.

The habitat of grassy hills interspersed with wooded knolls and bottomlands is home to herds of free-roaming elk, bison, deer, prairie dogs, and even longhorn cattle. The visitor's center provides maps of the various trails and features detailed dioramas as well as extensive hands-on exhibits.

With the setting sun as the compass, the drive west through the rolling hills on U.S. 62 offers a sense of timelessness. The grass-carpeted hills, the rocky outcroppings, and the riparian oasis of the North Fork of the Red River enhance the illusion that the landscape is little changed despite the passing of centuries.

The size of Altus, county seat of Jackson County, belies the opportunities that await. Excellent fishing at the Altus Reservoir and

Route **21**

In Weatherford, drive south 16 miles on State Highway 54 to the junction of State Highway 152 and turn east. Drive 1 mile and then turn south on State Highway 115. Continue south 65 miles to U.S. Highway 62 and turn west. Drive to the junction of U.S. Highway 283 and then turn north on U.S. 283 to Sayre.

BELOW: Wichita Mountains National Wildlife Refuge near Lawton, Oklahoma, maintains a herd of long-horned cattle. RICK & NORA BOWERS

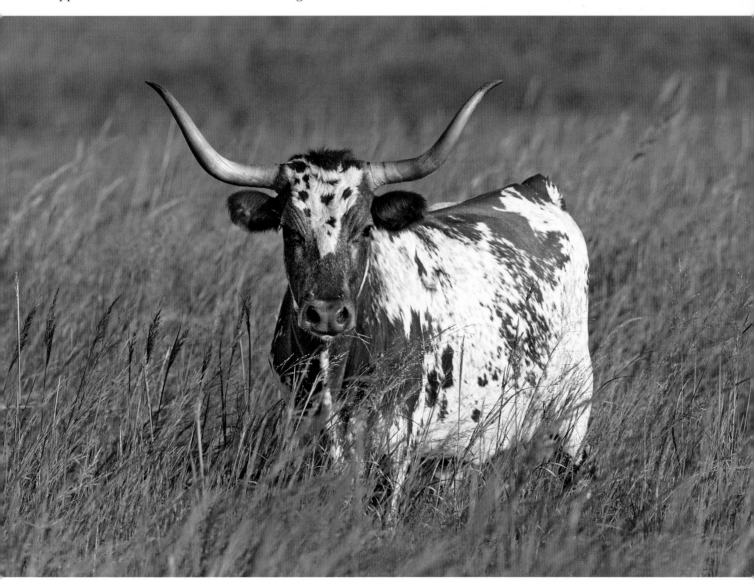

nearby Lake Altus, wonderful bronze sculptures, and the Museum of the Western Prairie, as well as a plethora of special events, urge one to stay for a while.

The drive north into the Quartz Mountains takes you through an intricate mix of grassy plains and hillsides of mesquite and oak. Timeworn rocky outcroppings accentuate the land's ancient look.

The 4,500-acre Quartz Mountain Resort, Arts and Conference Center, and Nature Park on Lake Altus in Lugert is a short detour of a few miles. Here you will find more than forty miles of sandy beach; a first-class golf course; hiking trails, campsites, cabins, and RV hookups; and many opportunities for boating and fishing. For the kids, or the kid in all of us, there are paddleboats and miniature golf.

The Old Greer County Museum & Hall of Fame in Magnum is, to say the very least, different. Exhibits fill the sixty rooms of the 1908 hospital building and run the gamut from a vintage fire truck to a replica dug-out home.

Overall, this drive epitomizes much of what made Route 66 an icon. Two lanes of asphalt roll through a natural landscape unchanged for centuries, interspersed with endless opportunities to experience the simple pleasures of camping under the stars and good food with friendly folk in distinctive, old-style cafés.

ROUTE 22

Into the Wilderness

SAYRE TO GATE

First impressions of Sayre suggest that this town is just another wide spot along the road through the high plains. Those who choose to explore beyond the usual clutter at the off ramps of Interstate 40 will quickly discover otherwise.

Sayre's historic district features two interesting museums—the Shortgrass Country Museum and the RS & K Railroad Museum—and a unique Route 66 artifact. At the corner of Fourth and Elm streets, a pedestrian walkway runs underground below the street. With the endless stream of traffic that flowed through town before the opening of I-40, this sheltered passage was, at one time, a necessity.

The drive north from Sayre takes you through a land of rolling grasslands cut by deep arroyos and sets the stage for a little gem found just north of our next stop, Cheyenne.

This quiet little community offers almost all modern amenities, but they seem somehow out of place. Something about this town gives the impression that the modern era is accepted grudgingly here.

Route **22**

From Sayre, drive north on U.S. Highway 283 approximately 113 miles to the junction of U.S. Highway 64. Turn west on Highway 64 and drive 5 miles to Gate.

A DARK CHAPTER

THE BATTLE ON THE WASHITA RIVER is a tragic chapter in our nation's history. Almost from the beginning, the relationship between native peoples and immigrants from Europe was a clash of cultures that resulted in atrocities committed by both sides.

This pivotal battle in the war against the tribes of the western plains has come to represent the genocide of Native Americans by whites. In November 1868, Lt. Col. George Armstrong Custer and the Seventh U.S. Cavalry, under command of General Philip Sheridan, quietly surrounded the large encampment of Black Kettle, a respected leader of the southern Cheyenne who had made several efforts to broker peace.

Misunderstood orders or overzealous command resulted in a dawn raid by the Seventh Cavalry. When the smoke cleared, the cavalry had carried the day with the loss of twenty-one men. The Indians' losses were far graver than the thirty killed. Black Kettle and his wife, and fifty more natives, mostly women and children, were captured.

All of the Cheyennes' ponies and mules were killed, and the lodges and an extensive supply of winter food and clothing for Black Kettle's band and other tribes in the area were put to the torch. Starvation or surrender was now the only option.

Cheyenne is the gateway to the Black Kettle National Grasslands, a 30,000-acre expanse of mixed grass–covered hills, wooded ravines, timeworn, red shale hills, wetlands, and the Washita River. Hundreds of bird species winter here, and the diversity of wildlife is nothing short of stunning.

Only the monuments at the Washita Battlefield National Historic Site hint at the human tragedy that took place along the Washita River in November 1868. Here, on a cold, late-fall day, Lt. Col. George Armstrong Custer led the Seventh Cavalry in a raid on the encampment of Black Kettle, a Cheyenne leader, described in detail above.

From the Canadian River, about eighteen miles past Cheyenne, the drive north takes you through a landscape little changed since

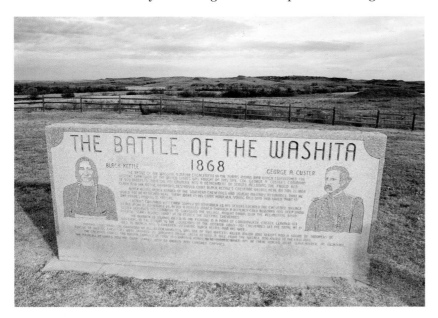

The dark ribbon of trees in the background is the Washita River valley where Chief Black Kettle and his band of Southern Cheyenne were wintering in 1868 when they were attacked by George Armstrong Custer and his troops.
RICK & NORA BOWERS

The Windmill Museum and Park in Shattuck, Oklahoma, features forty-five vintage windmills and a dugout similar to the first homes constructed by area settlers. RICK & NORA BOWERS

herds of buffalo roamed these hills. With the exception of Arnett, the communities that provide a brief respite from the endless prairie here are all little hamlets.

Gate is the final destination for this drive, and the starting point for several small drives that make up the High Plains Loop. A detailed map of this and other drives nearby is available at the Gateway to the Panhandle Museum in Gate. This delightful, award-winning community museum was established in 1975 to preserve the rich history of Gate and the surrounding area.

With the exception of Sayre and Cheyenne, amenities such as lodging are in short supply, and even in the larger communities they are limited in scope. Plan your trip accordingly, and be sure your vehicle is in good condition.

The well-known song of the Northern Bobwhite is frequently heard from the tall grass of the Black Kettle National Grasslands near Cheyenne, Oklahoma.
RICK & NORA BOWERS

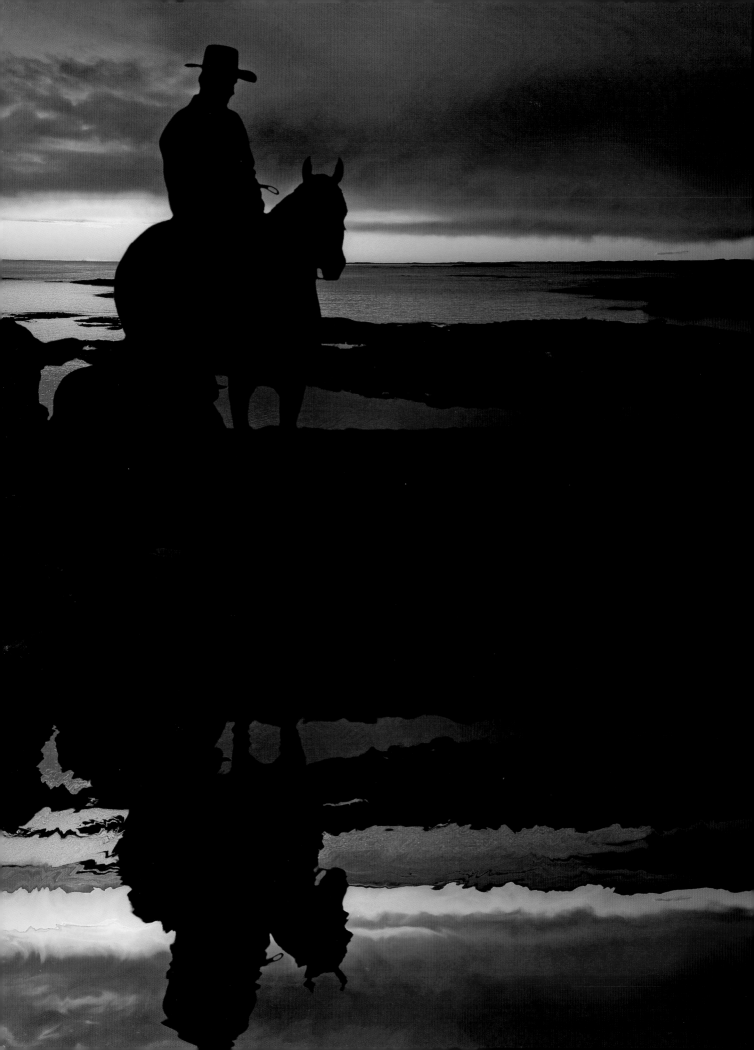

PART IV

Texas

The Panhandle, Land of Surprises

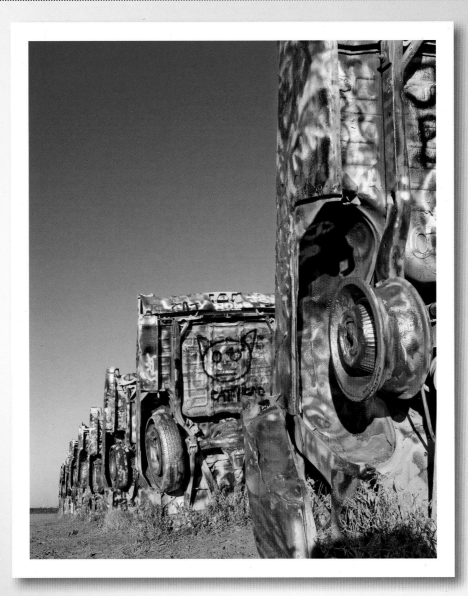

ABOVE: Stanley Marsh 3 built Cadillac Ranch in Amarillo, Texas, along old Route 66 in 1974 with ten classic Cadillacs buried at the same angle. RICK & NORA BOWERS

OPPOSITE: A lone cowboy on horseback against a blazing sunset presents the quintessential Texas scene. ©TYLER OLSON/SHUTTERSTOCK

Texas—the very name conjures images of wild-eyed cowboys riding hard among a herd of cattle stampeding like a thundering prairie storm, Indians swarming an encircled wagon train, and vast plains that stretch to the horizon. Most states associated with the western frontier have larger-than-life reputations, but none compare to Texas.

In Texas, everything really does seem bigger and better, even in the state's small panhandle, which Route 66 crosses through. The drives in this section only cover a slice of the Lone Star State, but they are a perfect introduction to the voluminous complexity of this great state.

The drives in this section are unique in another way. As this part of the state is rather narrow, many of the outlined adventures will end with destinations in the neighboring states of New Mexico and Oklahoma. Fittingly, the first drive detailed here will be from Route 66's eastern terminus in Texas to its western terminus in the state. At both borders, communities straddle the Texas state line with that of the neighboring state.

Many of the drives in this section will take you to remote places, places often missed by all but by the most ardent adventurer in search of backroad wonders. Many, such as the breathtakingly beautiful Palo Duro Canyon country and the oasis of the Lake Meredith National Recreation Area, are some of the most overlooked sights in the state.

Because the population in this area is small, these roads have little traffic and few road-side services and amenities. So plan accordingly. As the majority of these drives are relatively short, choosing a central base camp such as Amarillo may be the best option.

Most importantly, be prepared to be surprised along the way, just as the explorers of old were. This is truly a unique place.

ROUTE 23

The Panhandle's Main Street

ROUTE 66 IN TEXAS

This route begins in Texola. Officially an Oklahoma town off Exit 176 on Interstate 40, this community straddles the Oklahoma–Texas state line. The place makes visitors feel like adventurers in search of lost civilizations. The town's jail (built in 1910), red brick stores with boarded up windows, vintage service stations being reclaimed by the prairie, and other substantial buildings hint that at some point this community was more than the dusty bump in the

Route **23**

In Texas, the old highway is segmented but relatively easy to follow as there is adequate signage and often it serves as a frontage road for Interstate 40.

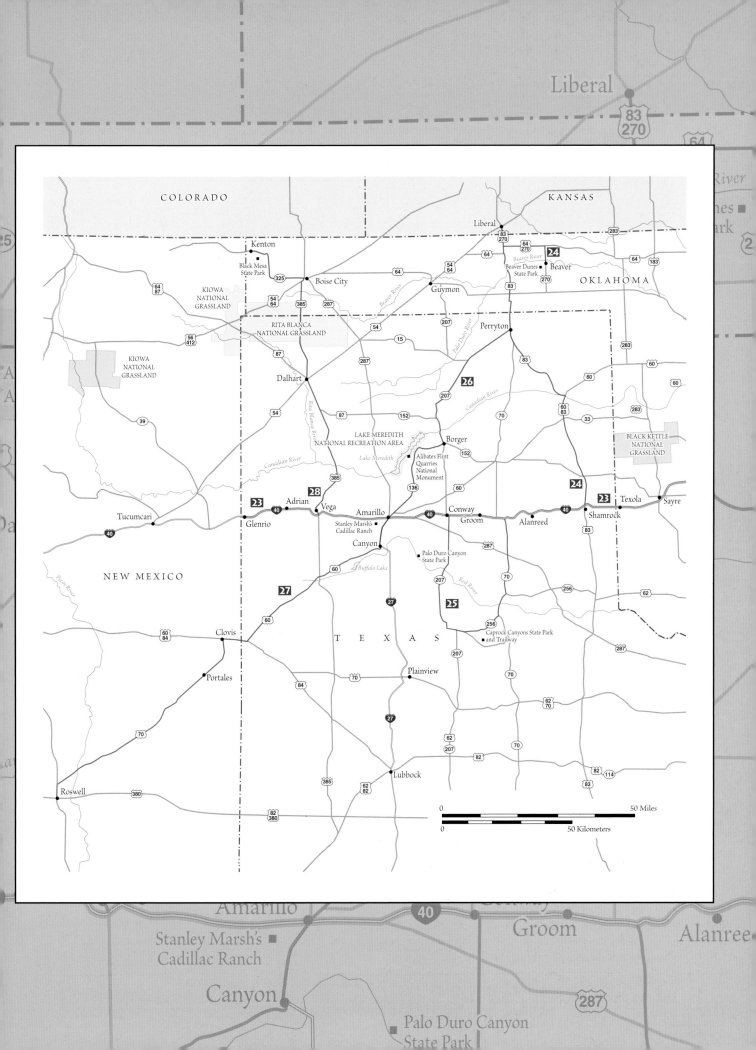

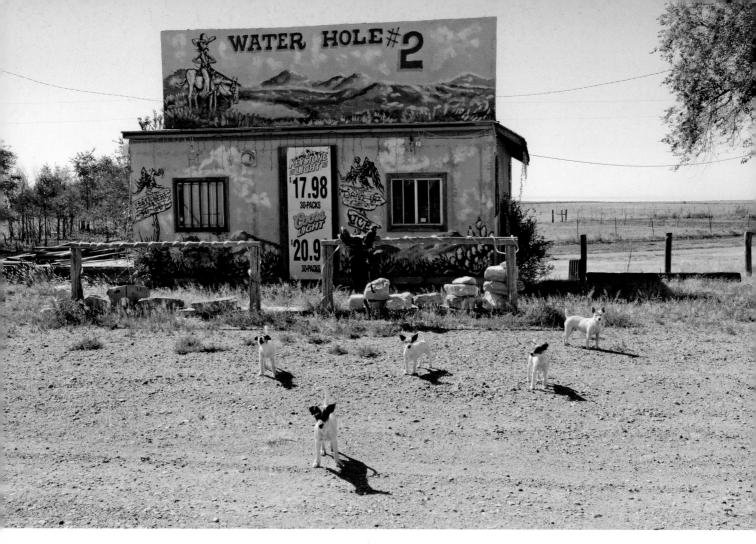

road it is today. A sign on a bar on the western edge of town adds to the mystery and reflects the humor of the few residents who remain: "There's no other place like this place anywhere near this place so this must be the place."

Follow the setting sun west across the increasingly arid plains to Shamrock. Here a vintage motel district and the refurbished U-Drop Inn, a Route 66 icon, give you a small glimpse of the roadside as it was in the mid-1940s, when Nat King Cole was on the radio singing

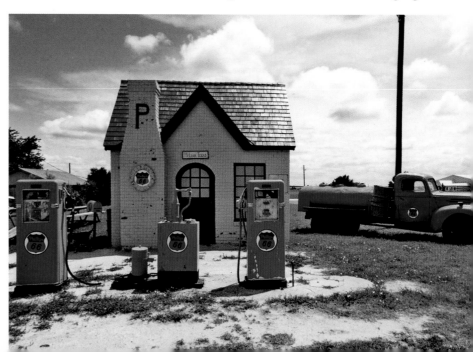

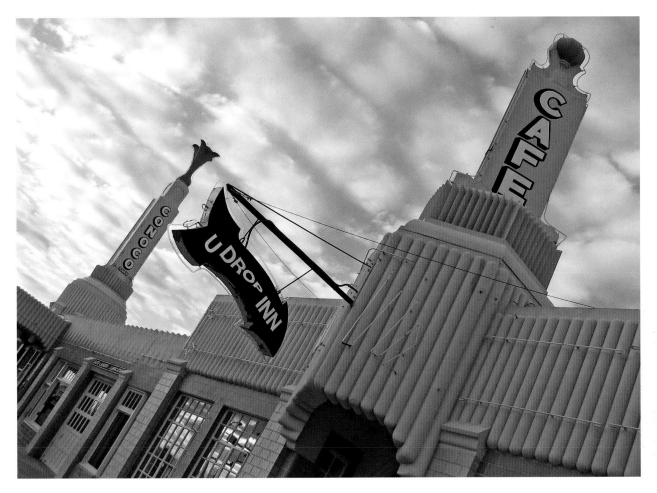

about getting your kicks on Route 66 and cars traveling this path were brand-new DeSotos and Packards.

If you stay on the south frontage road here, you will travel a stretch of Route 66 that's billed by numerous Route 66 associations and afficinados as the most authentic in Texas.

Eventually, you will cross under Interstate 40 and head into McLean, where beautiful murals adorn buildings throughout town and stately but simplistic structures, such as the Avalon Theater, hint of better times. Two excellent museums are here: the Devil's Rope Museum/Texas Route 66 Exhibit complex and the McLean/Alanreed Area Museum.

The former museum offers extensive exhibits geared toward the Route 66 enthusiast, but the exhibits of devil's rope, otherwise known as barbed wire, really grab the attention. An astounding collection details the evolution of this peculiar fencing that tamed the western plains. At the McLean/Alanreed Area Museum, visitors learn the history of a World War II prisoner-of-war camp that was located here.

As you leave McLean, be sure to have your photograph taken at the Phillips 66 Service Station on westbound Route 66. This re-created and restored facility was the first Phillips 66 in the state. Also make sure that you leave town on the south service road

The grain elevator in Groom, Texas, is a beacon seen for miles on the featureless plains of the Panhandle.
ROUTE66PHOTOGRAPHS.COM

heading toward Alanreed. Here you will see old service stations, crumbling cemeteries, and a number of buildings in various states of decay, all of which are wonderful material for the photographer, amateur or professional.

At Alanreed, you will have no other option but to rejoin I-40. At the exit for State Route 70, go south to Jericho. In the 1930s, travelers coming this way were often immobilized in the sticky gumbo of the Jericho Gap, a section of Route 66 that was never paved and not bypassed or improved until the closing years of that decade.

After heading back to the south service access road of I-40, continue west on the service road to Groom, home of a world-famous leaning water tower. Other landmarks of note include the world's largest freestanding cross, a beacon on the plains at night, and the Golden Spread Café, another survivor from the glory days of the highway.

After passing through Groom, you will cross the prairie to Conway. Here you will see a Volkswagen Bug planted nose down in emulation of the world-famous Cadillac Ranch, a modern incarnation of Stonehenge. This monument to a nation obsessed with automobiles and the open road is a few miles further west. This offbeat roadside attraction wasn't built until 1974, when Route 66 was no longer the favored way west. "The ranch" features ten graffiti-covered

cars that are half-buried, nose-down, facing west at the same angle as Egypt's Cheops pyramids.

Near the rest area outside of town, rejoin I-40.

The next stop is Amarillo, at the junction of I-40 and I-27. This city offers two different glimpses into the history of Route 66. Third Street and Sixth Street are part of the Mother Road's original alignment while Amarillo Boulevard represents Route 66's 1950s glory days.

Little is left of Bushland or Wildorado, the next stops on this route, as many of the buildings in these communities were in the direct path of I-40.

In little Vega, America's Main Street originally rolled through town, headed right, and at the community bank turned toward Adrian, fourteen miles to the west, the official midpoint of Route 66. This segment of the highway now dead-ends at Dot's Mini Museum in Vega.

At Adrian, the old highway disappears entirely under the asphalt of Interstate 40. About one mile outside of Glenrio, it reappears as the south service frontage road. Glenrio is the end of this route—a community with one foot in Texas and the other in New Mexico. It is also less than a shadow of what it once was. Still, this ghost town has many vintage buildings that reflect a long association with Route 66 and, as a result, is a photographer's paradise.

ROUTE 24

The Land of the Staked Plains

SHAMROCK TO LIBERAL, KANSAS

The Pioneer West Museum in Shamrock is a great place to kick off this journey. Here you will learn about the rich history of this part of Texas, where treeless plains cut by the North Fork of the Red River make horizons seem endless. The small communities that dot these plains are reflections of the durable people who call this land home. The cafés offer solid fare, and Main Streets here have not given way to malls or suburbia.

Even though the roads, including U.S. Highway 83, that cross these rolling plains seem designed to induce drowsiness, intriguing sights and attractions abound on the drive north. Consider County Road 2266 just to the north of Canadian. The pleasant, scenic drive

Route **24**

From Interstate 40 at Exit 163 near Shamrock, Texas, turn north on U.S. Highway 83 and travel to Liberal, Kansas, approximately 150 miles. For the side trip to Beaver Dunes State Park, turn east on U.S. Highway 64/270 and drive 20 miles to Forgan. There turn south on State Route 23/U.S. 270 and drive 6 miles to the town of Beaver and the park.

This "Rattlesnakes Exit Now" sign between Shamrock and McLean off Route 66 stood for decades before high winds blew it down in 2007. ROUTE66PHOTOGRAPHS.COM

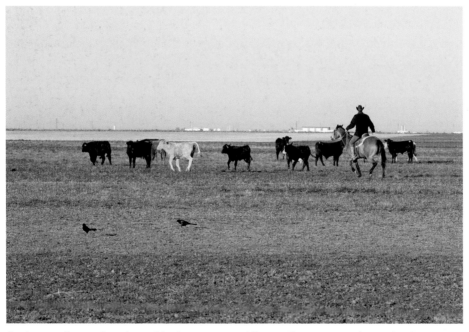

Cattle roam free and cowboys ride the range, providing stark contrast to the modern urban landscape of Amarillo, Texas. RICK & NORA BOWERS

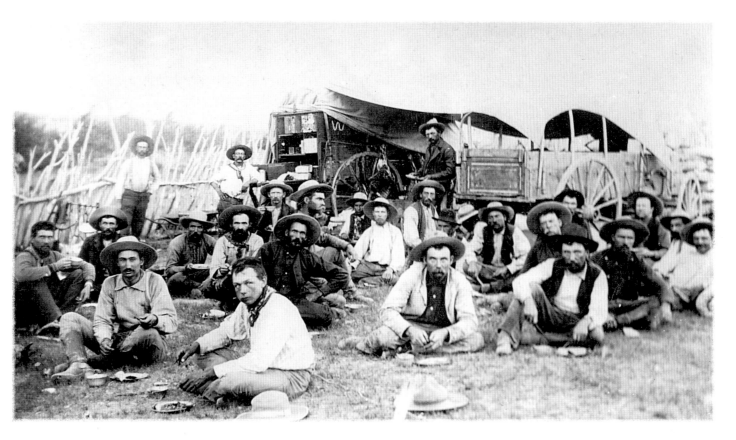

along the Canadian River provides access to the northern edges of the Black Kettle National Grasslands, which offer a glimpse as to how these plains looked a century ago.

Perryton is a delightful respite from this land of boundless horizons. It is also home to the Museum of the Plains, a surprisingly extensive and informative window into the rich natural diversity and colorful history of the area—from when the nomadic tribes once hunted these plains to the days Dust Bowl refugees headed west on Route 66.

U.S. Highway 83 in Oklahoma is a leg of the High Plains Loop, one of several designated Western Oklahoma Wildlife Scenic Drives. This loop drive will quickly dispel the misconception that the plains are an endless sea of grass-covered hills.

Examples of the treasures that await in this landscape are found east of Turpin at Beaver Dunes State Park and in the hills along Beaver Creek. The park and nearby Beaver River Wildlife Management Area are stunning places where seas of sand blend with oceans of grass, rolling endlessly. The natural beauty of the area can be overwhelming with its vastness. The area attracts few visitors, the result of its remote location. And yet the park offers a wide range of family recreational activities—from horseshoe courts to volleyball and from picnic sites to hiking trails.

This drive is long on solitude and short on services, though, so plan accordingly. You especially don't want your car to break down on one of the lonely roads through here.

This 1877-era photograph shows a group of cowboys taking a break for chow time while bringing 3,500 cattle from Mexico through Texas to the Oklahoma Panhandle.
©AMARILLO PUBLIC LIBRARY

Route 25

Begin this loop drive at Exit 124 on Interstate 40 and turn south on State Route 70 toward Jericho. Continue south to the junction of State Route 256, approximately 48 miles, and turn west on Route 256. Follow Route 256 to the junction with State Route 207. Turn north on Route 207 and drive approximately 60 miles to Conway.

OPPOSITE: The Lighthouse is one of many fascinating and unique rock formations in Palo Duro Canyon State Park in Texas.
©MIKE NORTON/SHUTTERSTOCK

BELOW: In Jericho, a dilapidated building hints of a time when this was a town with a future.
ROUTE66PHOTOGRAPHS.COM

Lost Treasure in the Panhandle

JERICHO TO CONWAY

Texas' Panhandle isn't home to the breathtaking natural wonders you'll see on New Mexico and Arizona Route 66 backroads, but it is home to three scenic highways. The longest and arguably the most scenic, as it provides access to the wonders of the Caprock Canyon and Palo Duro Canyon country, is along State Route 256 and State Route 207, from Brice to Conway.

Little remains of the community of Jericho, a town that never was much bigger than a bump in the road—even when it was the last stop before travelers heading west on Route 66 reached the muddy gumbo of the infamous Jericho Gap. Still, the town is important in the history of the legendary highway. As the landscape here has changed little, you can more easily imagine how it was to traverse this desolate landscape in the likes of a Model A Ford.

Near Brice, the land begins to change dramatically. By the time you reach Caprock Canyons State Park, the rolling prairie of the

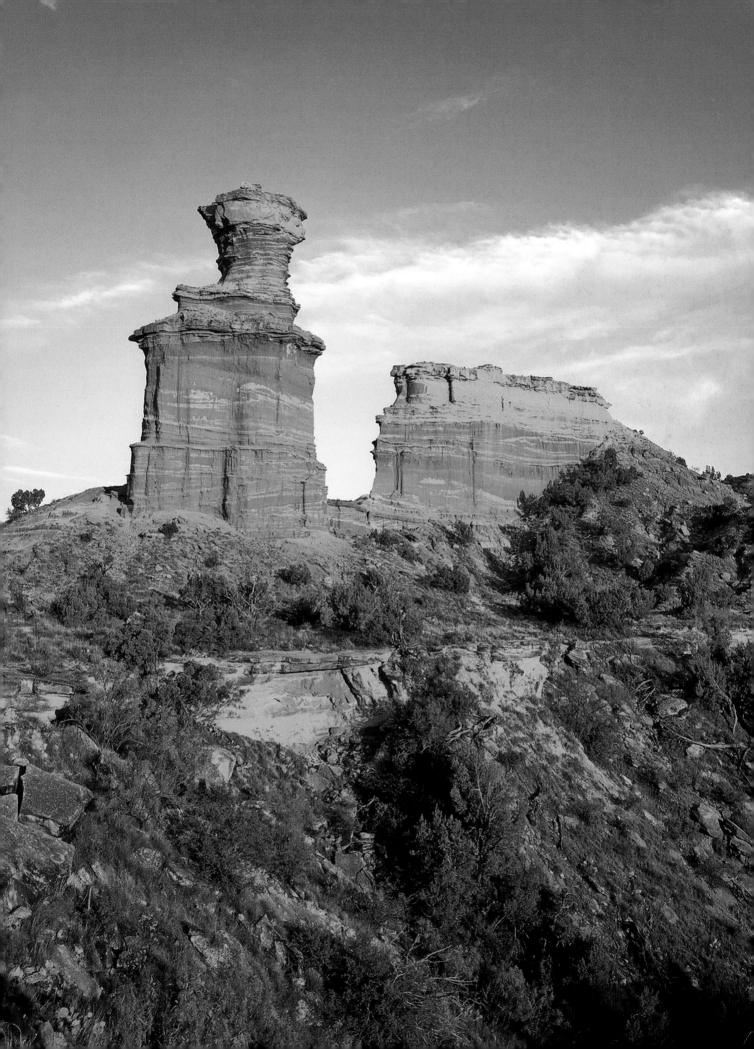

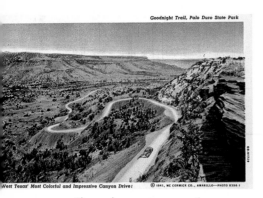
Goodnight Trail, Palo Duro State Park

West Texas' Most Colorful and Impressive Canyon Drive! © 1941, MC CORMICK CO., AMARILLO—PHOTO 8386-1

The park encompasses 26,275 acres of the scenic, northernmost portion of the Palo Duro Canyon.
AUTHOR'S COLLECTION

Route **26**

Begin with State Route 136, Panhandle Boulevard/Fritch Highway, in Amarillo. Drive north 50 miles to Borger. Continue north on State Route 207 to Spearman, 41 miles. Then turn north on State Route 15 and drive 26 miles to Perryton.

Panhandle has disappeared. The park, one of the largest in the state, is an unexpected wonderland of deep arroyos; ribbons of towering trees amid rugged, red-tinged hills; towering monuments of broken stone; and breathtaking vistas. The heart of this prairie oasis is a large preserve of rugged canyons that delineate the eastern edges of the high plains. In addition to hiking and biking trails that lead through some of the most spectacular scenery in the Panhandle, the park offers both modern and rustic campsites and opportunities for boating and fishing.

The highlight of a visit to this wonderland is to travel along part or all of the sixty-four-mile hiking/equestrian/bike trail, the Caprock Canyons Trailway, a former railroad bed. It traverses the rolling plains and takes you through the high plains to scenic Quitaque Canyon, offering unobstructed views most of the way. Another delightful aspect of this trail system is a long tunnel with picturesque portals cut into a deep brown rock face. With the trail's several points of access, your trip along this path can be as long as you want it to be.

The drive north to Conway on Route 207 is one of delightful contrasts. From the tranquil shores of the Mackenzie Reservoir to the beauty of the Palo Duro Canyon and the Prairie Dog Town Fork of the Red River, photographers looking for great landscape shots will not be disappointed.

To enhance your visit to this region, plan some hiking and camping adventures. Make sure to call ahead to reserve camp spots, as they are sometimes hard to come by.

It is also best to travel this route in late spring and fall. Summers can be quite hot, and winter snowstorms are a common occurrence.

ROUTE 26
The Road Less Traveled
AMARILLO TO PERRYTON

Amarillo is one of those towns often overlooked in the rush to get from point A to point B, but if you take the time to explore this community, you will be pleasantly surprised.

In Amarillo you'll find The Big Texan Steak Ranch, a Route 66 icon, and Mother Road namesakes like the Route 66 Motor Speedway. The town is also home to an array of museums, from the Amarillo Museum of Art to the American Quarter Horse Hall of Fame & Museum to the Amarillo Railroad Museum.

The Amarillo Zoo, Amarillo Botanical Garden, and Wonderland Amusement Park are just a few of the places here where you can spend a fun day with the family. Others include the Harrington Discovery Center and Kwahadi Kiva Indian Museum, a living history complex that preserves the legacy and culture of the tribes that called these high plains home.

If you prefer more highbrow entertainment, you can catch a performance at the Amarillo Opera, Amarillo Symphony, Amarillo Little Theater, or even the Lone Star Ballet.

Sports fans, too, can find ample entertainment in Amarillo. The Amarillo Dusters, a minor-league arena football team, play

The iconic Big Texan Steak Ranch opened its doors in 1960 along Route 66 and relocated along Interstate 40 in 1970.
RICK & NORA BOWERS

A float full of roses travels along the route of the fifth-annual Amarillo Mother-In-Law Parade in 1938. The parade was part of the city's Mothers-In-Law Day celebration, which became a tradition in 1934 after Gene Howe, editor-publisher of the *Amarillo Globe-News*, vowed to make up for a disparaging comment about mothers-in-law that appeared in his column.
©AMARILLO PUBLIC LIBRARY

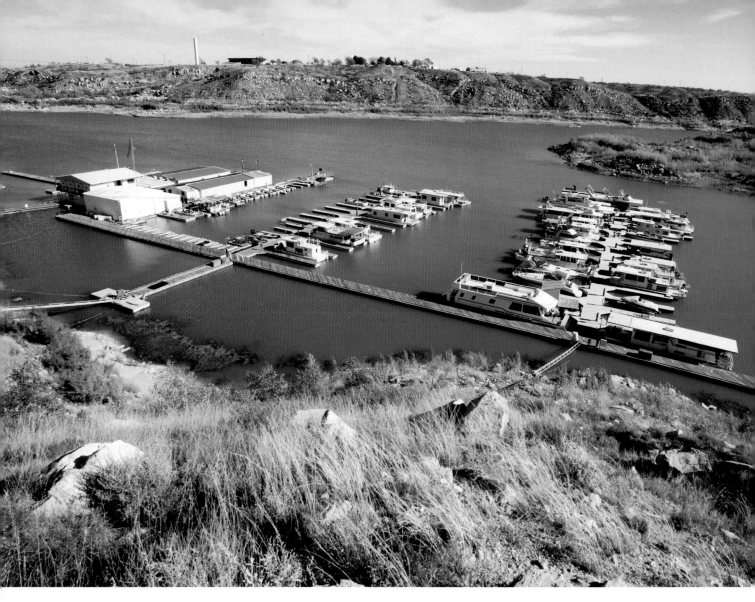

A ten thousand–acre oasis on the high plains of the Texas Panhandle, Lake Meredith National Recreation Area provides boating, fishing, hunting, and camping along the two hundred–foot cliffs carved by the Canadian River.
RICK & NORA BOWERS

their home games in the Amarillo Civic Center Coliseum, as do the Amarillo Gorillas, a professional minor-league hockey team.

The drive north on State Route 136 to Borger is another one of three routes in the Panhandle listed as scenic drives by Rand McNally's 2005 atlas. Offering far more than mere scenic landscapes, this route passes by Lake Meredith on the Canadian River, the largest lake in the Panhandle. Here you can swim, fish, and rent houseboats. If getting wet is not your cup of tea, you can visit the Lake Meredith Aquatic and Wildlife Museum, which offers walking tours through well-designed natural fish habitats and wildlife dioramas.

Nearby is the Alibates Flint Quarries National Monument. For the tribes of the plains, these quarries were an indispensable source of raw material for tools as well as weapons. The best way to explore this attraction is to take the informative 1.5-mile guided walking tour.

By the time you reach the town of Stinnett, the landscape will have almost imperceptibly changed back to one of rolling plains and grass-covered knolls dotted with forlorn windmills and equally lonesome-looking ranch houses. This last leg of the trip through desolate places seems timeless, tranquil, and maybe even eerie.

ROUTE 27

Cattle Barons and Aliens

AMARILLO TO ROSWELL, NEW MEXICO

In summer months, the shimmering air above the desolate roads south of Amarillo creates the mirage of pools of water on the hot pavement ahead. In winter, snow dances and swirls in fanciful patterns across the horizon—unless, of course, the wind is howling. Then a sheet of white blows across the highway in streams.

These wide-open, almost sterile spaces may seem unlikely locales for scenic beauty, but taking a short detour from U.S. Highway 60 on State Route 217 will lead you to one of the most spectacular state parks in Texas, Palo Duro Canyon State Park. An overlook on the rim near the park's entrance foreshadows the wonders this park has to offer. Here the flat plains drop away with startling suddenness into an eight-hundred-foot-deep chasm where multihued formations of red, yellow, and purple stone stand in stark contrast to skies of deep blue and gnarled forests of junipers. A ribbon of lush cottonwood trees shades a tiny creek, the Prairie Dog Town Fork of the Red River, at the bottom of the abyss.

The park is also home to stunning rock formations, making this one of the most worthwhile attractions in the Panhandle. For a brief time, officials even considered adding it to the national park system. This wild canyonland was once a natural fortress for the Comanche, who dominated the area. The last major battle of the Red River War between Native Americans and the U.S. government in Texas, the Battle of Palo Duro Canyon, was fought here in 1874. The park is now a paradise for campers, hikers, and even horseback riders.

In nearby Canyon, back on the main route, the Panhandle Plains Historical Museum is a must-see. This is the largest history museum in Texas, with exhibits on everything from conquistadors to dinosaurs to the oil industry. The museum also has a life-size re-creation of an 1880s frontier town and a fine art collection.

Back on U.S. 60 heading toward the state line, the plains take on a more arid appearance with each passing mile. Ranching has long been an important way of life here, and the names of communities such as Hereford and Bovina reflect this.

Just over the state line into New Mexico, you'll reach Clovis, home to a fine zoo, an excellent model railroad museum, the Norman Petty Studio (the foundation for such recording legends as Buddy Holly and Roy Orbison), and the Eula Mae Edwards Museum & Art Gallery.

Between Clovis and Portales, the Blackwater Draw Museum is a must for anyone with even a passing interest in archaeology.

Route 27

At the junction of Interstate 40 and Interstate 27/U.S. Highway 60 in Amarillo, turn south on U.S. 60 and drive to Clovis, New Mexico. In Clovis, turn south on U.S. Highway 70 and continue to Roswell. The approximate distance of this drive is 120 miles.

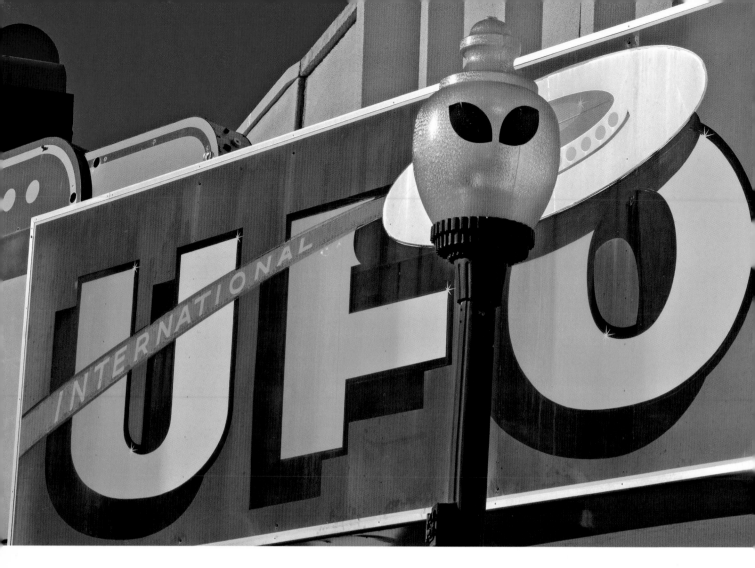

The UFO Museum in Roswell, New Mexico, has several tongue-and-cheek exhibits, like this alien movie prop below, that point to this city's international notoriety. KERRICK JAMES

In addition to dioramas and multimedia presentations, the museum offers tours of nearby excavation sites where a number of scientific groups, including the Smithsonian Institutions, the Academy of Natural Sciences, and the National Geographic Society, have participated in important research on the prehistoric peoples and animals of this area.

In addition, Portales is home to the Miles Mineral Museum, the Roosevelt County Museum, and the Natural History Museum. A unique attraction is the Dalley Windmill Collection at 1506 South Kilgore, with more than seventy-five windmills profiling more than a century of development. The charming historic district with its quaint cafés is an excellent place to complete your visit to Portales.

The last stop on this drive is out of this world, or at least enterprising business people would have you think so. However, Roswell does have more to offer than the International UFO Museum, the Roswell UFO Festival, and the Alien Zone. There is a wonderful historic district with numerous buildings listed on the National Historic Register of Places, the Robert H. Goddard Planetarium, the Spring River Park & Zoo, and the nearby Bottomless Lakes State Park. Best of all, Roswell is a friendly, small town where visitors—aliens or not—often feel encouraged to stay a little longer than planned.

ROUTE 28

Land of Never-Ending Vistas
VEGA TO KENTON, OKLAHOMA

A drive along Route 66 through the small town of Vega, once a popular stopping point, will lead you by many of the sights that greeted travelers in the heyday of America's Main Street—a vintage 1920s gas station, the Hickory Café, and the Vega Motel, an original tourist motor court built in 1947.

Once you've passed through this little hamlet, you'll travel north on U.S. Highway 385 through an area of never-ending vistas, where the only break in the plains is the Canadian River and little towns like Channing and Hartley. Take advantage of the emptiness by pulling off onto the road's shoulder, turning off the car, and simply listening.

Route 28

From Vega, drive north on U.S. Highway 385 to Boise City, Oklahoma. Then turn west on State Route 325 and continue to Kenton. This drive is approximately 150 miles.

In the late 1920s and 1930s, Route 66 in Oklahoma became the road of flight for families fleeing Dust Bowl–ravaged farms.
LIBRARY OF CONGRESS

Texas / 119

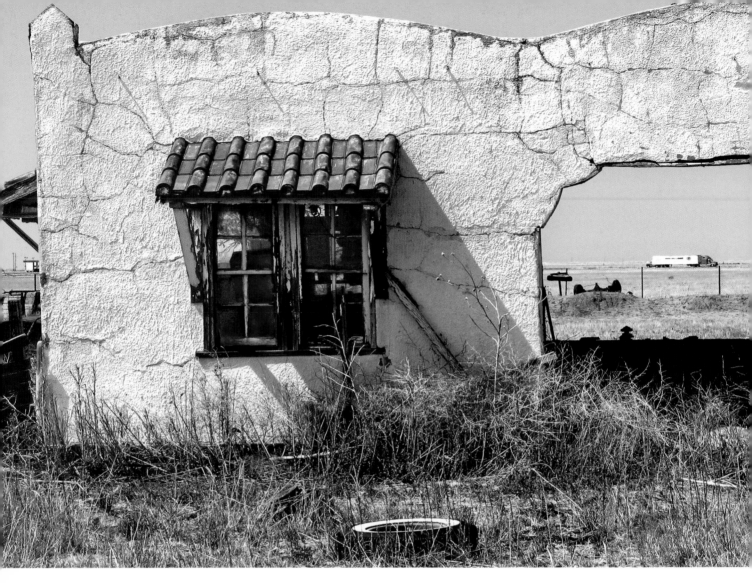

Motel ruins are a common sight on Route 66 on the plains of the Panhandle in Texas.
ROUTE66PHOTOGRAPHS.COM

Once you feel the peace of the surroundings, you'll be right at home in the Rita Blanca National Grasslands on the Oklahoma/Texas border, where buffalo and wildlife abound. With towering summer thunderheads above, the simple beauty of this area is overwhelming.

Boise City, Oklahoma, at the junction of U.S. 385 and State Route 325, is no bustling metropolis, but a relatively quiet, charming little community nestled among the rolling hills and bluffs. One of its more interesting attractions is Autograph Rock, where rugged American and Mexican traders traveling along the Santa Fe Trail in the 1800s chiseled their names into a 200-foot-tall and 700-foot-wide slab of Dakota sandstone. At the chamber of commerce is a memorial commemorating an accidental bombing in World War II. Army airmen mistakenly dropped six practice bombs over the town in 1943; they had miscalculated their true target forty miles away. Thankfully, no one was hurt in the incident, but the munitions did leave large craters behind.

The best place to visit in Boise City is the Cimarron Heritage Center Museum and Information Center. The attention to detail in the museum's exhibits reflects an honest love for this rugged land and its rich history.

The drive on Route 325 from Boise City to Kenton is very scenic, with horizons of startling blue skies broken by craggy hills, knobs of stone, and stands of juniper.

Black Mesa State Park and Nature Preserve is the highlight of a visit to Kenton. Here, the short grass prairie collides with lava-capped flat-top mesas, deep canyons, and the raw landscape of the Cimarron River. The park's namesake is Black Mesa, the highest point in Oklahoma at 4,972 feet above sea level. A somewhat strenuous trail leads to the summit and passes a small field of dinosaur tracks preserved in stone.

In town, you should visit the Kenton Mercantile, where you can enjoy a juicy buffalo burger and pick up a certificate marking your four-hour hike to the summit of Black Mesa (if you persevered and made it to the top).

As with so many drives in this part of the country, roadside services are few and far between along this route, so plan accordingly.

ABOVE AND BELOW: The American badger and the scaled quail are common inhabitants of the grasslands and prairies of the Kiowa and Rita Blanca National Grasslands.
RICK & NORA BOWERS

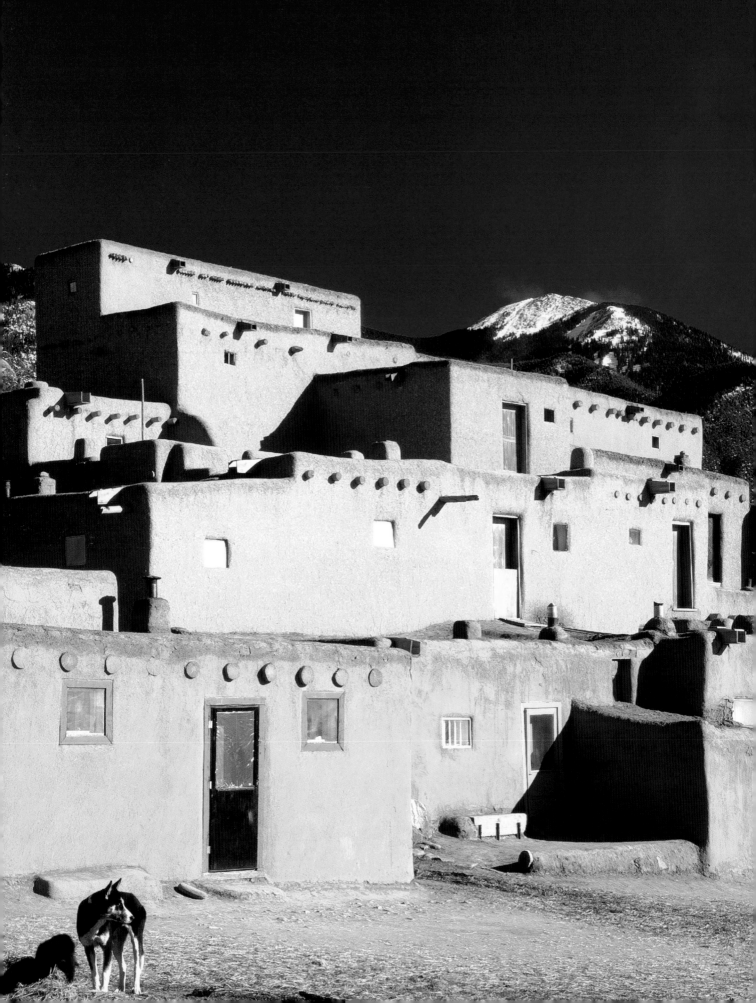

PART V

New Mexico

Discovering the Land of Enchantment

ABOVE: In Gallup, New Mexico, Route 66 and the classic Cadillac are celebrated with colorful neon.
KERRICK JAMES

OPPOSITE: The Taos Pueblo, in Taos, New Mexico, has changed little in appearance since first seen by the Spanish Conquistadors in the 1500s. KERRICK JAMES

New Mexico is a land of gorgeous landscapes and rich cultural diversity. Vast prairies, stretches of black lava flows, high-plateau mesas, and snow-covered mountains form the backdrop to centuries of history. In Albuquerque and Santa Fe, the old town centers are reminders of when these communities were little trading towns under Spanish rule in the 1700s, yet both have grown to become modern metropolises.

While the glory days of Route 66 have long been over in this state, in some communities, such as Acoma, the highway's opening in 1926 is too recent to even be considered history. Known as Sky City, Acoma is a seventy-acre Indian village that's been inhabited since at least A.D. 1150.

In the niches of shaded canyon walls and along quiet streams are ruins of communities such as Chaco Canyon, abandoned more than a thousand years before the likes of Billy the Kid, Kit Carson, and even Spanish Conquistadors traversed this land.

New Mexico also has a number of wilderness areas where you can hike for days and easily believe no one has been there before you. Yet within an hour's driving distance, you'll find cities with fine dining, excellent lodging, and all the trappings of the twenty-first century. Only in New Mexico can you see the following in one day: a monument commemorating the dawn of the Atomic Age, one of the oldest, continuously inhabited communities in the country, and a world-class ballet.

New Mexico is heralded as the land of enchantment for good reason. By traveling along one or all of the drives in this section, you too will discover the magic of this land.

ROUTE 29

Double-6 in the Land of Enchantment

ROUTE 66 IN NEW MEXICO

Route **29**

As with most of Route 66, the highway in New Mexico is broken and segmented with large portions serving as an access road for Interstate 40. However, the portions that remain are well posted and are easily followed.

The best way to enjoy Route 66 in New Mexico today is to look for the 1940s- and 1950s-style neon signs that hearken back to when Route 66 provided travelers their first introduction to the wonders of the Southwest. In Tucumcari, you'll see the classic signs for the Blue Swallow Motel, The Paradise Motel, La Cita Restaurant, and the TeePee Curio Shop (the last three have been recently refurbished thanks to the Route 66 Neon Restoration Project). In Albuquerque, you'll find the bright lights of the Aztec Motel, El Rey Theater, and Westward Ho Motel.

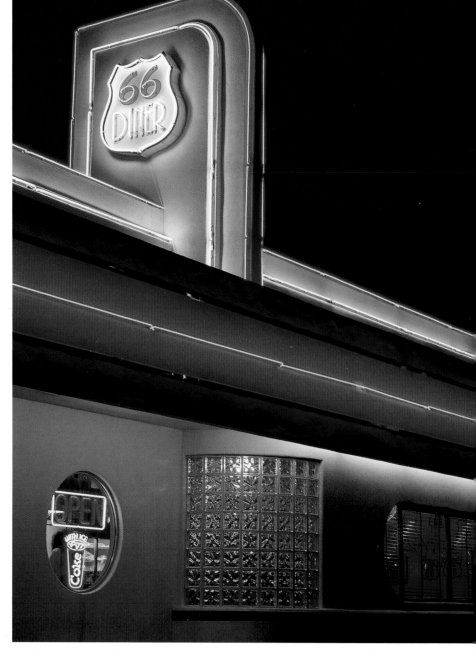

In Montoya, New Kirk, and Cuervo, there are a wealth of opportunities for the photo buff. These include an original alignment of the highway and picturesque ruins.

Santa Rosa is experiencing a tourist revival, which centers around Route 66, in particular the Route 66 Auto Museum, a delightful, eclectic collection of tin and chrome legends of the highway. Santa Rosa also is home to The Sun 'n Sand Motel, whose neon sign is glowing again, and the Blue Hole, an eighty-one-foot-deep artesian well that delivers crystal-clear water.

Clines Corners owes its existence to the 1936 alignment of the Mother Road. Nestled among the pines on a high mountaintop, this proverbial wide spot in the road is a truck stop, café, small motel, and gift shop all in one.

Moriarty, located in an agricultural area, is a quintessential western farming community with a blend of modern roadside America

FORGOTTEN 66

IN NEW MEXICO, as with the other states through which it passes, following Route 66 can be quite a challenge. The highway was rerouted several times in its history, and the last incarnation was segmented by the interstate highway system.

The initial alignment was a 506-mile route that followed many existing roads, some of which were centuries old. This early alignment began in Glenrio on the Texas state line, rolled across the high plains to Tucumcari and then Santa Rosa, New Mexico, turned north to Romeroville, and then followed the old Santa Fe Trail into Santa Fe.

From Santa Fe to Albuquerque, the highway followed the path of the historic El Camino Real (Spanish for The Royal Road) down precipitous grade. From Albuquerque, the highway swung south through Los Lunas and then north to Correo.

In 1936, the highway underwent a dramatic realignment. An old trail over the mountains between Santa Rosa and Moriarty was regraded, enabling the bypass of the Santa Fe leg. During the same period, the highway was rerouted to link Albuquerque directly with Correo. Thus, the trip across New Mexico was shortened by 107 miles.

and vintage Route 66 motels, a wrecking yard, and a truck stop little changed since 66 was the main drag. From here to Albuquerque, old 66 passes through an increasingly urban landscape.

In Albuquerque, the Main Street of America is Central Avenue. In addition to the vintage neon, refurbished Route 66 properties, blighted roadside attractions spanning fifty years, and the modern generic age, historic Old Town is found here. This plaza dates to Albuquerque's founding in 1706 and today is a treasure trove of authentic Spanish cuisine, fascinating shops, galleries, and historic buildings. Two of those are the San Felipe de Neri Church, completed at its present location in 1793, and the restored railroad station.

An Albuquerque visit offers much more than a trip down Route 66 and historic attractions. The city has a wonderful zoo on the banks of the Rio Grande River, fine museums, an aquarium, and the Sandia Peak Aerial Tramway, the longest, and perhaps most scenic, tramway in the nation.

The drive west from Albuquerque presents some of the best opportunities in the state to travel the old 66 highway. At the crest of each hill on the

BELOW: The Plaza in Old Town Albuquerque, as it appeared in 1908. LIBRARY OF CONGRESS

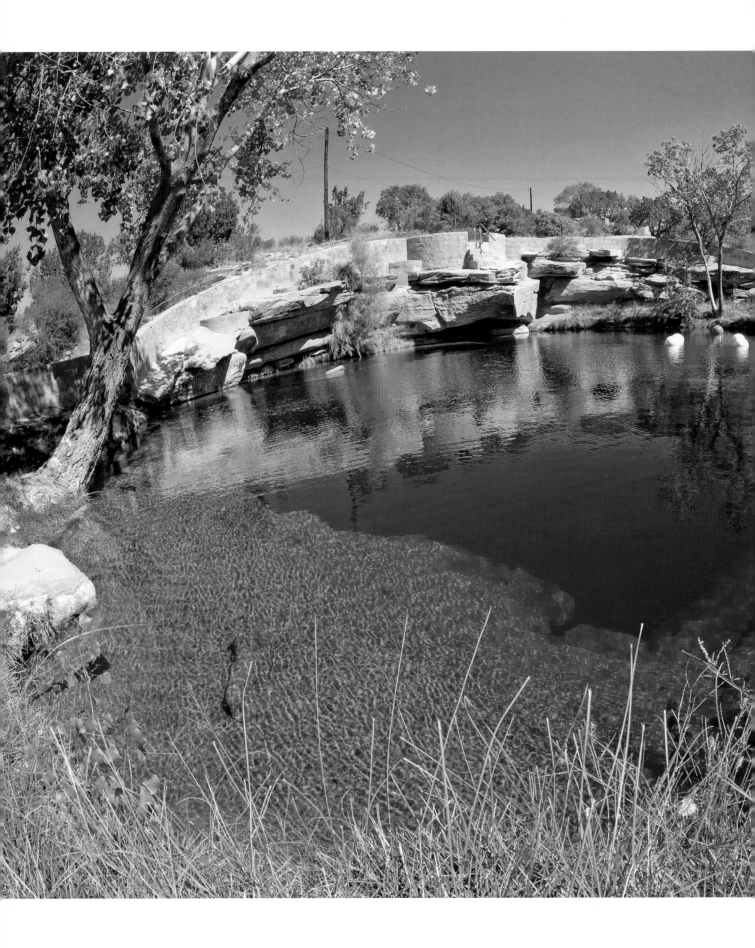

ABOVE: Acoma Pueblo is known as Sky City and has been inhabited since at least A.D. 1150.
KERRICK JAMES

LEFT: The Blue Hole, an eighty-one-foot-deep artesian spring near Santa Rosa, is a haven for scuba divers, bird-watchers, and photographers.
KERRICK JAMES

climb from the Rio Grande River, Interstate 40 and the old road both appear as arrow-straight black ribbons pointing toward mesas on the horizon.

The first hint that this is more than a pleasant drive through western landscapes under dazzling blue skies is at Old Laguna, home to the San Jose de Laguna Mission Church, built in 1699. The next is Acoma, a little further to the west and sixteen miles south of the highway.

Perched atop a mesa that towers above the plains, this small community is a living time capsule. The families that live in these old stone homes have no electricity or running water, often enter the second floor by ladder, and depend on water that collects in holes in the rocks—much as their ancestors did. First settled by native tribes around A.D. 1150, this is one of the oldest continuously inhabited villages in America.

After returning from this ancient settlement to Route 66, you will next arrive in Grants and Gallup, both communities that have served tourists for decades. Evidence of the ranching and mining industry abounds here, and roadside establishments that sell handcrafted Native American jewelry are everywhere. The result is a delightful blend of architecture spanning decades, cultural festivals, intriguing museums, and unique dining options in a landscape immortalized in countless epic westerns.

The El Rancho Hotel in Gallup, built in 1937, is considered the grande dame of Route 66 lodging in New Mexico.
KERRICK JAMES

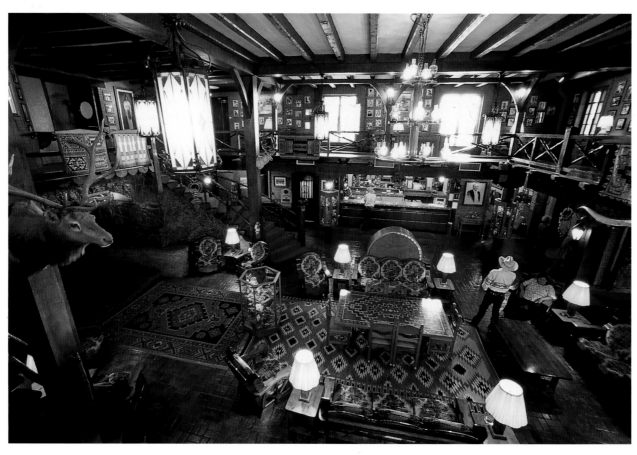

A wonderful link to the golden age of the western movie is the renovated El Rancho Hotel, built in 1937. Between 1940 and 1964, numerous actors, including Ronald Reagan and Robert Taylor, stayed at this Route 66 icon while filming in the area. John Wayne stayed so frequently he had his own room next to the bar.

There are so many sights along New Mexico's section of Route 66 you may not be able to fit them all in during one journey. Plan your trip so as not to be rushed. You can always come back again and again and again.

ROUTE 30

High Plains Adventures

TUCUMCARI TO GUYMON, OKLAHOMA

This pleasant drive rolls northeast from Tucumcari over high plains hills speckled with stands of juniper. Initially short on natural beauty, however, the first few miles provide nothing to look at but heavy traffic, most notably trucks rolling toward Wichita.

Yet just thirty miles north on U.S. Highway 54 is Ute Lake State Park on the Canadian River, which offers a respite from the road and the landscape. During the summer, this is a wonderful place to have a picnic lunch or perhaps take a dip.

Most of the dusty towns along this route offer only the most basic services, at best. Dalhart, Texas, is an exception. It is home to locally owned retail businesses, restaurants, modern motels and service stations, and quaint antique stores, as well as the XIT Historical Museum located at 108 East Fifth Street.

The XIT Historical Museum is far more than a community-operated facility that chronicles the local history. An extensive collection of hats, guns, and ranching equipment traces the history of the American cowboy, in general, and the XIT ranch in particular, at one time the largest fenced range in the world. There is also a wonderful art gallery, an extensive display pertaining to the history of railroading in the area, and information about the nearby Kiowa and Rita Blanca National Grasslands. If you can, time your trip to coincide with the XIT Rodeo and Reunion, a bustling event that draws old friends back to the ranch and offers traditional rodeo activities.

Lake Rita Blanca State Park, the northernmost park in Texas, also is here. The shallow, 150-acre lake was created by damming the Rita Blanca Creek, and it is surrounded by a sea of grama and buffalo grass. The lake is a popular stop for bird-watchers during the winter migration. You can often see bald eagles, mule deer, foxes,

Route **30**

From Tucumcari, drive north on U.S. Highway 54 approximately 170 miles to Guymon, Oklahoma.

The proximity of open desert wilderness and towering peaks to the city of Albuquerque surprises many who head out from there on horseback day rides.
KERRICK JAMES

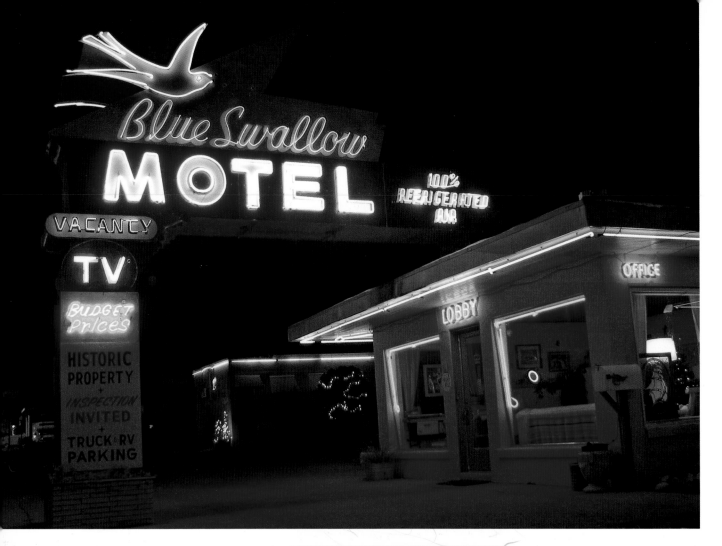

ABOVE: Once a beacon for weary travelers, the neon sign for the Blue Swallow Motel in Tucumcari is now an internationally recognized symbol of a new era on Route 66.
ROUTE66PHOTOGRAPHS.COM

RIGHT: Wild flowers add a splash of color to the boundless horizons of the Rita Blanca National Grassland.
RICK & NORA BOWERS

and coyotes in the surrounding area. From Dalhart, the highway skirts the Rita Blanca National Grassland. Scattered throughout northwest New Mexico and the Panhandles of Oklahoma and Texas are similar pockets of original prairie and others reclaimed from Dust Bowl–ravaged farm lands that are as windows into a different time–when Route 66 became known as the road of flight for those heading toward California in hopes of a better life.

Just north of Texhoma, at Goodwell, Oklahoma, is the No Man's Land Museum and Oklahoma Panhandle State University. The former chronicles the history of an area that remained one of the most remote places in the country until the first years of the last century.

ROUTE 31

To the Clouds

SAN JON TO RATON

Shortly after you pass through the dusty little village of Roy, the tall grass prairie of the Kiowa National Grassland seems to swallow all but the tallest landmark. It also provides a beautiful foreground for the Cimarron Range, often crowned with clouds, that rises to the northwest.

From Mills, you can take a short detour on an unpaved road (inquire in Mills about road conditions) to the oasis of Mills Canyon. A small campground, a wide array of wildlife, and the awe-inspiring beauty of an 800-foot deep chasm of the Canadian River make this a prime destination for those in search of solitude.

Though historic Springer features all modern amenities, they seem out of place, especially against a backdrop of the circa-1882 Colfax County Courthouse, home to the Santa Fe Trail Interpretive Center and Museum. If you stop here, you will be treated to a fine exhibit of photographs that bring more than a century of the area's rich, colorful history into focus.

Climbing into the Cimarron Mountains on State Route 58 quickens the senses. Even in the summer, the air feels cooler and crisper, and after driving across the high plains, the towering peaks in the distance urge one on to see what lies ahead.

Walking the streets of the historic district in Cimarron, you might feel like you've stepped back in time. The highlight of any stop here has to be the St. James Hotel. The hotel began as a rowdy saloon on the Santa Fe Trail in 1872. Seven years later, the saloon had

Route **31**

From San Jon, drive north on State Route 469 to Logan; then continue north on State Route 39 approximately 100 miles to Abbott. Turn west on U.S. Highway 56/412 to Springer, 20 miles. In Springer, turn north on Interstate 25 and drive 6 miles to the junction with State Route 58. Drive west 20 miles on Route 58 to Cimarron and then turn north on U.S. Highway 64 to Raton.

ABOVE: Bullet holes in the ceiling at the St. James Hotel are tangible links to when Cimarron, New Mexico, was at the heart of the Wild West.
KERRICK JAMES

LEFT: The Jesse James room at the St. James Hotel commemorates one of the many famous guests at this historic hotel.
KERRICK JAMES

morphed into an opulent hotel, one of the first between San Francisco and the Mississippi River to offer running water, gourmet dining, and luxurious furnishings.

The original saloon, with bullet holes in the pressed tin ceiling, is now a dining room that specializes in fine foods. The hotel still provides lodging, but be warned: The owners say it is haunted.

Once you get closer to Raton on U.S. Highway 64, you'll realize why this is designated by the 2006 Rand McNally atlas as a scenic highway. It follows the north fork of the Santa Fe Trail toward the 7,834-foot Raton Pass, and at every turn there are wondrous views.

Raton began life as Willow Springs Station in 1866. With the coming of the railroad in 1879, the area mines and ranches roared to life, pushing the community into boomtown mode overnight. The best of what Raton has to offer is in the district surrounding the historic railroad depot. If time allows for but one stop, make it the Shuler Theater. It was built in 1915 and features a beautiful mural of the area history, created by locally born artist Manville Chapman in the 1930s.

Enhancing this drive is a plethora of short detours to wonders such as Capulin Volcano National Monument, the ghost town of Elizabethtown, and Sugarite Canyon State Park. Inquire locally for some of the best.

The reward for following the trails to the summit of the 1,400-foot Capulin Volcano Crater is in the panoramic views of the surrounding Raton-Clayton Volcanic Field. KERRICK JAMES

CROSSROADS OF THE FRONTIER

LESS THAN THIRTY MILES east of Raton on U.S. Highway 64/87 is Capulin Volcano National Monument, one of the lesser-known gems hidden along the backroads of New Mexico. Capulin is a near symmetrical cone of cinder that rises 1,400 feet above the surrounding grassland plains.

From the rim, which can be accessed by a trail, the views are stunning. The prominence of the peak made it a landmark on the historic trails that pass below.

To the southeast ran the Fort Union/Granada supply road. The Goodnight Trail, blazed by cattle baron Charles Goodnight, also ran nearby.

Dominating the southeastern horizon is Rabbit Ear Mountain. This unique formation was a landmark on the Cameron cutoff of the Santa Fe Trail.

Route **32**

Head northwest out of Tucumcari on State Route 104, a 106-mile drive to Las Vegas. There continue north on State Route 518 to Taos, 77 miles.

RIGHT: Spiral carved beams in Taos, New Mexico, offer testimony to the centuries that have passed since the founding of this community.

KERRICK JAMES

ROUTE 32

An Ancient Land

TUCUMCARI TO TAOS

As with the prior two routes, this one begins in the high plains, but a pleasant lake offers a break from the miles of sameness. Conchas Lake lies off of State Route 104 in a state park that is quite popular during summer months, but even then you can find a camping spot and enjoy some simple solitude under a canvas of stars.

Las Vegas, New Mexico, is very different from its more famous namesake in Nevada. With more than nine hundred structures listed on the Register of Historic Places, this Las Vegas is a wonderland for those who love vintage architecture. Adobe homes on winding streets hark back to the early days when this was an important watering hole on the Santa Fe Trail. Elegant Victorian-style brick homes reflect the boom the railroad brought and the subsequent growth that led to a larger population than the capital at Santa Fe by 1900.

The delightful Plaza Hotel provided rest to many famous weary travelers over the years. Among the notables was Teddy Roosevelt. He stayed here while he was in town on a recruitment drive for his band of Rough Riders.

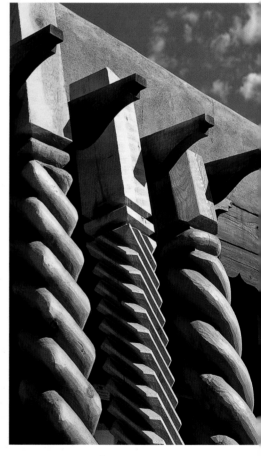

Driving north from Las Vegas on State Route 518, you will pass through forested parks and quiet mountain communities where time has moved at a crawl for centuries. The enchanting vistas are many along this road.

The last stop on this route is Taos, a community that is known today for its eclectic artists, rich and famous residents (Julia Roberts among them), and abundance of New Age practitioners. This, however, is but the most recent incarnation of an ancient community that has seen waves of fads, cultures, and languages over the years. From the Anglo perspective, Taos dates to 1725. But actually, the original Taos Pueblo is a World Heritage Site, documented to have been inhabited for more than one thousand years.

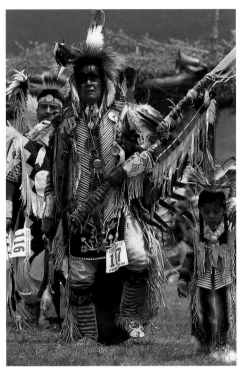

With this in mind, it's no surprise that Taos is an intensely diverse community with an equally diverse array of sights and attractions. The plaza is the heart of Taos, as it has been for centuries. Today, fine art galleries, shops, and exotic restaurants encompass it. The ancient and modern flow together here as a stream over stones worn smooth by the passing of centuries.

An entire book can easily be devoted to the sights and attractions in and around Taos. There are a few, however, that really should not be missed. Among these would be the Millicent Rogers Museum, a staggering display of modern as well as historic Native American crafts, and the Kit Carson Home and Museum.

The surrounding area is more than scenic, with the most stunning natural attraction being the Rio Grand Gorge. This 650-foot deep chasm is eleven miles northwest of Taos and has a bridge you can cross to experience its dramatic views.

Sadly, many others have discovered Taos' beauty and diversity of attractions over the last several years, so plan ahead if you decide to stay there more than just a day.

LEFT: The Taos pow-wow celebrates a culture and society that predates the arrival of the Spanish Conquistadors by centuries.
KERRICK JAMES

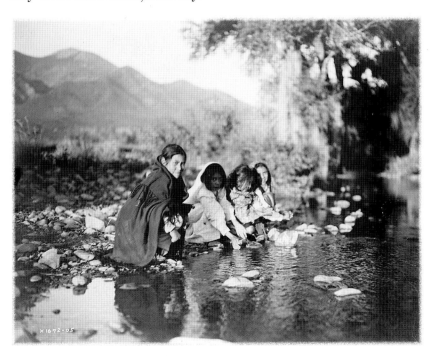

LEFT: Native American children play at the Taos Pueblo in 1905.
LIBRARY OF CONGRESS

A Land of Snow and Snow-White Sands

CEDAR CREST TO ALAMOGORDO

This drive is an adventure through the land of the unexpected—a mix of snow-white sands and snow-covered peaks. To set the mood, start at the Museum of Archaeology and Material Culture, at 22 Calvary Road in Cedar Crest. This museum is a condensed version of life on planet Earth for the past twelve thousand years that will provide sobering perspective about how rapidly the world we live in can change.

The drive south to Mountainair, as with so many in New Mexico, is a scenic one. Towering peaks dominate the western skyline, while to the east the plains stretch toward a seemingly endless horizon.

Mountainair is a charming little town with numerous delights. Perhaps the most notable is the Shaffer Hotel, a pueblo-deco structure built in 1923 by folk artist Pop Shaffer.

However, the true treasures in this area are those that predate the construction of the hotel by more than two centuries. The Salinas Pueblo Missions National Monument comprises ruins of four seventeeth-century Spanish missions. The two at Quarai, eight miles north of Mountainair on State Route 55, and Abo, nine miles west of town on U.S. Highway 60, are spectacular. At Quarai, the ruins of Nuestra Senora del la Purisima Concepcion tower over the valley and gently rounded hills, which are the ruins of the even older pueblo of Cuarac.

The crown jewel of these historic missions, however, is Gran Quivira, located twenty-six miles south of Mountainair on Route 55. When the Spanish arrived here, this was a thriving, powerful trading center serving the pueblo Indians to the west and Indians of the plains to the east. Construction of the first church began in 1629, which was abandoned before completion. A second attempt began in 1659. By the Pueblo Revolt of 1680, these missions were well on the way to ruin.

The Pueblo Revolt is a pivotal event in New Mexico history. In

Route 33

From Cedar Crest, drive south on State Route 337 to Tajique and continue south on State Route 55. In Mountainair, drive south on Route 55 to the junction with U.S. Highway 54; then turn south on U.S. 54 and continue to Alamogordo. This entire drive is about 160 miles.

The ruins of Gran Quivira at Salinas Pueblo Missions National Monument are remnants of a city that once was a powerful trading center for the pueblos to the north and the tribes of the plains.
KERRICK JAMES

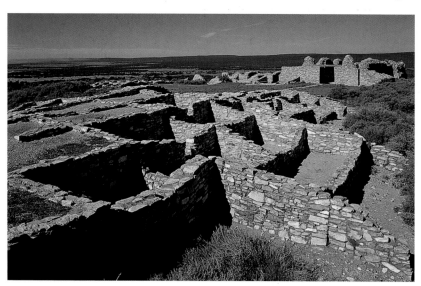

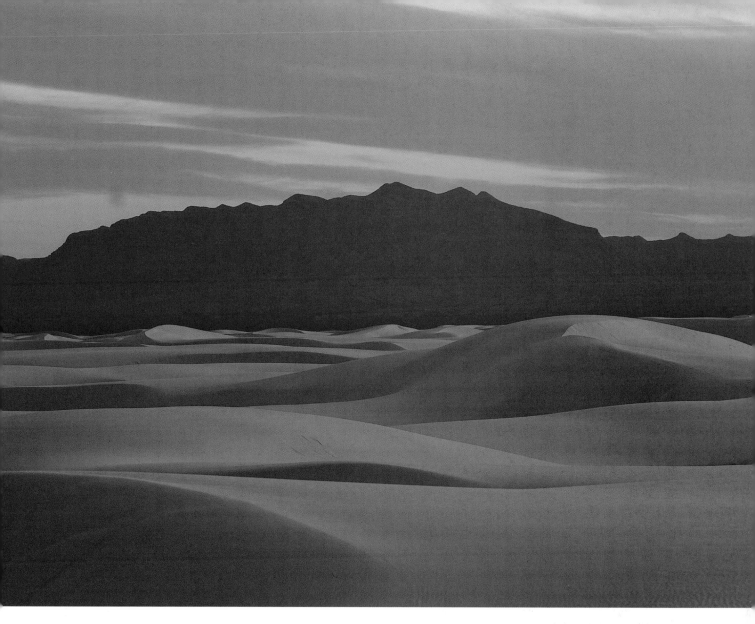

August of 1680, in a surprising display of unity, several tribes and pueblos united in a meticulously planned coup that effectively drove the Spanish from New Mexico. The combined Indian forces held the Spanish at bay for more than a decade.

Each pueblo in Salinas Pueblo Missions National Monument has a small visitor's center with exhibits and marked trails. The headquarters for the monument is in Mountainair at the corner of Ripley and Broadway.

Shortly after joining U.S. Highway 54, you enter the land of legend. Carrizozo has been the seat of Lincoln County since 1912, the year of statehood, and Lincoln County is the home of Wild West legend Billy the Kid. The ghost town of White Oaks, where the Kid once roamed the streets, is but a few miles to the northeast. To the southeast on U.S. Highway 380 is Lincoln. This dusty town is preserved in its entirety as a national historic landmark. The town played a pivotal role in a power struggle that erupted into a full-scale war, one that elevated William H. Bonney, aka Billy the Kid, to mythical status.

Watching twilight shadows at Gypsum Sands, part of the White Sands National Monument, is a mesmerizing experience.
KERRICK JAMES

THE MAKING OF AN OUTLAW

HISTORIANS' BEST GUESS is that he was born Henry McCarty in New York City in 1859. Billy the Kid's first association with New Mexico Territory was in the spring of 1873 when, after years moving from place to place, he was a witness at his mother's marriage to her longtime companion, Bill Antrim, in Santa Fe. He later used his stepfather's last name as an alias, being called William Antrim as well as William Bonney.

In 1874, his already hardscrabble life took a turn for the worse when his mother died and his stepfather abandoned him. The next step toward a tragic end came when Billy was arrested and thrown in jail. He escaped by worming his way up the jailhouse chimney.

A few years later, in Bonita, Arizona Territory, "William" killed a man and returned to New Mexico just ahead of the Arizona Rangers. In Silver City, his small stature had earned him the moniker Kid Antrim. After the incident in Arizona, a run with a band of horse thieves in New Mexico, and an attack on the jail in Lincoln to free the band's leader, he simply became known as the Kid.

Whether he chose sides in a building range war for money, thrills, or loyalty is unknown. What is known is that his death by ambush in Lincoln elevated him to the big league of Old West outlaws.

The last leg of this drive is listed as a scenic highway in Rand McNally's 2005 atlas, and no wonder, with the foreboding, fortress-like walls of the Sacramento Mountains dominating the eastern horizon and the desolate Tularosa Valley sweeping to the west. Fittingly, this barren valley is the location of Trinity Site, where the world's first atomic bomb was tested more than sixty years ago. Today, it is the stark beauty of White Sands National Monument, 275 square miles of gypsum dunes, that draws visitors from throughout the world.

ROUTE 34

The Trail of Discovery

CEDAR CREST TO CHAMA

Be sure your cinch is tight for this wild ride through centuries of history and some of the most scenic landscapes in the state. This route will give you the chance to find something new to explore for the next twenty years.

Starting in Cedar Crest, you will follow State Route 14 as it twists and turns across hills, skirts canyons, dips into wide valleys, and slips through sleepy little villages such as Golden. Although there is little left in Golden today, other than an old, white-washed church, this mining community once thrived with the discovery of gold and the first rush west of the Mississippi River in 1825.

Route 34

From Cedar Crest, drive north on State Route 14. This becomes Cerrillos Road (the pre-1937 alignment of Route 66) in Santa Fe. Turn north on U.S. Highway 84 and drive 100 miles to Chama. This drive is approximately 160 miles.

Another mining town along this route, Madrid, has been reborn as home to an eclectic group of counter-culture artists. The picturesque community, nestled in the Ortiz Mountains, dates to the discovery of extensive coal deposits in 1850. With the decline of coal use after World War II, particularly by the railroads, the town began a precipitous slide toward oblivion. Then, in the mid-1970s, artists with a dream of starting a new community discovered it.

The quiet village of Los Cerrillos, with miles of hiking trails in the surrounding hills, is among the oldest mining districts in the nation. Turquoise mining here dates to at least A.D. 1000 and modern mining to 1581, when the Spanish began extracting silver here.

Even though the roots of Taos reach further back in time,

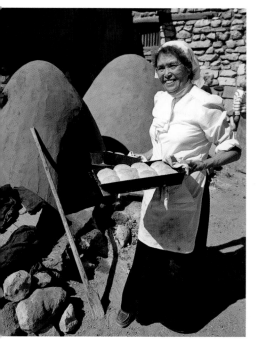

ABOVE: Palace Avenue off The Plaza in Santa Fe, New Mexico, is a portal through centuries of history, art, and culture. KERRICK JAMES

LEFT: A baker prepares bread at El Rancho de las Gonlondrinas (The Ranch of the Swallows), a living history museum near Santa Fe that provides a tangible link to the city's Spanish colonial era.
KERRICK JAMES

New Mexico / **143**

Right: The entrance to Ford Ruthling's home in Santa Fe reflects the artistic talents that have brought him international acclaim. KERRICK JAMES

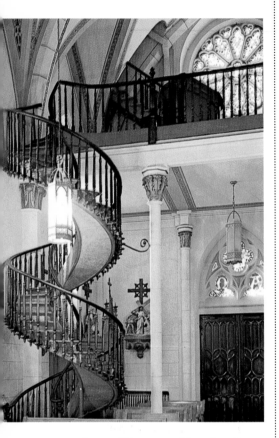

Above: This postcard from Loretto Chapel in Santa Fe features the Miraculous Staircase, an engineering marvel that seems to be unsupported. AUTHOR'S COLLECTION

Santa Fe also has a timeless quality. For most of the past four hundred years, this small city has been the capital of the land now known as New Mexico, and Native American vendors have sold all manner of goods in its plaza, which is surrounded by old adobes casting long shadows in the once mule-navigated narrow streets.

Four flags have flown in Santa Fe since its founding in 1610: the Spanish, Mexican, Confederate, and American. The city has four historic districts with more than three thousand historic listed structures, including the Palace of the Governors (built shortly after the Pueblo Revolt of 1680 on the ruins of a pueblo abandoned around A.D. 1425).

Fine museums, art galleries, and dining opportunities are plentiful here. You can also visit historic sites such as the Loretto Chapel with the Miraculous Staircase that seems to defy all principles of engineering and the San Miguel Mission Church, one of the oldest churches still in use in the nation today.

The diversity of scenery, cultures, sights, and sounds on the drive north from Santa Fe is dizzying. Espanola, a farming community founded more than a century ago, was home to renowned artist Georgia O'Keeffe and is, as with so much of the Southwest today, an

A CASE OF FRONTIER JUSTICE

TIERRA AMARILLA, Rio Arriba's county seat, was the site of an infamous clash between local Hispanic land-rights activists, ranchers, and the government in 1967. The firestorm erupted when the activists, led by Reies Lopez Tijerina, stormed Rio Arriba Courthouse. They wanted to make a citizen's arrest of the district attorney, who was cracking down on the group. Angered by his absence, the crowd took out its frustrations in a scene reminiscent of cinematic epics of the Old West—they shot up the courthouse and then found themselves in a shootout with local law enforcement.

In the melee, a jailer and state police officer were shot and wounded, and hostages were taken. The armed men fled into the neighboring mountains, the governor called out the National Guard to restore order, and eventually the hostages escaped.

144 / Route 66 Backroads

odd blend of the modern and the ancient. There are cyber cafés and a Walmart, yet strings of bright red chilies and other locally grown produce are sold from roadside stands in their shadows.

Back in the 1790s, quiet little Abiquiu was one of the largest towns in the territory, and for more than a century it was a pivotal trade center. Now it is home to the Ojo Caliente Mineral Springs, a day spa where you can soak in different pools and baths, have a massage, or have a sea salt scrub. Bode's Mercantile, an old-fashioned general store with nearly everything you could be looking for, is also here.

The final stop on this drive is Chama, home to the historic Cumbres & Toltec Scenic Railroad. Riding these vintage rails is an excellent opportunity to experience the beauty along every mile of this drive without the distraction of having to watch the road ahead.

ROUTE 35

The Lost Highway

GRANTS TO SANDERS, ARIZONA

This entire drive is less than 116 miles, making it possible to travel this route on a leisurely Sunday cruise. However, if you want to see but a fraction of the sights and attractions along the way, you could spend a week going through here; after all, parts of this drive have been followed by travelers for almost a thousand years.

Grants is the starting point for this route, and it is one of those towns with amazing resilience. Since its founding in the 1880s, Grants has served as a supply center for area ranches, been at the center of a uranium mining boom, and met the needs of travelers on Route 66 as well as Interstate 40.

One of the highlights of a stop in Grants is visiting the New Mexico Mining Museum at 100 North Iron Avenue. While small, the museum has an amazing array of gem, mineral, and mining exhibits, including the world's largest drill bit.

Shortly after leaving Grants, the State Route 53/61 begins to pass through a forbidding moonscape of ancient lava flows Spanish explorers dubbed El Malpais, or badlands. Large portions of this harsh landscape are part of the El Malpais National Monument. Its headquarters is east of Grants at Exit 89 on I-40, but Route 53 follows the monument's northern boundary and parallels the El Calderon Lava Flow, which is estimated to be 115,000 years old.

Numerous trails provide access to the area's choicest location, the monument's Sandstones Bluff overlook that juts above the dark flow like a ship's prow, offering a panoramic view of this amazing

Route 35

Take State Route 53 west from Grants. This becomes State Route 61 in Arizona. At Route 61's junction with U.S. Highway 191, turn north to Sanders. This drive is approximately 116 miles.

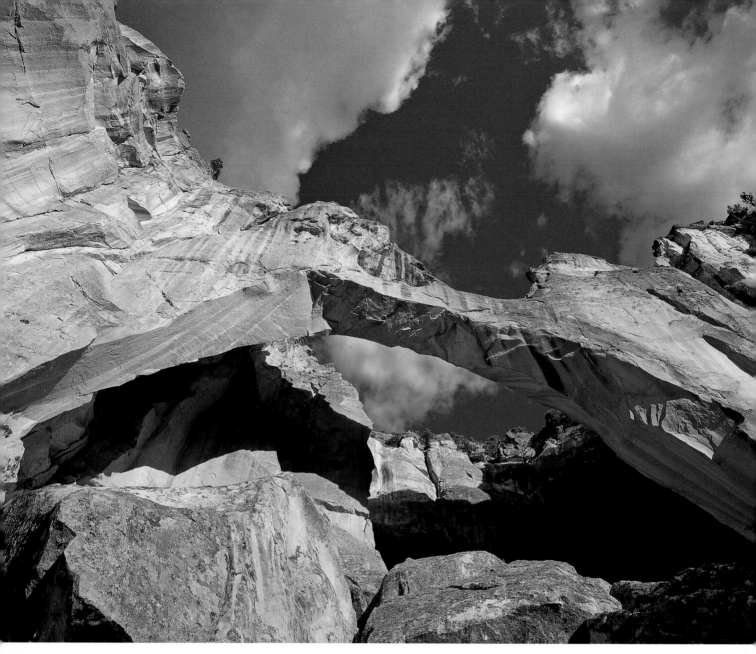

ABOVE: La Ventana Arch at El Malpais National Monument outside Grants is New Mexico's largest natural arch. KERRICK JAMES

RIGHT: The artistry of the Zuni, as seen in this jewelry and pottery, has been admired by collectors for centuries. KERRICK JAMES

landscape. The most dramatic feature found here is La Ventana Arch, the largest natural arch in the state.

With unexpected suddenness, Route 53/61 climbs from a lunar landscape into a parklike setting of meadows punctuated with juniper groves and then skirts the base of Bandera Crater. And then you see it: The sandstone monolith of El Moro, the namesake for El Moro National Monument, appears on the horizon. This unique geologic formation is distinctive in that it has a gradual incline on one side and a near vertical front on the other. The monolith also served as a landmark denoting a reliable water source on a trade route between the pueblos and the Pacific Coast for decades before the arrival of Spanish explorers. All who have stopped here—from Native American traveler to Spanish conquistador, from American explorer to railroad survey crews—have felt obligated to carve a note or signature in the soft rock, making this a tangible link to more than a thousand years of history.

ABOVE: At Bandera Crater, seventeen miles of developed trails allow safe exploration of lava tubes and ice caves. KERRICK JAMES

The drive west follows much of this ancient highway and enters what Coronado had hoped was the fabled land of Cibola at the Zuni Pueblo. Inhabited for nearly a thousand years, this pueblo is known by the Zuni as the Middle Place of the World. Tribal myths say that the Zuni came here after emerging from the underworld and spending many years wandering this region.

The best seasons to take this drive are early fall, late spring, or early summer. Winter storms arise quickly and with ferocity here, often dumping large amounts of snow and bringing cold temperatures.

ROUTE 36

Land of the Ancients

GALLUP TO TUBA CITY, ARIZONA

For those traveling along Route 66 in its 1950s heyday, two things stood out about Gallup: its towering redrock cliffs and its strong ties to Native American life in the Southwest. Both remain today.

Native-American art galleries and trading posts line the Mother Road as it travels through Gallup, which also hosts the Inter-tribal Indian Ceremonial each year. This festival features the most

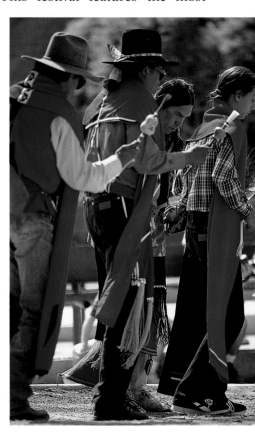

complete and varied displays of genuine Indian fine art—Navajo rugs, kachinas, jewelry, pottery, basketry, bead work, paintings, and sculpture—as well as authentic powwows, Native-American dance demonstrations, and all-Indian rodeos.

Gallup also has two wonderful historical attractions. The Rex Museum presents a wide panorama of the community's rich history—from its railroad and mining days to its Route 66 era. In the chamber of commerce building is an exhibit commemorating the Navajo Code Talkers, who used their distinctive language as a secret code for the military in World War II.

Rolling west into the redrock country, you may feel as if you've

Route **36**

Drive north 7 miles on U.S. Highway 491 from Gallup and then turn west on State Route 264. Follow Route 264 to the Arizona state line and continue approximately 165 miles to Tuba City.

RIGHT: The Gallup Indian Market in Gallup, New Mexico, is a favorite for those seeking authentic Native American crafts and artwork. KERRICK JAMES

OPPOSITE: Dinosaur footprints cross the colorful desert near Tuba City, Arizona. KERRICK JAMES

With the exception of electric lights, the Hubbell Trading Post in Ganado, Arizona, is as it was when built in 1883. KERRICK JAMES

been here before. Maybe you have, if you're a fan of old Hollywood western epics. Many of them were filmed in this area.

Just over the state line is Window Rock, Arizona, the capital of the Navajo Nation and home to the Navajo Nation Tribal Museum, the largest Native American museum in the nation.

In St. Michaels, a few miles west of Window Rock, the St. Michaels Historical Museum preserves a forgotten chapter of Southwestern history. In the mid-1890s, this native stone building was home to Franciscan friars who, in an effort to spread the gospel, became integral in the creation of a written language for the Navajo. Next door to the museum, you can view a sculpture titled *Redemption of Mankind*, the work of German sculptor Ludwig Schumacher. It has been called the American Pietà. Carved from a section of juniper bark, this sculpture differs from Michelangelo's famous version in St. Peter's in that it is a vertical depiction of the lowering of Christ from the cross.

The next stop on this route will truly take you back in time. Entering the Hubbell Trading Post, a National Historic Site near Ganado, you will realize not much has changed here since the store

was established in the late 1880s, other than the addition of electric
lighting. You can still buy Navajo rugs, jewelry, and baskets, just as
fellow travelers did back in the frontier days. For reasons that will
become obvious with the passing of every mile, the remainder of this
drive is designated a scenic highway in Rand McNally's 2005 atlas.
However, to experience some of the best this region has to offer, park
the car and lace up the boots for some hiking.

Several miles from the Keams Canyon Trading Post in the Hopi
village of Keams Canyon, deep in beautiful Keams Canyon, rises the
imposing Inscription Rock. As the name implies, this sandstone wall
is inscribed with centuries of petroglyphs and a few famous signa-
tures, such as that of Kit Carson.

Keams Canyon is in a Hopi reservation, where there are three
primary villages: First, Second, and Third Mesa. The Hopi Cultural
Center is located at Second Mesa, where there is also a motel, gift
shop, and restaurant with many traditional foods on the menu. The
cultural center is an excellent source of information about proper
etiquette for those visiting the reservation and what tribal ceremo-
nies are open to the public.

The village of Old Oraibi on the Third Mesa looks more like an
outcropping from the stony soil than an actual village. Age has much
to do with this perception, as the community has stood on this
rocky knoll since A.D. 1100, making it one of the oldest continuously
inhabited villages in the United States.

This drive from Gallup to Tuba City through Native American
lands is nothing short of extraordinary with its expansive scenery
and cultural diversity. Because of the remoteness of these reservation
lands, be sure your car is in good condition. Roadside services are
limited here.

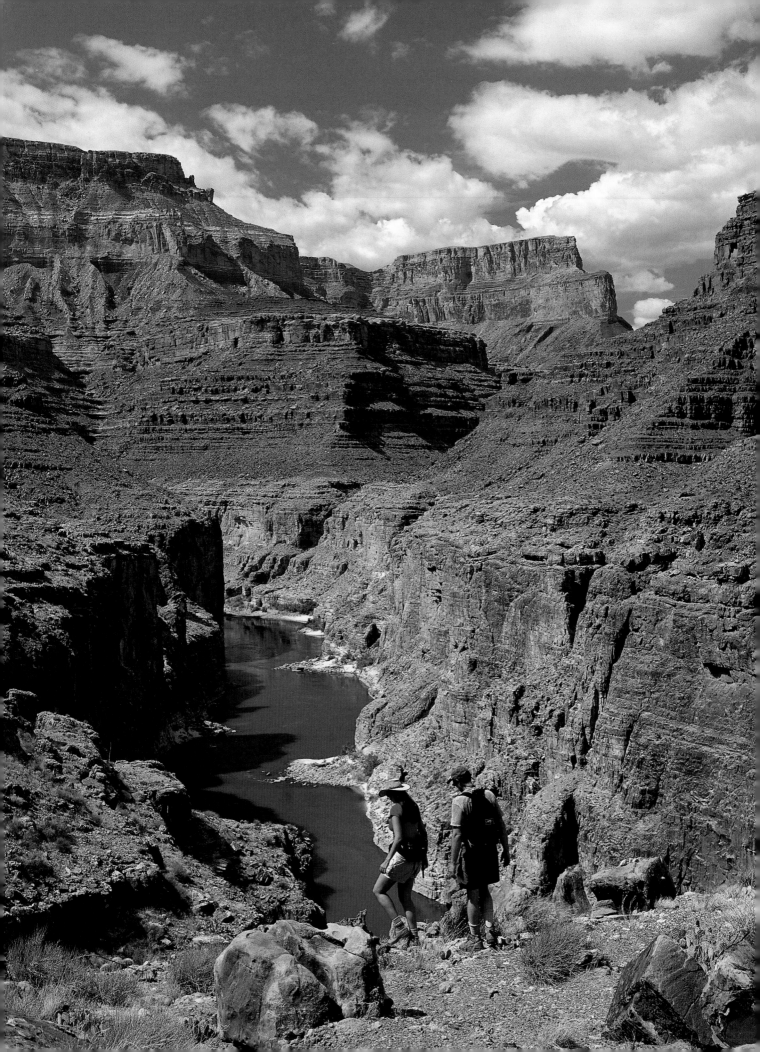

PART VI

Arizona

Technicolor Wonderland

ABOVE: The interior of Hackberry General Store is a delightful cornucopia of Route 66 memorabilia, both historic and modern. KERRICK JAMES

OPPOSITE: Hikers trekking along the Colorado River at Grand Canyon National Park are dwarfed by the immensity of the canyon with its multihued stone walls. KERRICK JAMES

For the first-time visitor, Arizona is a land of breathtaking wonders and stark contrasts. And also for those who come back time and again, or even those who live here, the Grand Canyon State never ceases to amaze.

In northern Arizona, through which old Route 66 runs, you can drive fifty miles and experience both the warmest winter temperatures in the nation as well as snow. Add another one hundred miles and you can sunbathe in a bikini, don your skis, and still enjoy an evening with the symphony.

With equally short detours off the Mother Road, you can experience the raw beauty of thundering waterfalls in a community so remote mule trains still deliver the mail there or all the amenities of a five-star hotel.

So much of this state, in spite of explosive growth during the past few decades, is still a lost world. Wilderness and primitive areas, to which access is granted only to those with a pair of sturdy boots, equally sturdy legs, and a heart for adventure, abound.

New Mexico is the land of enchantment. Arizona is the land of entrancement, where an afternoon spent on a rocky outcropping watching the shadows creep across the valley below can pass without notice.

ROUTE 37

In the Footsteps of the Camel Corp

ROUTE 66 IN ARIZONA

At one point, Route 66 traversed more than four hundred miles of Arizona. As you try to follow the broken pieces of the road in eastern Arizona, you probably wouldn't guess that 350 of these miles are still intact in the state.

From Lupton to Holbrook, the best-preserved portions of the old highway are the access roads. These serve as links to attractions that have changed little since the dismemberment of Route 66. The first of these throwbacks is Fort Chief Yellowhorse and Yellowhorse Trading Post. Located fourteen miles west of the New Mexico state line, this stop dates to the 1960s and is the quintessential Route 66 roadside attraction. It has changed little in spirit even though a fire resulted in reconstruction in the early 1970s and the completion of Interstate 40 necessitated relocation.

Route 37

With the exception of the section between the Colorado River and the Crookton Road exit on Interstate 40 west of Ashfork, about 180 miles, Route 66 is segmented and broken. All remaining portions are well marked with many portions serving as an access road for I-40.

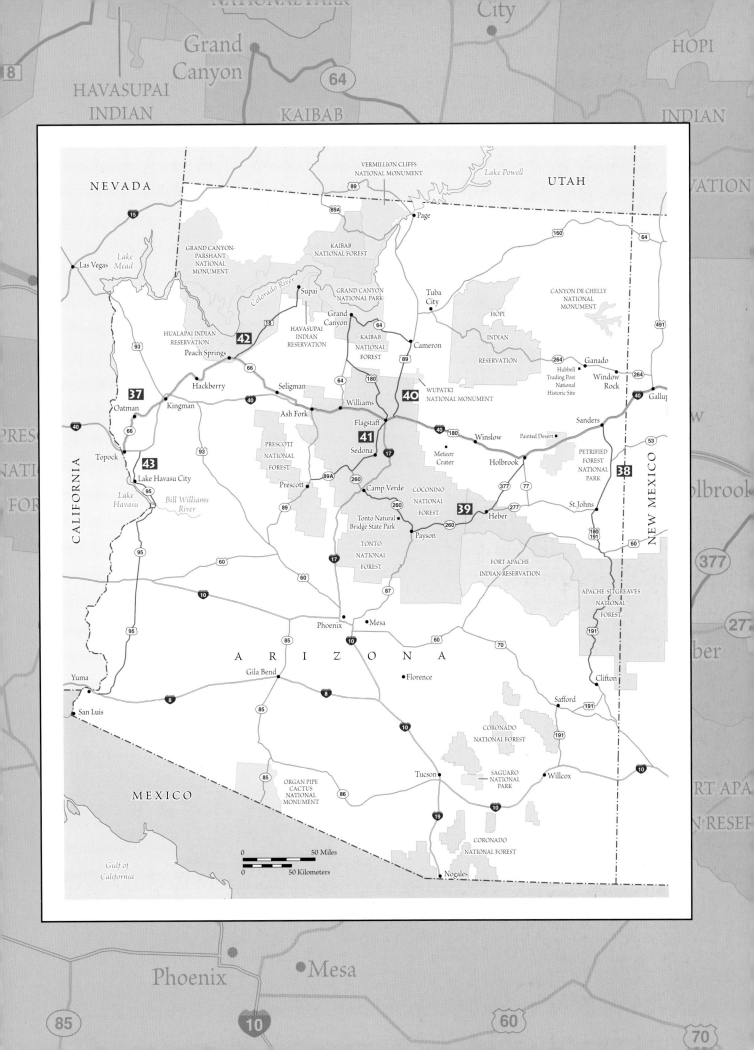

A short but well-recommended deviation from the route tour begins at Exit 311, the Petrified National Forest exit on I-40. This delightful little drive is through the heart of the Petrified Forest and the colorful hills of the Painted Desert.

Back on the main route, Holbrook always reminds me of those pictures of a once-bustling city, abandoned to the swirling desert sands and rediscovered by tourists who come to gawk at the remnants from that forgotten time. Vestiges of more than a century of history, from a simplistic cut-stone railroad depot to abandoned and restored Route 66–era businesses, are easy to find.

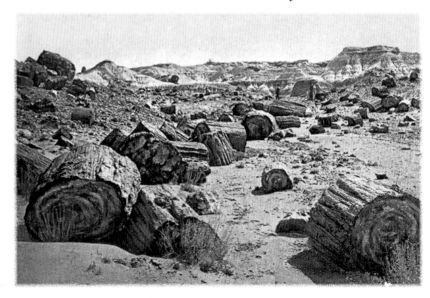

ABOVE: The statue of a guitar player in the historic downtown streets of Winslow, Arizona, commemorates this town's mention in the Eagles' hit "Take It Easy." KERRICK JAMES

OPPOSITE: The bright colors of a rainbow in a desert sky accentuate the muted shades of the Painted Desert. KERRICK JAMES

RIGHT: The multihued landscapes of the Painted Desert, dotted with an intriguing forest of stone trees, have long been a major attraction for Arizona visitors. This postcard dates to the 1920s. KERRICK JAMES

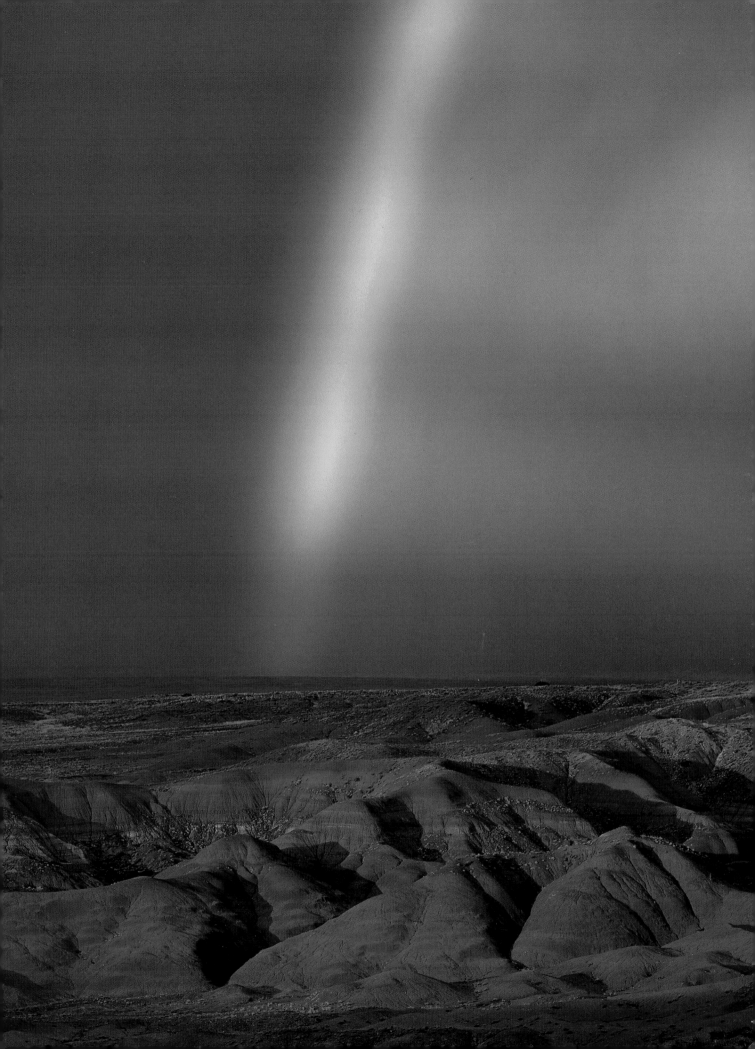

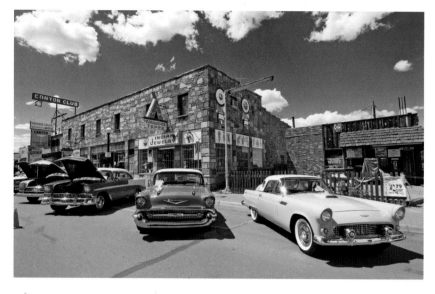

RIGHT: A car show fills the streets of Williams, Arizona, giving the illusion that Route 66 is still the Main Street of America. KERRICK JAMES

Winslow has fared somewhat better. Long before the town became famous through the Eagles hit "Take It Easy," tourists arriving by rail and automobile knew this as an oasis on the high desert plains. One of the crowning attractions from that fabled era was La Posada, one of several Harvey Houses in northern Arizona. After years of abandonment, this architectural gem, built in 1929 for the Santa Fe Railway, again serves guests in an atmosphere of renovated splendor.

West of Winslow, Meteor Crater continues to attract visitors as it has for more than a century. Today, however, the crater is just part of the draw, as there is also an excellent museum dedicated to geology and space travel here. Apollo astronauts trained in the area in preparation for the moon landings. In fact, the area so closely resembles the moon's surface that skeptics thought images of the astronauts on

RIGHT: With a diameter of nearly a mile and a depth of six hundred feet, Meteor Crater is the largest and best-preserved crater on the planet. KERRICK JAMES

OPPOSITE: The Hackberry General Store on Route 66 is an idyllic three-dimensional portrait of life along the highway before the age of the interstate highway. KERRICK JAMES

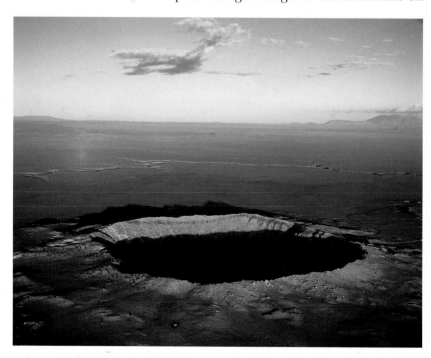

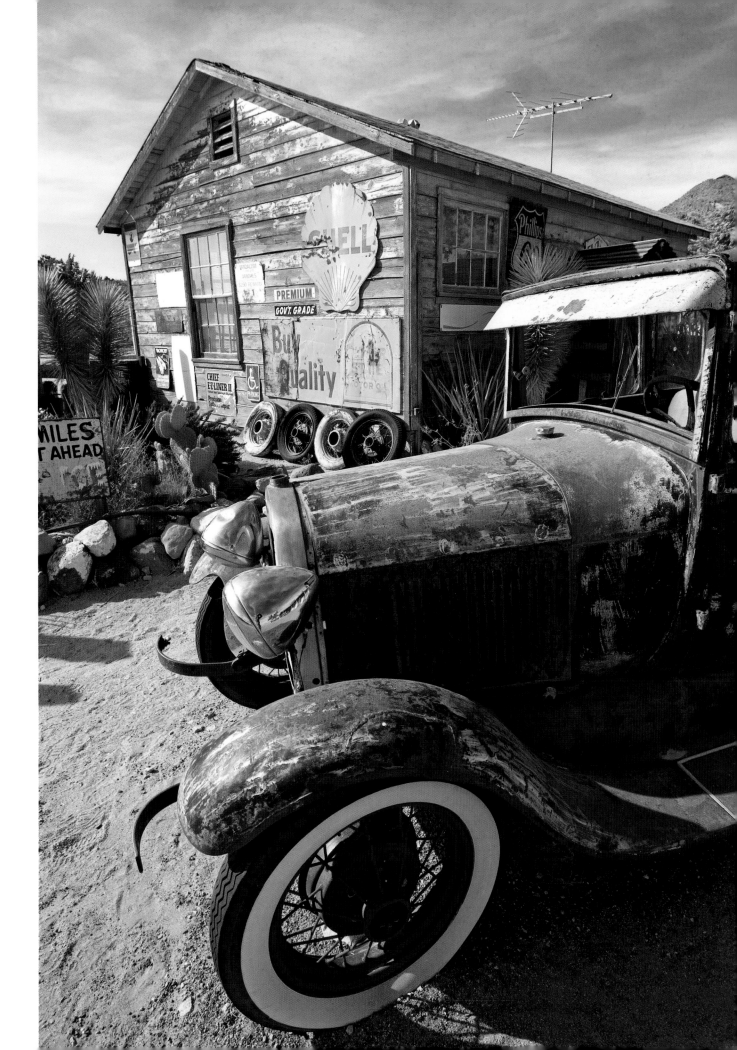

STARDUST IN KINGMAN

FOR NEARLY A CENTURY, Kingman has flirted with fame as well as the famous. With the exception of Andy Devine Avenue—the Route 66 main drag was named after the native son actor known for his portrayals of Old West comic cowboy sidekicks—you won't see much to remind you of Kingman's days in the spotlight.

In 1914, the route for the last of the famous Cactus Derby Desert Classic races from Los Angeles to Phoenix came through here. Among the legendary racers to roar through town that November day were Barney Oldfield, the first driver to run a mile track in one minute flat, and Louis Chevrolet.

In 1928, *Spirit of St. Louis* aviator Charles Lindbergh was a frequent guest at Kingman's Beale Hotel, owned by Andy Devine's father. Lindbergh came to town to oversee the construction of an airfield that would become a stop for forty-eight-hour mail service between Los Angeles and New York. Clark Gable and Carol Lombard tied the knot at the local Methodist church and, as the story goes, spent their first night as husband and wife at the Oatman Hotel.

the moon were actually shot here. Additionally, numerous science-fiction films have used the crater as scenery.

Do not forget to stop in Winona on the drive into Flagstaff. While there, you might consider a short detour to Walnut Canyon National Monument, a series of ancient cliff dwellings built in beautiful canyon walls.

In Flagstaff, under the shadow of the San Francisco Peaks, Route 66 is almost exactly as it once was; traffic and countless survivors from the glory days line the shoulder of the highway. Perhaps the most notable of the latter is the Museum Club, a venerable roadhouse and dance club in the truest sense of the term. Not only is the club on the National Register of Historic Places, but it has been named as one of the top ten roadhouses in the country by *Car and Driver* magazine.

It is possible to follow Route 66 west from Flagstaff for several miles. With a mountain bike or hiking boots, you can follow it even further with the assistance of well-marked trails.

Williams, the last Route 66 community bypassed by the interstate, has re-created itself as a time capsule from when this highway truly was the Main Street of America. An added attraction for railroad buffs is the Grand Canyon Railway that provides a unique way to see the Grand Canyon.

Exit 139 off I-40 is the entrance to the ultimate Route 66 experience in Arizona. Here you can travel more than 180 uninterrupted miles of the Mother Road, much of it along the original alignments of the highway that followed the National Old Trails Highway, which itself followed the earlier Beale Wagon Road.

Among the legendary trails and roads over which pioneers traveled west, the Beale Wagon Road is singular. In 1857, President James Buchanan commissioned Lt. Edward Beale and Major Henry Wayne to survey a feasible route from Fort Defiance, near present-day

Window Rock, to the Colorado River. What set this endeavor apart from similar ones is that it was also an experiment in using camels for military transport in the desert Southwest.

The high points of this drive, to name a few, are the iconic Snow Cap Drive In in Seligman, the Hackberry General Store, and the sharpest grades, steepest curves, and best views found anywhere on the highway in the Black Mountains near Oatman.

Traveling through Arizona from Route 66 is still a grand adventure. When experienced in the context of an event such as the Route 66 Fun Run held every year on the first weekend in May in Kingman, it becomes a memory you'll want to revisit time and again.

ROUTE 38

The Coronado Trail

SANDERS TO CLIFTON

A large portion of this drive follows the Coronado Trail, which first served as a footpath for Native American tribes, then became a horse path for conquistadors and prospectors, and then a wagon trail for pioneers. While admiring the scenic beauty of the desert plains and forests you pass, you can easily imagine nomadic tribes of hunters, gatherers, trappers, outlaws, and homesteaders who traveled along this route.

The first stop, St. Johns, is a small farming community where a stroll through the quiet streets on a Sunday afternoon makes it difficult to guess the year or even the century.

The landscape changes little between St. Johns and Springerville, another little farming community about thirty miles to the south. Here the small one-screen theater still draws a full house on Friday and Saturday evenings, the cafés do some of their best business on Sunday afternoon, and the sculpture, *Madonna of the Trail*, one of twelve placed along the National Old Trails Highway in the 1920s, still casts its shadow across the highway.

Just south of Springerville, the highway ascends quickly, climbing Flat Top Mountain. A few short miles from the summit, there is a breathtaking change in the landscape—from rolling high plains to alpine meadows and forest.

The drive from the quaint mountain resort community of Alpine to Clifton is less than one hundred miles. As most of this route is a series of sharp curves and steep grades that give way to hairpin curves and extreme grades, both up and down, allow three hours to complete the entire journey from Sanders to Clifton. This is an

Route **38**

At Sanders, turn south on U.S. Highway 191 and drive approximately 200 miles to Clifton.

ABOVE: The Phelps Dodge open pit mine that swallowed the picturesque town of Morenci, Arizona, was the second-largest mine in America by the 1950s. KERRICK JAMES

RIGHT: The old jail in Clifton, Arizona—carved from a solid wall of stone in 1881 on the plain above the river—was truly escape-proof. KERRICK JAMES

all-weather road, but as it climbs to some of the highest elevations in Arizona, you should inquire about road conditions in Springerville or Morenci during the winter.

The last few miles into Morenci take you partly through and around the gaping maw of an open-pit copper mine. As interesting as this may be, after driving through miles of scenic Arizona backcountry, the mine appears as an open wound. The old town of Morenci is gone, a victim of the mine that spawned it. Today, it is a modern company-owned town perched at the head of a canyon overlooking its forlorn cousin, Clifton, below.

Clifton is an intriguing community built on the narrow slopes of a deep canyon through which the San Francisco River flows. The picturesque ruins that constitute a large percentage of the old mining town present the illusion that this is a ghost town preserved in an arrested state of decay. Look closer at the well-worn mini-mart, the well-kept

older houses on the hillside, and the restored depot, and you see this town is still home to a hearty few who keep it alive by a thread.

Personally, this is one of my favorite drives in the state and is in my top ten list of drives in the nation. It offers awe-inspiring views and overlooks, deep forests of spruce and aspen, miles of hiking trails, campgrounds, picnic areas, and Hannagan Meadow, a rustic lodge and resort almost wholly unchanged since its opening in 1926. So it's almost impossible not to make several stops on this route, and you could easily spend all day on this mesmerizing journey.

Every season lends something special to this drive. Winter, however, may be the most beautiful, but as elevations on this drive top eight thousand feet, snow and ice can be a problem.

ROUTE 39

Gunmen, Writers, and Range Wars

HOLBROOK TO CAMP VERDE

This drive begins and ends with remnants of Arizona as it was a century ago. On one end are dusty vestiges of the Old West and on the other is a full re-creation of a fort as it was during the Indian Wars of the late 1800s. In between are the land of western author Zane Grey under the beautiful Mogollon Rim and the modern incarnation of Arizona—a sea of strip malls, generic eateries, and resorts.

One hundred twenty years ago, a visiting journalist noted that Holbrook was "too tough for woman or children," and the aptly named Bucket of Blood saloon was the scene of numerous drunken shootouts. Seeking out the multitude of historic sites, such as the Wigwam Motel, in this dusty little town is as easy as picking up a walking tour guide at the historic Navajo County Courthouse at 100 East Arizona Street.

Mushing across the finish line at the annual winter games in Sunrise is not a sight one expects to see in Arizona. KERRICK JAMES

Route **39**

From Holbrook, drive south on U.S. Highway 180/State Route 77 for 5 miles to the junction of State Route 377 and continue south 36 miles. At the junction with State Route 277, turn west on Route 277 and drive 7 miles to Heber. Then continue west on State Route 260 to Payson (55 miles). In Payson, turn north on State Route 87/260. Follow Route 260 west to Camp Verde. The approximate distance of this drive is 140 miles.

HOLBROOK SHOOTOUT

IN THE 1880s, Pleasant Valley, a land of grassy meadows and towering pines with ample water in the shadow of the Mogollon Rim, was the scene of a simmering feud between the Graham and Tewksbury families. By 1887, the feud had escalated to a full-blown shooting war.

The violence spilled over into Holbrook when Andy Cooper rode into town boasting of killing two men in Pleasant Valley. Unaware of this, Commodore Perry Owens, sheriff of Apache County, rode to the house Cooper was staying in to serve a warrant for horse stealing. Cooper, believing Perry was there about the murders, decided it was time to fight or die.

Cooper underestimated Owens' prowess. Cooper cracked the door, raised his revolver, and fell to the floor mortally wounded. Owens had shot him through the door.

Relatives of Cooper and fellow outlaws took up the fight. When the smoke cleared, two men and a fourteen-year-old boy who had joined the fight were dead. Owens, unscathed, became a legend of the Old West.

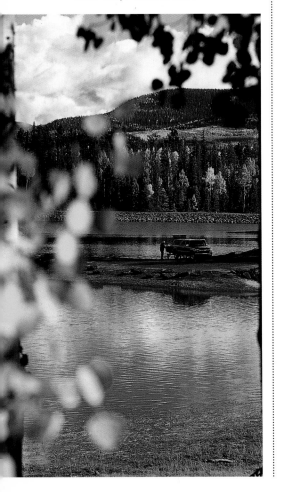

A-1 Lake on the Mogollon Rim is just one of many jewels that lure residents and visitors to the land of Zane Grey. KERRICK JAMES

South of town, the old steel bridge that spans the often dry bed of the Little Colorado River is a portal into a land of grassy hills little changed since this was the center of vast cattle empires. The views from the crest of each hill are the same ones famed lawman Commodore Perry Owens would have seen when keeping the peace here in 1887.

With the increase in elevation, the grassy hills slowly give way to stands of scrub oak and juniper, which in turn give way to sky-high pines. This is the edge of the Mogollon Plateau with the largest stands of ponderosa pines in the world.

With the booming city of Phoenix basking in the sun just a few hours to the south, the small mountain communities of Heber, Overgard, and Payson are fast becoming popular spots for those wanting to escape from the heat. Weekend cabins, resorts, and their supportive infrastructure have, to a large degree, transformed these communities into long strip malls. Like colorful wildflowers on a sterile hillside of stone, the vestiges of the old, quiet frontier communities stand in stark contrast. For the best glimpse of what once was, visit the Rim Country Museum in Payson, which includes the first forest ranger station in Payson and a replica of the historic Herron Hotel, which burned in 1918. Payson is also home to the world's oldest continuous rodeo, established in 1884.

Near Payson are the Shoofly Village Ruins, a clear indication that these forested hills in the shadow of the Mogollon Rim have nurtured people for millennia. Excavations of this small village indicate inhabitation to A.D. 1000.

Climbing back onto the Mogollon Plateau through the small towns of Pine and Strawberry, you will be treated to wonderful views and, in the summer months, cool pine-scented breezes. These towns also provide a glimpse into the Arizona of just a few decades ago, before the population boom began in earnest.

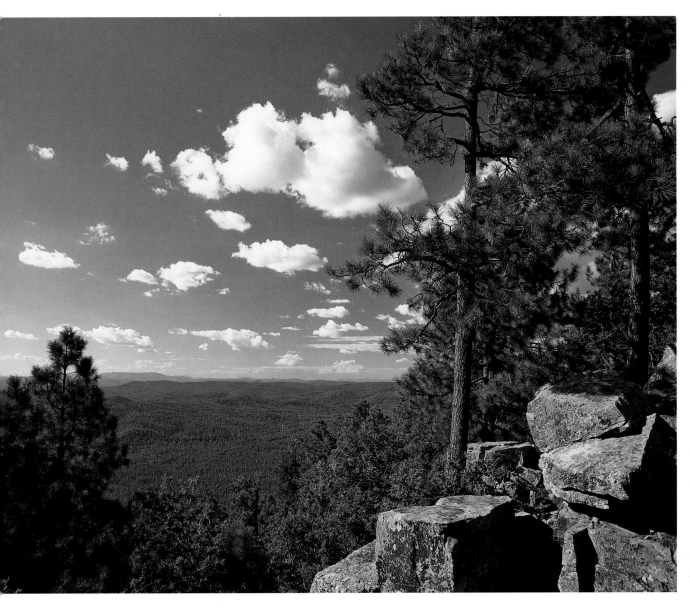

Midway between Payson and Strawberry, look for the turnoff to the Tonto Natural Bridge State Park. The centerpiece of this stunning park is, of course, the bridge itself, a 400-foot-wide travertine arch that shades Pine Creek 183 feet below.

The descent from the Mogollon Plateau to the lush Verde River Valley and the desert is rapid. Each mile offers beautiful views.

The historic district at Camp Verde, encased by modern, urban sprawl, is surprisingly charming. The highlight of any visit must be Fort Verde State Historic Park, a wonderful combination of well-preserved original structures and faithful re-creations that present the fort as it was in 1865.

ABOVE: The towering ponderosa pines make the view from the Mongollon Rim one of the most surprising and scenic ones in Arizona. KERRICK JAMES

LEFT: Calf wrestling is just one of the traditional events at "The World's Oldest Rodeo," held every August in Payson, Arizona. KERRICK JAMES

Arizona / **165**

ROUTE 40

Around the Mountain and through the Land Time Forgot

FLAGSTAFF LOOP

Route 40

Follow U.S. Highway 89 north from Flagstaff to Cameron and the junction with State Route 64. Turn west on Route 64 and follow it through Grand Canyon National Park and then south toward Williams. At the junction of U.S. Highway 180, turn south on U.S. 180 back to Flagstaff. The approximate distance for this drive is 90 miles.

After battling the traffic in Flagstaff on old Route 66, you'll find rural landscapes in the shadow of the San Francisco Peaks to be a breath of fresh air. Almost as quickly, the highway breaks from the forest into a high desert plain.

Don't miss the turn for the small loop drive to Wupatki National Monument, just twelve miles north of Flagstaff on U.S. Highway 89.

When viewed against the backdrop of the snow-covered San Francisco Peaks, these large redrock Pueblo Indian ruins are entrancing. Two other attractions on this loop drive are worth seeing. The first is Sunset Crater Volcano National Monument, a towering volcanic cinder cone, and the second is Painted Desert Vista, an overlook that presents panoramic views of the vivid colors of the Painted Desert.

The drive west on State Route 64 from Cameron to the Grand Canyon is sixty miles of nonstop visual overload. The gorge of the Little Colorado is a real jaw dropper. The Anasazi ruins at Tusayan are incredible, and the vistas at Desert View could easily have been the source of the term awe-inspiring, as they reveal some of God's finest handiwork.

For more than a century, artists in oils, film, and words have attempted to translate the beauty of the South Rim of the Grand Canyon, to no avail. All fall short, as it is impossible to capture the depth, the ever-changing array of colors, and the play of shadows that transforms every crevice.

Hiking opportunities run the gamut from wheelchair-accessible paved paths along the rim to the strenuous 9.3-mile Bright Angel Trail that descends to Phantom Ranch and the Colorado River more than a mile below. Lodging opportunities are equally diverse, but as the canyon is the top attraction in the state, you need to make reservations months in advance.

The first miles of the drive south back toward Flagstaff seem anticlimactic after seeing one of the greatest wonders of the world. But when you turn south on U.S. Highway 180, the scenery undergoes a dramatic transformation from high grassy plains to thick forests of ponderosa pines. As the road climbs even higher into the mountains, white aspen and alpine meadows begin to appear.

OPPOSITE: The awe-inspiring view of Wukoki Ruin in Wupatki National Monument, with the San Francisco Peaks serving as the backdrop. KERRICK JAMES

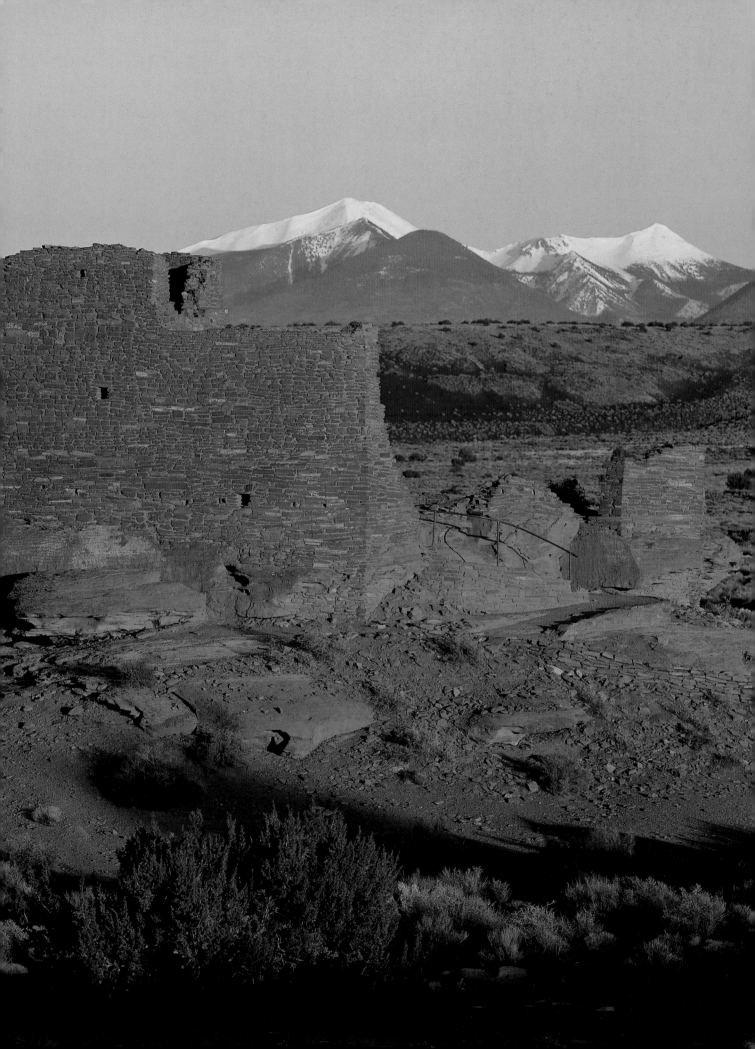

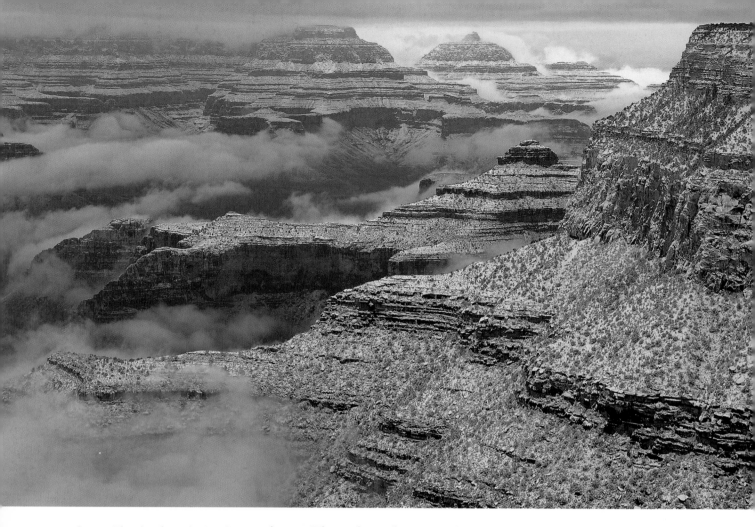

ABOVE: The view from the South Rim of the Grand Canyon is always spectacular, but when dusted in winter snows, the landscape has a special majesty. KERRICK JAMES

BELOW: The mouth of the Colorado River in the Grand Canyon offers endless opportunities for exploration and adventure. KERRICK JAMES

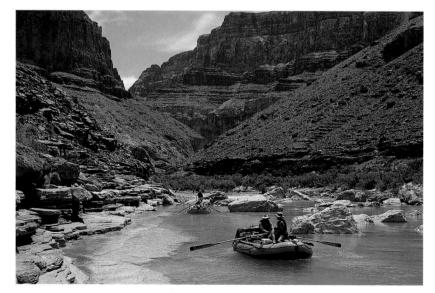

Throughout the route, the gorgeous beauty of the San Francisco Peaks looms in the background. The most notable mountain in the range is Humphrey's Peak, the highest point in Arizona with a summit elevation of 12,633 feet. During the summer, a sky ride provides access to the 11,500-foot level of the mountain. In the winter, these slopes become a premier ski destination.

Snows come early and are often deep here. On occasion the road is even closed, but that is to be expected anywhere mountains support a world-class ski resort such as the Arizona Snowbowl.

On the west end of Flagstaff, accessed by U.S. 180, are two more places worth visiting: The Lowell Observatory and the Museum of Northern Arizona. The observatory is where astronomers discovered the dwarf planet Pluto. The museum has a vast collection of more than five million pieces, covering most aspects of the area's geology and rich history.

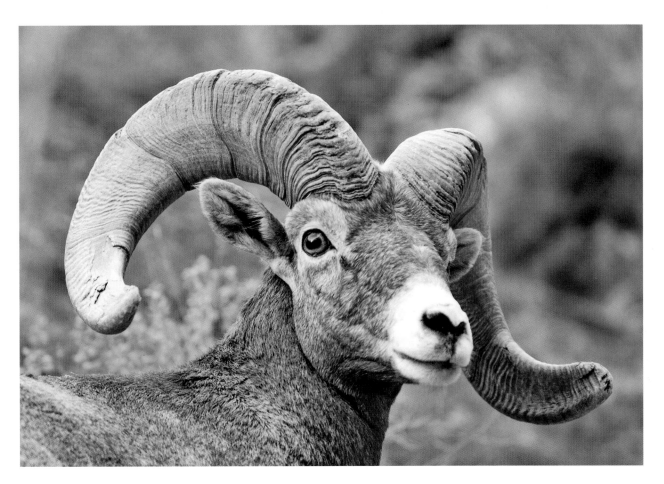

Above: Big horn sheep are a common sight in the Grand Canyon and along the Bright Angel Trail, which provides access to the Colorado River. KERRICK JAMES

Below: A vintage postcard showcases the view of the Kaibab suspension bridge, built in 1921, across the Colorado River. AUTHOR'S COLLECTION

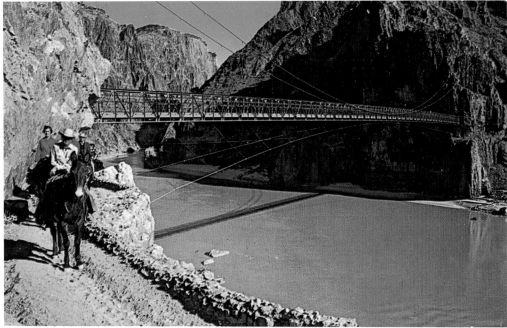

Kaibab Suspension Bridge - Colorado River Grand Canyon, Arizona

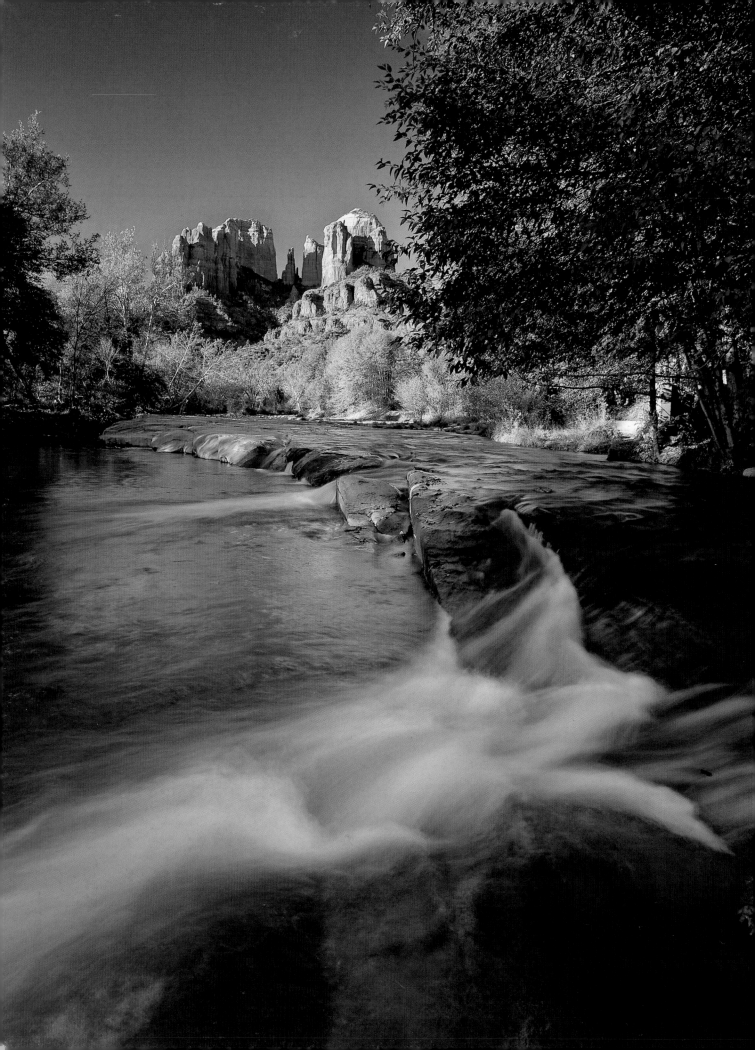

ROUTE 41

Arizona's Finest

FLAGSTAFF TO PRESCOTT

The thirty-mile drive from Flagstaff to Sedona through the Oak Creek Canyon is often listed by magazines and newspapers as one of the top ten drives in the nation. In 2003, in fact, *USA Weekend Magazine* called this *the* most beautiful place in the nation, saying that the area's "canyons, wind-swept buttes, and dramatic sandstone towers embody the rugged character of the West—and the central place that character holds in our national identity." You'll certainly see some of the most stunning redrock buttes and mesas anywhere.

For more than a century, artists and photographers have vainly tried to capture the singular beauty of the Sedona area and Oak Creek Canyon. The television and film industries have also frequently used the colorful buttes and mesas as backdrops, making this one of the most well-known sights in the state.

One of the best places to visit in Sedona is Tlaquepaque, a replica of a Mexican village built in the Spanish colonial style with stucco walls, cobble-stoned walkways, and magnificent arched entryways.

Route 41

This drive follows Alternate State Route 89 southwest from Flagstaff, through Sedona, to the junction with Route 89 about 6 miles north of Prescott. The approximate distance for this drive is 90 miles.

ABOVE: A biplane soaring over the redrock country near Sedona adds a whimsical touch to this stunning landscape. KERRICK JAMES

OPPOSITE: The Cathedral Rocks near Sedona are among the most photographed landmarks in the state of Arizona. KERRICK JAMES

A LAWMAN'S LAST STAND

CLARKDALE, BELOW JEROME, is a thriving community, experiencing the same growing pains that many small Arizona towns are today. With new businesses and homes popping up everywhere here, you'd never know this was the place of the last shootout by storied frontier lawman Jim Roberts.

On June 21, 1928, Earl Nelson and Willard Forrester, two outlaws on the run in Oklahoma, held up the Bank of Arizona in Clarkdale, taking $50,000. Just as they got into their getaway car, they were spotted by Roberts, a seventy three-year-old survivor of the infamous Pleasant Valley War in 1887 and former peace officer in several woolly territorial towns, including Congress and Douglas.

Roberts, well known for his coolness under fire and deadly aim, calmly stepped into the street, drew his Colt revolver, and fired one shot into the fleeing car. The driver, Forrester, slumped over the wheel with a bullet wound to the head. The car had barely come to a halt before Nelson meekly stepped out with his hands over his head.

ABOVE: Watson Lake is a hidden treasure often overlooked by visitors to the vacation paradise of historic Prescott. KERRICK JAMES

BELOW: The city of Jerome is in itself an engineering marvel that seems to defy gravity as it perches precariously on the slopes of Cleopatra Hill. AUTHOR'S COLLECTION

Conceived as an artist community, Tlaquepaque is home to a number of art galleries, specialty shops, and studios. It is not uncommon to see a sculptor finishing his or her latest piece or a glassblowing demonstration during your visit.

The towns of Cottonwood and Clarkdale boast delightful historic districts, but both communities have succumbed to the onslaught of Arizona's explosive growth. Jerome is another matter.

A century ago, Jerome—perched precariously on the slopes of Cleopatra Hill overlooking the Verde River Valley and the redrock country of Sedona—was one of the largest communities in the state. With the closure of the mines in the 1950s, the community began a slide into oblivion.

In the late 1960s, artists and eccentrics began discovering the old town and its million-dollar views. Today, Jerome is a pleasant mix of bed and breakfasts operating in vintage homes and old businesses, fine dining, quiet burger shops, and art galleries, all set among picturesque abandoned buildings and ruins sliding down the mountainside.

The road from Cottonwood through Jerome and over Mingus Mountain has seen little change in more than a half century. The twists and turns from the valley and through Jerome are so sharp that some curves have mirrors mounted to the trees and rock walls, so drivers can see what is coming around the corner.

Prescott is unique in that its historic district—with courthouse square, federal courthouse, whiskey row, and business district—has not been re-created. Even though the community has experienced urban sprawl and astounding growth in recent years, Prescott has never fully succumbed to the era of the strip mall and suburbia. The Hotel St. Michaels, facing the courthouse square, has served guests for more than a hundred uninterrupted years. The Palace Saloon on historic Whiskey Row has been wetting whistles even longer. The home of community festivals, microbreweries, bookstores, and Mexican restaurants, Prescott's historic district has always been the heart of the community.

No visit to Prescott is complete without a stop at the Sharlott Hall Museum Complex. Here you'll find a botanical garden, art gallery, and collection of historic buildings, including the log-constructed territorial governor's home.

Vintage railroads, fine dining, unique lodging opportunities, and some of the most spectacular scenery in the United States not only make this a delightful route to follow, but also provide for a spectacular vacation.

ROUTE 42

A Glimpse of Eden
ROUTE 66 TO SUPAI

If you drove every mile from Chicago to Santa Monica on old Route 66 and took every side road you came to, you would never find another detour like this. On this trip, less than seventy-five miles separates the Mother Road from the Garden of Eden.

The route begins just west of historic Grand Canyon Caverns, a Route 66 icon. This roadside attraction has everything you're looking for—a limestone cavern 210 feet underground that you can tour, kids' play areas, gardens, a restaurant and shop, plus motel lodging and an RV campground.

Initially the drive, though scenic, seems rather mundane as you pass through gentle rolling hills studded with cedar and juniper

Route 42

From U.S. Highway 66 about 30 miles west of Seligman, look for the turnoff to Indian Highway 18. Follow Indian Highway 18 north 60 miles. The last 8 miles to Supai require hiking, renting a horse, or taking a helicopter. The series of waterfalls, including the world-famous Havasu Falls, are a couple of miles further.

One of the most gorgeous places in Arizona is Havasu Falls on the Havasupai Reservation, an idyllic wonderland of towering canyon walls and thundering waterfalls.
KERRICK JAMES

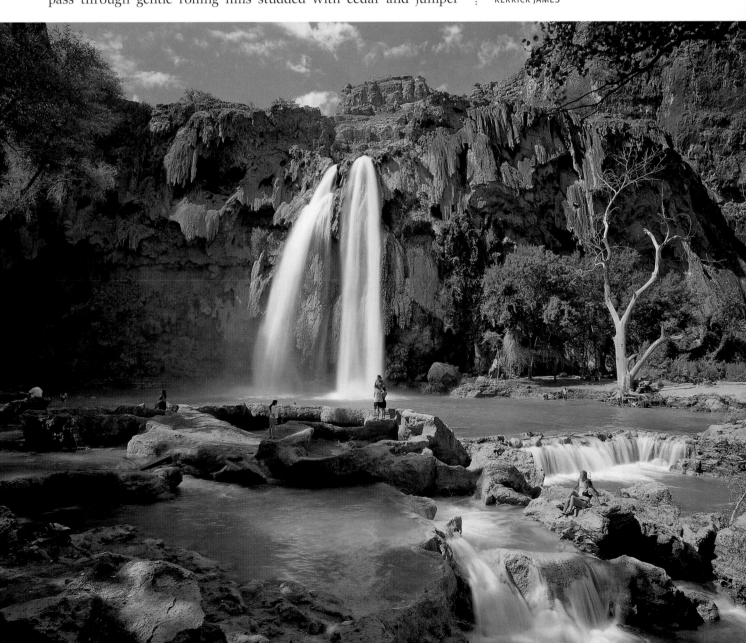

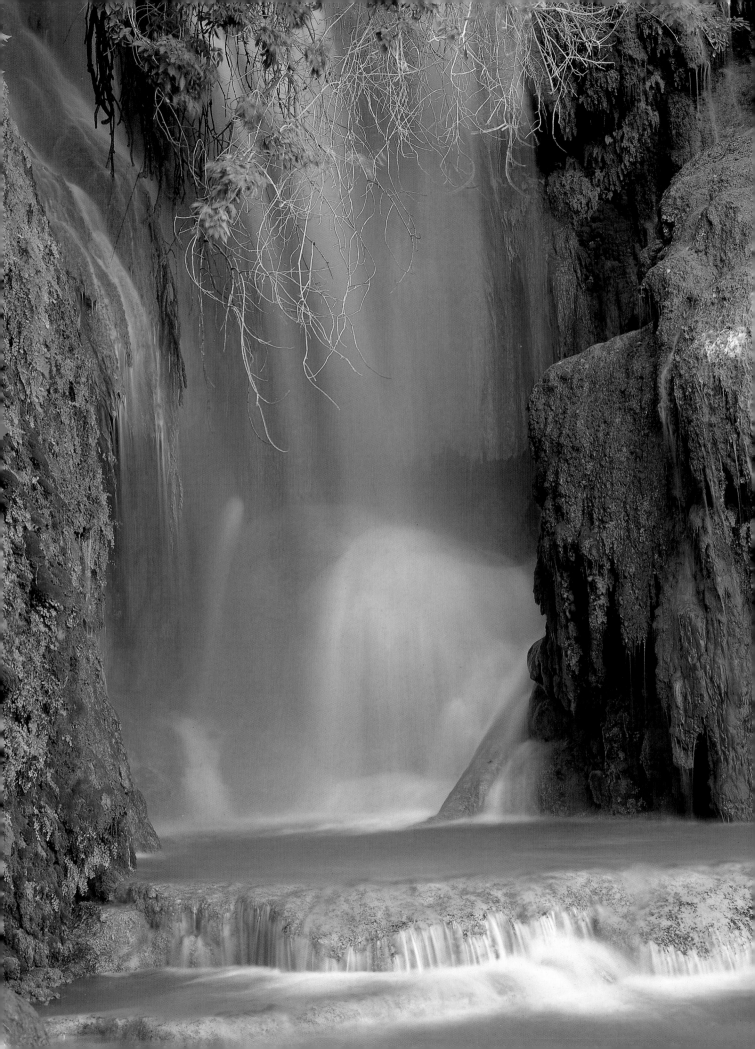

with the Aubrey Cliffs on the horizon. Almost without notice, you begin to ascend, into a landscape of towering pines, deep meadows, and sweeping vistas.

Though tens of thousands of visitors travel this road to Supai annually, it still feels off the beaten path. Wildlife such as deer, turkey, elk, and coyote are seen often on the shoulder of the road or in the shadows under the trees.

The picturesque ruins of Frazer Wells momentarily break the illusion of traveling through uncharted territory. Until the 1960s, this remote woodcutter's camp marked the end of the road, and even with completion of the road to Hualapai Hilltop, this didn't become an all-weather highway until the 1970s.

Shortly after the ruins have faded from view in the mirror, the highway passes from the shadows of the pines to an open plain. This is open-range country where the cattle have the right of way, so drive accordingly.

Abruptly, the plains give way to deep, narrow canyons, and the road clings precariously to the walls through a series of twists and turns. Almost as quickly, the highway vanishes into a vast parking lot suspended above a deep canyon on a shelf of rock. Here, bright, clean rental cars intermingle with dusty trucks, livestock trailers, pack trains, cursing Indian muleskinners, and gawking tourists. But beyond is a scene of jaw-dropping beauty; this is Hualapai Hilltop, the end of the road but not the end of the adventure.

ABOVE: Visitors to Grand Canyon West can experience many aspects of Native American traditional life, including the sweat lodge at Hualapai Village. KERRICK JAMES

OPPOSITE: Navajo Falls on the Havasupai Reservation is the first of a series of waterfalls that are the reward for the long hike from road's end. KERRICK JAMES

Arizona / **175**

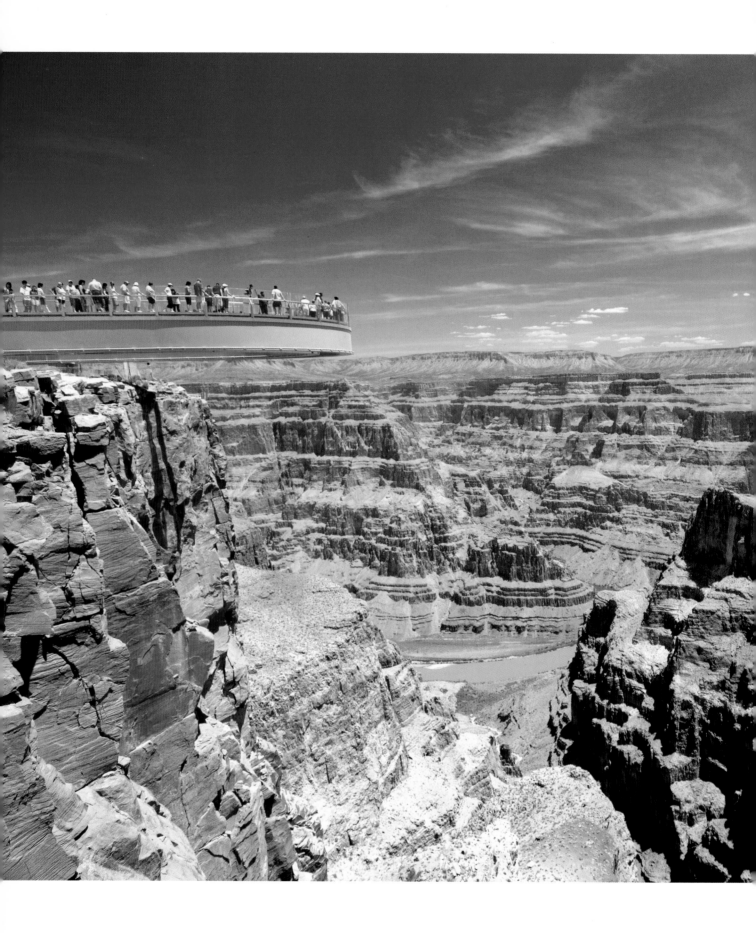

ABOVE: A 1938 travel poster promoting one of the greatest natural wonders in the world.
LIBRARY OF CONGRESS

LEFT: The Grand Canyon Sky Walk at Grand Canyon West on the Hualapai Reservation provides visitors with a one-of-a-kind opportunity to experience one of God's grandest creations. KERRICK JAMES

From here, it is just over eight miles to the village of Supai and another four miles to the first in a series of the most scenic waterfalls on earth. This is not an exaggeration. To continue from this point, you will need to proceed on horseback with a guide, take a wild helicopter ride, or hike through a long, dusty maze of deep canyons. Whichever you choose, permits are required and reservations recommended.

The village of Supai on the Havasupai Reservation is one of the most remote communities in America. Here, mule trains still transport the mail, as well as a large percentage of supplies for the village and its two general stores.

Supai is also one of the most beautiful places imaginable. The village is set in a valley surrounded by towering redrock walls and by waterfalls that dominate the canyon between the village and the Colorado River. Each of these falls is more spectacular than the one before. One, Mooney Falls, thunders into a turquoise blue lagoon from a height greater than that of Niagara.

The trip to Supai is more than a mere drive. It is time travel of the highest order, from the glory days of the tail fin and the Main Street of America to the beginning of time in the land that time forgot.

ROUTE 43

Adventure on Arizona's West Coast

JUNCTION INTERSTATE 40/STATE ROUTE 95

TO SAN LUIS

This nearly two hundred–mile odyssey along the western border of Arizona will truly show you the diversity of Arizona's landscape. Here as you follow the Colorado River south toward the Mexican border, you will pass beautiful lakes, thriving marshlands, and a desolate Old West prison that once housed some of the state's most notorious criminals.

You'll begin by getting off Interstate 40 at the junction for State Route 95. As you head south, the freeway's congestion will become a distant memory when you see Lake Havasu dominate the horizon ahead. The descent to the lake and the community of the same name is a fast but pretty one.

The crown jewel here is, of course, the lake's deep blue waters. This recreational paradise is a delight for swimmers, boaters, water-skiers, sailing and canoeing enthusiasts, as well as anglers. Adding

Route 43

From the junction of Interstate 40 and State Route 95, follow Route 95 south to the junction with U.S. Highway 95 at Quartzsite (also near the junction of Interstate 10). Then continue south on U.S. 95 to San Luis. This drive is approximately 195 miles.

to the lake's appeal is the picturesque London Bridge. The bridge once traversed the Thames River in England but was decommissioned, sold, dismantled piece by piece, and reconstructed here in the early 1970s. An English-style village surrounds the bridge, but in recent years its buildings have been in decline. Thankfully, the city has now begun to restore them to their former luster.

Just south of Lake Havasu City, the highway skirts the Bill Williams National Wildlife Refuge, a wild marsh at the confluence of the Bill Williams and Colorado rivers. This oasis is more than a rare wetland in the surrounding desert; it is also a pivotal location in the state's history.

Juan de Oñate camped near here on his expedition from New Mexico to Yuma in 1604. American fur trappers stopped here as early as 1820 to trap beaver. In 1854, the first railroad survey in the Arizona Territory evaluated this location for a river crossing. And until 1865, the community of Aubrey Landing served as the northern-most stop for steamboat traffic on the Colorado River.

The next stop along this route is Parker Dam, the deepest dam in the world. More than two-thirds of the dam is built below the riverbed and the Parker Strip, a ribbon of businesses that caters to tourists as well as locals. The ten-mile strip and the community of

LEFT: Lake Havasu City, home of the London Bridge, is the crown jewel of Arizona's west coast.
KERRICK JAMES

BELOW: A boat under the London Bridge in Lake Havasu City, an idyllic scene in this desert oasis.
KERRICK JAMES

LEFT: A surprising chapter in the history of the Yuma Territorial Prison, built in 1876, began in 1910 when the facility was transformed into Yuma High School.
KERRICK JAMES

Parker are fast becoming a premier water playground in the summer and a golfing destination in the winter.

The history of this area is a fascinating one, best discovered at the Parker Historical Society. Here the construction of the dam is chronicled extensively in photographs, and there are displays about local Native American artistry. You can also see artifacts from the World War II Japanese internment camp that was located at nearby Poston.

Quartzsite is maybe a bit bigger than a four stoplight town, but not by much. You would never know this, though, if you drove through in January or February. Then the place swells from a population of around three thousand to tens of thousands, during what has become the world's largest mineral show and swap meet.

From Quartzsite to Yuma, this drive heads through a sun-baked desert under deep blue skies. The Chocolate Mountains line the western horizon.

Yuma has joined many Arizona communities in the rush to become cosmopolitan. Yet a few important pieces of its history remain, the most notable being its territorial prison.

Built on a bluff overlooking the Colorado River in 1876, the prison held some of the West's most famous outlaws—convicted of everything from murder to polygamy—before its closure in 1909. From then until restoration efforts began in 1941, the old prison served as the local high school and, when abandoned, eventually became home to vagrants. Today, the old prison and museum is a fascinating link to Arizona territorial history.

The last miles of this drive take you through the nation's winter vegetable garden. Farms, farms, and more farms can be found here. The final stop is the border town of San Luis, which resembles a Mexican village much more than an American small town.

It's best not to travel this route during the summer, when the temperatures in this region are among the highest in the nation (often above 110 degrees Fahrenheit). Even evenings offer little respite from the stifling heat.

OPPOSITE: Moonrise over the rugged Kofa Mountains, site of a small gold rush in 1896.
KERRICK JAMES

7221. Overland Limited at Yuma, Arizona.

LEFT: With the arrival of the railroad, Yuma began promoting itself as a cosmopolitan community with a climate that is pleasant for most of the year, "save for a short period in midsummer," according to this postcard.
AUTHOR'S COLLECTION

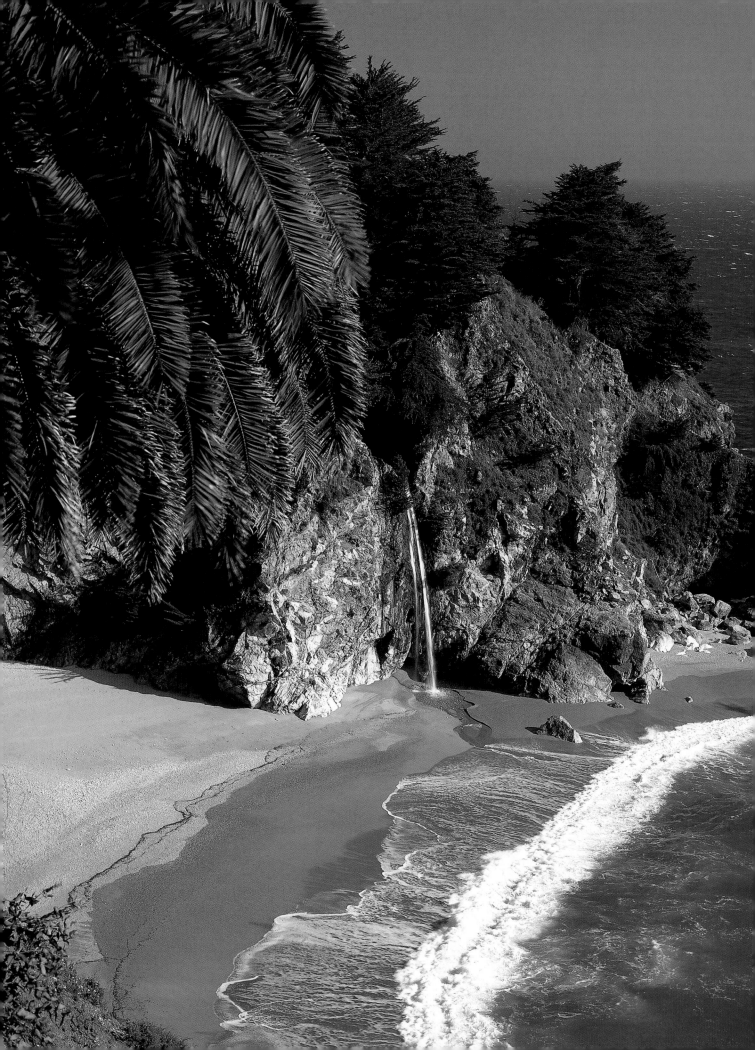

PART VII

California

A Land of Unexpected Discovery

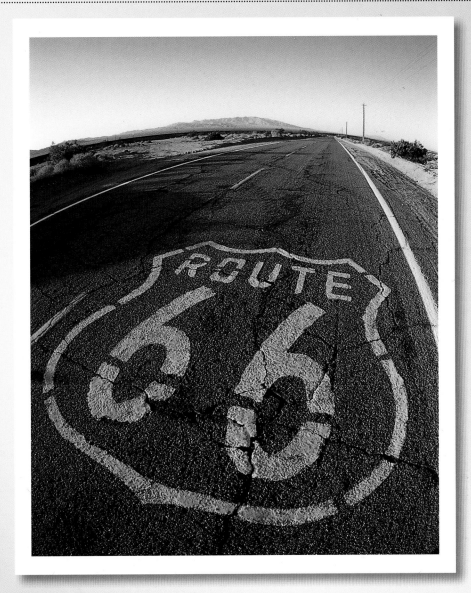

ABOVE: A pavement marker near Essex, California, leaves no room for doubt as to which legendary highway this is. KERRICK JAMES

OPPOSITE: Pacific Falls at Big Sur, California, is just one of the breathtaking places found along the rugged California coast. KERRICK JAMES

California—the promised land for *The Grapes of Wrath*'s Joad family and those fleeing the Dust Bowl, the end of the rainbow for those getting their kicks on Route 66. Can one state be the land of dreams for so many? With its varied landscapes and interesting mix of people, the answer to that question again and again is yes.

Here you'll find blistering deserts, snow-covered mountains, and sun-kissed beaches all within a few hours' drive of each other (well, it may take longer, depending on traffic, the bane of the southern California coast). You'll also discover a cornucopia of cultures, a rich tapestry of history, and a smorgasbord of attractions.

Slicing through the best, and worst, of southern California is Route 66. It travels across the stark plains of the Mojave Desert, through the San Bernardino Mountains, into the megalopolis of Los Angeles, and on to the Pacific Coast.

Short drives north and south of the old highway will show you the best this part of California has to offer. The stunning beauty of the Mojave National Preserve, Death Valley, Joshua Tree National Park, and the California coast are all but a short distance away.

Allow your imagination free rein for this part of the adventure. Disneyland and Santa Catalina Island, Malibu and the San Gabriel Mountains, and old town San Diego and the stunning beauty of Big Sur are just a few of the places where your mind can take you to another world.

Seeking the treasures and hidden spots on Route 66 in California is a wondrous journey. However, as with the entire roadway from Chicago to this point, the old highway here is merely a portal for those with a hunger for the very essence of what makes America the great nation it is.

ROUTE 44

Into the Setting Sun
ROUTE 66 IN CALIFORNIA

One of California's most recognizable Route 66 landmarks appears at the state's easternmost point. From Interstate 40, you can see the original Route 66 steel-arch bridge spanning the Colorado River, which forms the border between California and Arizona. Now used as a gas pipeline, the bridge is the same one seen in the classic film *The Grapes of Wrath*.

In nearby Needles, you'll find many Route 66–era motels—some still operating, others abandoned—as well as the spectacular

Route 44

Segments of Route 66 found near Needles and in Needles are well posted, but the longest drivable sections begin at Exit 133 on Interstate 40 west of Needles. From here, drive north on U.S. Highway 95 and turn west on historic Route 66 at Searchlight Junction. Continue to Ludlow. From Ludlow to Barstow, the highway is largely an access road, but there is adequate signage. From Barstow to Victorville, follow Route 66 through Helendale and Oro Grande; then continue through Victorville and Hesperia to Cajon Junction. Again, the highway becomes segmented here, but there are still large sections in Cajon Pass. Follow Cajon Boulevard to Fifth Street in San Bernardino. Continue west on Foothill Boulevard to Alosta Avenue. Then return to Foothill Boulevard and go to Colorado Boulevard, the Pasadena Freeway, and then Santa Monica Boulevard. Signage makes it relatively easy to seek out remaining Route 66 segments.

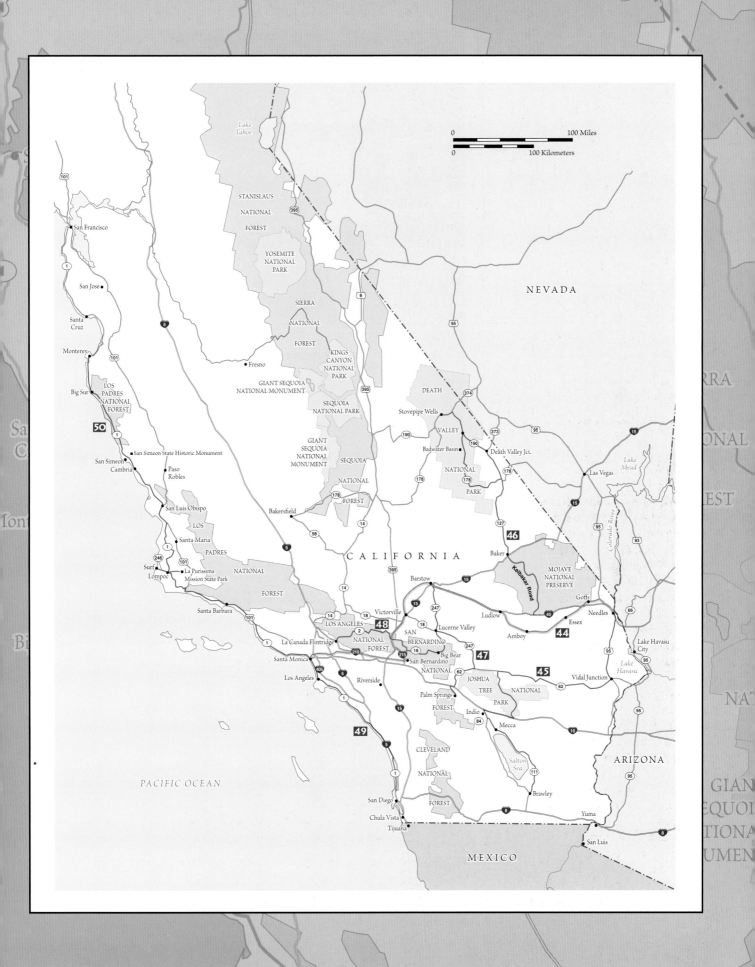

The Roy of Roy's Motel & Café in Amboy, California, was Roy Crowl, who built the initial complex in 1938. The landmark sign was added in 1959. KERRICK JAMES

former Harvey House, known as El Garces, on the town square. It is currently under renovation.

The road to Goffs, for those unfamiliar with the desert, can be unnerving. This desolate landscape does have a raw and enchanting beauty to it—one you must see to really appreciate. After traveling the next several miles of this trip, you, too, might become entranced.

Goffs never amounted to more than a wide spot in the road, and today it is even less than that. Back in Route 66's heyday, it was a little oasis for weary travelers. Now the only things that will stand out are Goffs' 1914 schoolhouse and the East Mojave Cultural Center, with extensive archives, maps, and photographs detailing the Mojave Desert's history.

The section of the Mother Road through Essex and Amboy follows the predecessor of Route 66, the National Old Trails

Highway (established in 1912). Though it was a rough gravel road back then, this was the route the road-racing legends Barney Oldfield, Louis Chevrolet, and Louis Nikrent followed in the 1914 Desert Classic Cactus Derby. This was the last in an annual series of races from Los Angeles to Phoenix (the first was in 1909).

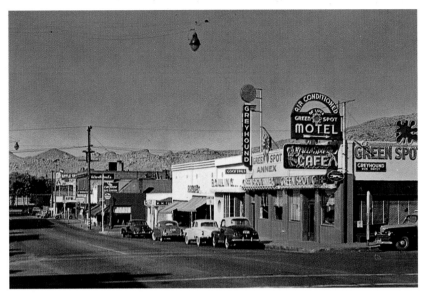

Essex, Cadiz, and Amboy are dusty, sun-baked towns in a raw land that at times has a sterile, lunar look to it. If you need a break from the endless horizon, stop at the Amboy Crater. This volcanic cone provides spectacular views of the surrounding desert, as well as an opportunity to stretch your legs.

At Ludlow, the old highway zigs and zags across Interstate 40 all the way into Barstow. Along the way are more dusty towns, many of which predate Route 66 by decades.

In Barstow, the modern has crowded out much of roadside Route 66, but in pockets, a surprising number of businesses remain. Many retain their vintage neon. You'll also pass by the El Rancho Motel and Restaurant and the Route 66 Motel, icons from the days when Barstow's Main Street was like the main drag through every Route 66 town.

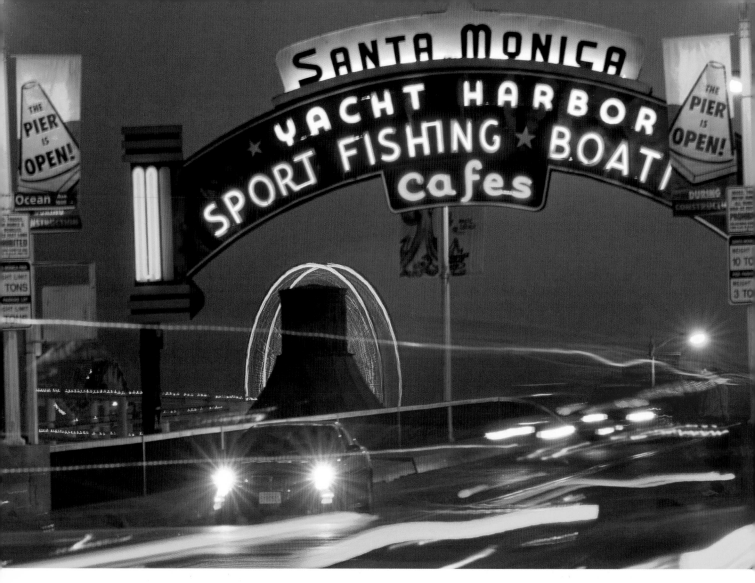

The Santa Monica pier is a delightful urban oasis that becomes a wonderland of lights after sunset.
KERRICK JAMES

Follow Route 66 south to Victorville and you'll be back on the path of the National Old Trails Highway. Neglect, abandonment, vandals, and the harsh desert climate have claimed most of the businesses that first met the needs of Route 66 travelers here. However, in a few places, such as Oro Grande, you will come across Route 66 survivors, like the Iron Hog Saloon (formerly the Lost Hawg) and Mojave Joe's Trading Post.

Shortly before reaching Victorville, Route 66 crosses the Mojave River on a 1930s-era double-truss bridge. Nearby you'll see Emma Jean's Truck Stop, a small roadside café still serving hearty meals to travelers passing through.

Route 66 enters Victorville on D Street and then follows Seventh Street. You'll see tangible links to the Main Street of America, including the California Route 66 Museum and the Green Spot Motel. The latter was a haven for celebrities filming on location in the high desert long before the era of the tail fin. It is currently undergoing renovation.

The interstate highway has truncated the various alignments of Route 66 on both sides of the Cajon Pass, but from San Bernardino to Palisades Park in Santa Monica, the road's end, Route 66 is largely intact. Historic sites abound—in San Bernardino there is the vintage

California Theater, and Rancho Cucamonga is home to Dolly's Diner and the Sycamore Inn.

The *Madonna of the Trail* statue, one of twelve placed along the National Old Trails Highway in 1920, still watches over visitors to Upland. The Colorado Street Bridge in Pasadena has served motorists for more than seventy years.

To drive Route 66 across the Mojave Desert and into the metropolis of greater Los Angeles is an increasingly rare opportunity to experience the highway as it was, not only in 1958 but in 1938. As you drive across the vast expanses of desert, imagine the apprehension of those who crossed here in well-worn vehicles, with radiators steaming in the heat. As you battle the traffic in the city, remember this is well-traveled Route 66 as it once was in every town along its route from Chicago to Santa Monica.

ROUTE 45

A Raw and Rugged Land

NEEDLES TO BRAWLEY

If the thought of driving miles upon miles across a near trackless wasteland of sun-burnt rocks where even cactus don't grow makes you apprehensive, you may want to avoid this drive. If, however, you enjoy cruising through a vast, awe-inspiring landscape that man has yet to conquer, this is a drive for you.

Needles and the surrounding Colorado River Valley are often the hottest places in the nation for most of the summer. Temperatures often exceed 125 degrees. So the best time to travel through here is in early spring, late fall, or winter. Then you'll actually enjoy the heat.

The first leg of this drive, across the wide Chemehuevi Valley, leaves plenty of time for quiet meditation, as there are few distractions. Soon you may come to feel that the sheer magnitude of the landscape here is stunning. To enhance the experience, try driving part of this route on a clear night, when the stars seem close enough to touch.

A stream of water in such a harsh environment can often be mistaken for a mirage, even if that stream is surrounded by concrete banks. But the Colorado River Aqueduct that parallels the highway for several miles west of Vidal Junction is no illusion; it is a key component in the population growth of southern California.

The Oasis Visitor Center provides a wealth of information about the area's history and attractions, most notably Joshua Tree National

Route **45**

From Needles, drive east on Interstate 40 to Exit 144. There turn south on U.S. Highway 95. Drive 47 miles south to Vidal Junction. At the junction with State Route 62, follow Route 62 west 94 miles to the Oasis Visitor Center. There turn south into Joshua Tree National Park and continue through the park to Interstate 10. Turn west on I-10 and drive 20 miles to Exit 145. Turn south on State Route 86. At the junction with State Route 111, turn south and continue on Route 111 to Brawley (about 60 miles).

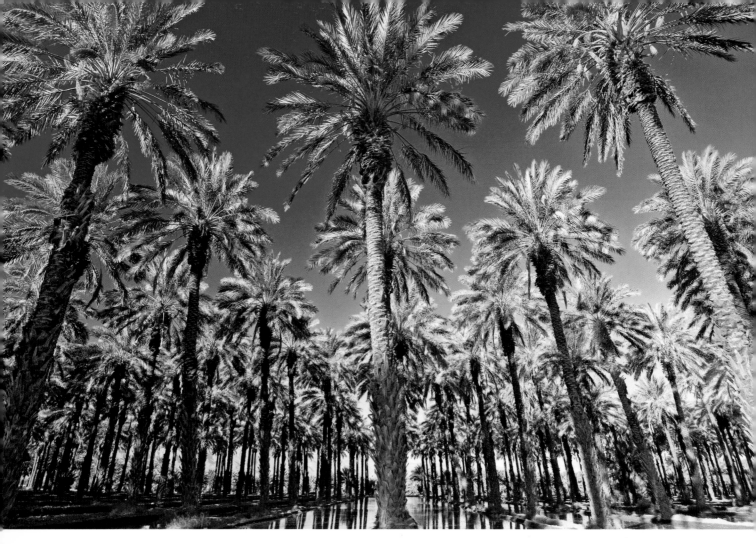

ABOVE: The date palms in the desert oasis of Mecca, California, appear to have been transported straight from the Sahara.
KERRICK JAMES

RIGHT: For those who love solitude, clear desert nights, and stunning sunrises, it is difficult to beat camping by the Salton Sea in California.
KERRICK JAMES

Park. A number of the exhibits at the visitors' center offer a great introduction to the biological diversity of the deserts.

Joshua Tree National Park is a wonderland of twisted Joshua trees and stark knobs of stone contorted into all manner of shapes. In recent years, the park has become a favorite haunt for campers and rock climbers.

One of the predominant features of the drive through Coachella to Mecca is a sea of date palm groves planted by Middle Eastern immigrants. The area reminded them of home, but it was missing one thing: the date palms. The addition of that missing ingredient resulted in the largest date-producing region in the United States.

In a harsh land of scorched sand, a massive lake with towering, desolate mountains in the backdrop may come as a surprise.

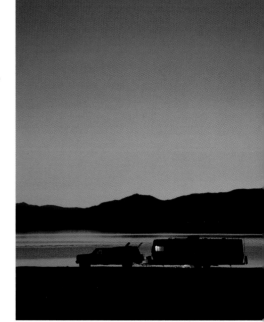

This desert anomaly is a twentieth-century phenomenon, dating to 1905. A dike breeched near Yuma and set the Colorado River on a flooding rampage that lasted two years, filling this desert valley. Heavy salinity, the harsh landscape that surrounds it, and a floor that is about 228 feet below sea level makes the Salton Sea unique.

Brawley, about twenty miles north of the Mexico border and the last stop on this route, is a strong farming community that hosts a yearly rodeo, celebrating the city's agricultural and ranching ties.

ROUTE 46

Discovering Beauty in a Valley of Death

KELBAKER ROAD TO STOVEPIPE WELLS

As you drive north into the Mojave National Preserve at the beginning of this route and the only tangible link to the modern era, Interstate 40, fades from your rearview mirror, you may feel adrift on a desolate sea of sand and stone. The uninitiated may even feel a sense of panic as civilization recedes in the mirror.

Some need time to find beauty in the desert; for others it is love at first sight. Here, especially in the pleasant months of late fall, winter, or early spring, something about the rugged land captivates and lures one ever deeper into the wilderness known as the Devil's Playground.

On the map, Kelso seems too small to be considered a destination. The vintage Spanish mission–style railroad depot, restored in 1995, is but one clue that, perhaps, there was once more here. And indeed, it is so. At one time this now–ghost town was the base of operations for the Los Angeles and Salt Lake Railroad.

Dry lakebeds where illusions of water dance in the heat waves that rise from the cracked surface, crooked arms of Joshua trees that serve as distorted frames for lunar landscape mountains, and unimpeded views greet visitors with the passing of each mile as they have for centuries. For a brief moment, the modern world intrudes on the ancient with the crossing of Interstate 15 and the dusty "blink and you will miss it" community of Baker. Driving north on State Route 127, through the Dumont Dunes, the desert continues unabated.

A loop drive provides the best opportunity to experience the highlights of a Death Valley visit. A couple of miles north of Shoshone, turn west on State Route 178, Badwater Road. This road hugs the rugged foothills of the Armagosa Range as it skirts the vast salt flats

Route **46**

Turn north off Interstate 40 at Exit 78 onto Kelbaker Road. Continue north through Kelso to Interstate 15 and the junction with State Route 127. Follow Route 127 north to Death Valley Junction. To visit some of Death Valley's most picturesque views, travel along State Route 178, Badwater Road, for a loop drive to Devil's Golf Course, Artist's Drive, and Badwater Basin. Watch for signs to State Route 190, where you'll travel north to Stovepipe Wells. This drive is approximately 175 miles.

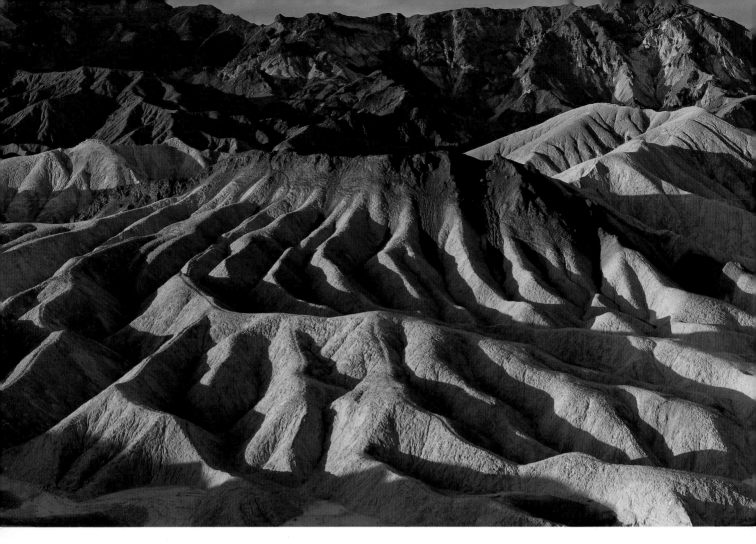

ABOVE: Sunrise at Zabriskie Point hints of the stunning beauty found in the stark wilderness of Death Valley National Park in California.
KERRICK JAMES

of the dry lakebed. It also provides access to such scenic wonders as the Devil's Golf Course, Artist's Drive, and Badwater Basin, the lowest elevation in the United States at 282 feet below sea level.

From Stovepipe Wells, follow State Route 190, the Death Valley National Scenic Byway. The most photographic spot along this road is the rocky outcropping of Dante's View. Here you can see the highest peak in California, Mount Whitney, often frosted with snow, on the far side of the valley. It provides a stunning backdrop for Badwater Basin far below.

Though austere, the valley is full of an array of colors, such as the fantastically colored clay and mudstones that make up Artist's Drive. These give the appearance that every crayon imaginable melted in the heat and poured over the hillsides. Zabriskie Point and its finely sculpted brown rock formations are just as beautiful.

The little town of Furnace Creek is an oasis in every sense of the word. Here, you'll find the Furnace Creek Inn, with swimming pools, tennis courts, and even a golf course. It is an excellent base camp for exploring the valley or nearby manmade treasures such as Scotty's Castle, a two-story Spanish Villa in Grapevine Canyon.

This is another drive that you'd best enjoy in early spring, late fall, or winter. If your car were to break down here in the extreme heat of summer, it could be very dangerous.

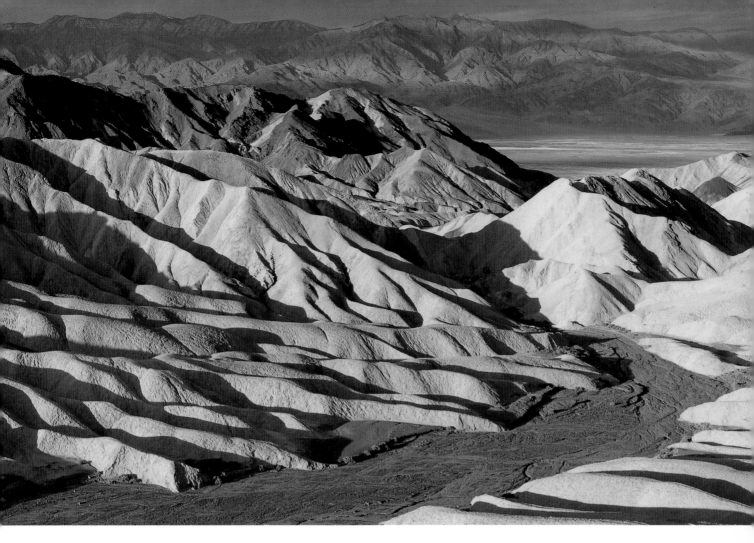

ROUTE 47

Sun-Drenched Sands and Snow-Filled Valleys

BARSTOW TO PALM SPRINGS

The drive south from Barstow, through the Granite Mountains, is quite pleasant, offering wonderful views of desert valleys accentuated with rocky knobs and mountains. Joshua trees add a whimsical touch to the relatively stark landscape.

Skirting the grand peaks of the San Bernardino Mountains, State Route 247 gently climbs through the Lucerne Valley, the earthquake-twisted landscapes near Landers, and then begins a scenic descent through the Yucca and Morongo valleys. The urban trappings of the modern era begin in Yucca Valley and culminate with the resort community of Palm Springs, pressed into the flanks of the Santa Rosa and San Jacinto mountains.

Yucca Valley and Morongo Valley are home to two often-overlooked sights that are well worth visiting. In the former is the Hi-Desert Nature Museum, a family-friendly facility with natural

Route 47

From Barstow, drive south on State Route 247 to the junction of State Route 62. Follow Route 62 south to Interstate 10. Turn west on the interstate and follow it to Exit 112. There follow State Route 111 south to Palm Springs. This drive is approximately 95 miles.

ABOVE: The Big Morongo Preserve, with over 250 species of birds, is a paradise for those who enjoy viewing these feathered friends.
KERRICK JAMES

history dioramas displaying wildlife of the desert, a mini-zoo with live desert creatures, and a gem and mineral collection. In Morongo Valley, you can visit the Big Morongo Canyon Preserve, a birding paradise where more than 250 species have been spotted.

Popular as a desert getaway with Hollywood celebrities for decades, Palm Springs now is the ultimate resort town—fine dining, entertainment, lodging, and relaxing retreats are plentiful.

The city's Moorten Botanical Gardens will introduce you to more than three thousand examples of desert cacti and other desert plants. The amazing array of plant life here will fascinate young and old. At the Palm Springs Air Museum, you'll not only find the largest number of operational World II airplanes in the world on display, but also a fine collection of vintage automobiles.

For a night out on the town, check out the Palm Springs Follies, an exemplary, Broadway-caliber show where the entire cast is over fifty-five years of age (some entertainers are even closing in on the century mark!).

The pinnacle of a visit to Palm Springs has to be the aerial tramway. Designated a historical civil engineering landmark, the tramway transports visitors from the searing desert heat to the cool

RIGHT: Joshua Tree National Park in California preserves a large portion of this strange forest for the enjoyment of future generations.
KERRICK JAMES

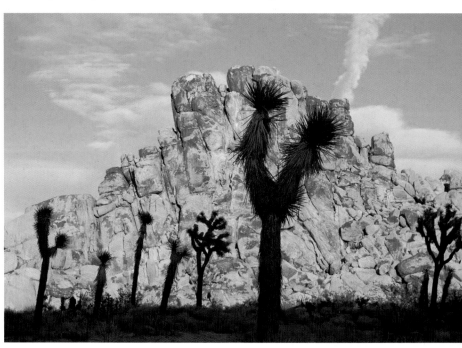

mountain air of the slopes. In the winter months, you can sunbathe in the morning and ski in the afternoon. The views you'll see during the climb from 2,643 feet to 8,516 feet are nothing short of breathtaking. For more doses of great scenery, visit the two restaurants at the upper summit or take one of the several hiking trails in the area. These range from an easy 1-mile nature trail to the challenging 5.5-mile climb to the 10,834-foot summit of Mount San Jacinto.

The secret to enjoying this drive is simple: Relax and allow yourself to be swept from one amazing sight to the next.

ROUTE 48

The Rim of the World

BARSTOW TO LA CANADA FLINTRIDGE

The drive south from Barstow, through the Granite Mountains, is largely across a high desert plain with 6,300-foot Ord Mountain dominating the eastern horizon. Stands of the twisted, ethereal Joshua tree become thicker with the passing of each mile.

To the south of Lucerne Valley, the mighty ramparts of the San Bernardino Mountains rise to the clouds. These formidable-looking peaks are part of a chain that separates the great expanses of the Mojave Desert from the valleys and plains of the coast.

The twenty-mile drive from Lucerne Valley to Big Bear City is remarkable, especially for those unfamiliar with the deserts of the Southwest. Through a series of sharp, steep twists and turns, the desert falls away rapidly, stands of tall pines become more numerous, and the views grow ever more fantastic.

Big Bear Lake, its counterpart Lake Arrowhead, and the mountains between provide a delightful oasis, an escape from the desert to the east as well as from the metropolis of Los Angeles, less than two hours to the west. Here the road is aptly known as Rim of the World Scenic Byway.

The ski lifts around Big Bear Lake serve a double purpose. In summer, they transport mountain bikers to the slopes.

Steeped in California history, Cajon Pass has been a key corridor for travelers and commerce between the coastal and desert regions for centuries. Here, the highway shares the canyon with the challenging border-to-border Pacific Coast Trail.

The distance from Wrightwood to La Canada Flintridge through the San Gabriel Mountains is a mere fifteen miles. This stretch is an island of wilderness with one of the world's largest cities bordering the eastern flanks.

Route **48**

Drive south from Barstow on State Route 247 to Lucerne Valley. Continue south on State Route 18. At Crestline, turn west on State Route 138. Nine miles west of Interstate 15 turn west on State Route 2. Follow Route 2 to La Canada Flintridge. This drive is approximately 135 miles.

Ski resorts, sensational views of the city below, and opportunities for hiking on scores of trails make this far more than a mere drive. Add the majesty of monumental peaks, such as 10,064-foot Mount San Antonio, and you have a photographer's heaven.

The one disadvantage to this drive can be traffic. The closer you get to Los Angeles, the more likely you will be joined on the roads by lovers of the outdoors, especially on weekends and during holidays.

ROUTE 49

West Coast Paradise

SANTA MONICA TO SAN DIEGO

Though this drive is largely urban, you will discover a surprising number of quiet places—like a car-free island—that provide a refuge from the hustle and bustle of the nation's largest metropolitan area. You'll also find a plentiful assortment of historic sites and attractions on the trip from Santa Monica to beautiful San Diego.

A short detour off the main route onto Venice Boulevard is the wonderland of Venice Beach Boardwalk. With skaters, bikers, and joggers taking in the fresh ocean air, this ocean-front walkway is great for people watching.

The drive south continues with a seemingly endless parade of attractions: Manhattan Village in Manhattan Beach, Redondo Beach Pier in Redondo Beach, South Coast Botanic Garden in Rolling Hills Estates, the Lomita Railroad Museum in Lomita, and the Museum of Latin American Art in Long Beach. If, however, time constraints preclude numerous stops on the first leg of this drive, then settle for what awaits in Long Beach.

The Aquarium of the Pacific is an incredible adventure for one and all. Interactive exhibits, discovery laboratories, and more than twelve thousand animals viewed in their natural habitat make this an attraction not to be missed.

The legendary *Queen Mary*, permanently berthed nearby, is now a luxurious floating hotel with fine shops and dining. All this, however, is but a foretaste of the greatest attraction of all, Santa Catalina Island, also called simply Catalina Island.

From Berth 95, the Catalina Express' high-speed boats will bring you to the wonders of Catalina Island in about one hour. This delightful car-free island offers a plethora of unique attractions, including glass-bottom boat tours, the historic Casino Ballroom, an underwater park for scuba divers, the Catalina Island Museum, and miles of hiking trails.

Route **49**

From Santa Monica, drive south on Highway 1, the Pacific Coast Highway, to the junction with Interstate 5 at Dana Point and then continue on I-5 to San Diego. This drive is approximately 145 miles.

OPPOSITE: Big Bear Lake is an oasis for those who live in the desert to the west, as well as those who live in the Los Angeles area to the east.
KERRICK JAMES

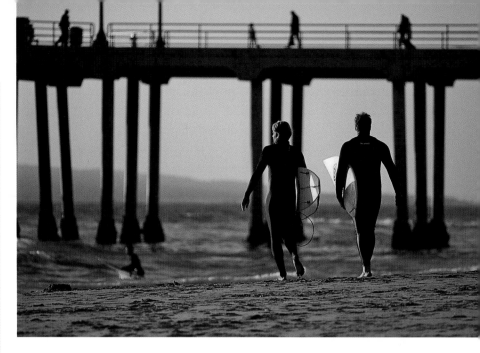

Surfers at Huntington Beach head out to catch a wave in a quintessential southern California scene. KERRICK JAMES

The drive south to Dana Point threads through a sequence of state beach parks and oceanside communities, each with a distinct personality. You'll find plenty of attractions here, more than a few of which are one-of-a-kind, such as the International Surfing Museum in Huntington Beach.

A short detour north on Interstate 5 from Dana Point to San Juan Capistrano is highly recommended. The Spanish mission there is a historic gem dating to 1776. Nearby you will find another site that dates to the same period: El Adobe de Capistrano, a Mexican

ISLAND PARADISE

Santa Catalina Island has been a haven for people for millennia, as archaeological evidence indicates this island has been inhabited for at least seven thousand years. Before 1820, the island served smugglers bringing undeclared goods to the Spanish colonies along the coast.

In the years that followed, the island became a ranching center, saw a brief mining boom, and was a favored locale for Hollywood producers. One of those movie producers introduced a herd of American bison that roam the island to this day.

Avalon, one of the island's little towns, is full of historic architecture. The legendary Catalina Casino, built in 1929,

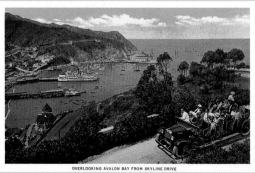

This vintage postcard is of Avalon Bay, as seen from Skyline Drive on Catalina Island, is a view that still thrills visitors today. AUTHOR'S COLLECTION

played host to the biggest names in the Big Band era and today is available for special events. It also houses a delightful museum.

Other notable attractions include the Tuna Club, the oldest fishing club in the nation (members have included President Teddy Roosevelt and Charlie Chaplin), and the Inn at Mount Ada, the former mansion of William Wrigley Jr., the chewing-gum magnate. The Wrigley family is also responsible for Chimes Tower, a Spanish mission–style bell tower that has chimed the quarter hour, from 8 A.M. to 8 P.M., since its construction in 1925.

restaurant and state historic landmark. The northern section of this eatery was originally the home of Miguel Yorba Adobe, built in 1797, while the southern part served as a court and jail beginning in 1812.

The rest of the drive south to San Diego passes by a number of fine beaches, fascinating communities, and delightful attractions. The crown jewel of this trip is San Diego itself.

One hallmark of California cities is the appearance of pockets of wilderness in the midst of their urban sprawl. In San Diego, those pockets are the Los Penasquitos Canyon Preserve, Torrey Pines State Preserve, and Torrey Pines State Beach.

Another aspect of California cities that gives each a unique feel are their wonderful parks. For San Diego, those include Balboa Park, with the world-famous San Diego Zoo, and Mission Bay Park with

ABOVE: Sailing on the *Star of India* gives passengers access to Harbor Island, famous for the wonderful views of San Diego. KERRICK JAMES

RIGHT: Balboa Park in San Diego is an urban oasis and home to the city's world-famous zoo. KERRICK JAMES

Sea World. Balboa is also home to the San Diego Air and Space Museum, the San Diego Museum of Art, the San Diego Natural History Museum, the Automotive Museum, and the San Diego Museum of Man.

Of the dizzying number of attractions and sights to see in and around San Diego, my favorite is Old Town San Diego State Historic Park. Here restored and re-created buildings present a look into this community when it was a small settlement on the frontier of the far-flung Spanish empire. They also house a wide array of businesses, including excellent restaurants.

There are more than enough attractions on this drive to fill a lifetime of vacations. Though the trip can be enjoyed by winging it, I recommend planning ahead for a more pleasurable experience.

ROUTE 50

Saving the Best for Last

SANTA MONICA TO MONTEREY

The drive north from Santa Monica is truly a magical one, with the first stop being a storied place called Malibu. As you stroll the beach, past the pretty girls with perfect bodies basking in the sun, just remember, as with Las Vegas, reality is often difficult to distinguish from illusion.

Beautiful beaches and even more beautiful beaches are the signature highlight along Highway 1 from Malibu to Santa Barbara. These beaches often steal the show for visitors, leaving a plethora of attractions overlooked.

In Oxnard are the fascinating Seabee Museum, the Carnegie Art Museum, and the Ventura County Maritime Museum. Neighboring

Route 50

From Santa Monica, drive north approximately 310 miles, on State Route 1 to Monterey. For a short detour to Surf, do not miss the turnoff in Lompoc for this loop drive. Above Lompoc, on State Route 246 is La Purisima Mission State Historic Park.

The Greek-styled Neptune Pool at La Casa Grande near San Simeon, California, is one of several pools at the historic 165-room mansion built by William Randolph Hearst.
KERRICK JAMES

ABOVE: A sunset seen through the Sea Arch at Pfieffer State Beach near Big Sur is only one of the many stunning sights found along this portion of the California coast.
KERRICK JAMES

OPPOSITE: Carmel Beach is a remarkable enclave of serenity that is within walking distance of fine restaurants and galleries.
KERRICK JAMES

Ventura is home to the historic Olivas Adobe and the San Buenaventura Mission, as well as Albinger Archaeological Museum.

Santa Barbara is home to an impressive number of sights and attractions. There are zoological gardens as well as botanical gardens here. Museums run the gamut from the South Coast Railroad Museum to the Museum of Natural History. Historic sites are as diverse, including the Santa Barbara Lighthouse and Mission Santa Barbara.

There are still beaches aplenty on the drive north from Santa Barbara, though the shore is rockier with steep slopes dropping directly into the sea. This rocky coastline becomes the rule north of Morro Bay, where at times the highway seems suspended hundreds of feet above the crashing waves below.

For a peek at the California coast as it was before it became a haven for the rich and the famous, do not miss the turnoff to Surf (you'll see signs in Lompoc for this loop drive).

Then you can swing east into the Purisma Hills above Lompoc on State Highway 246 and discover a lost chapter in the Golden State's history at La Purisima Mission State Historic Park. Here, you'll see the eleventh of the twenty-one Spanish missions established in what became California. For another detour off the beaten track, turn

CONSTRUCTION OF HWY. 1, 1926

This circa-1926 postcard provides insight to the engineering challenges involved with the construction of Highway 1.
AUTHOR'S COLLECTION

RIGHT: Feeding time in Monterey Bay Aquarium's main tank enhances any visit to this aquatic wonderland.
KERRICK JAMES

west on the road to Los Osos and Morro Bay State Park in San Luis Obispo. Here you'll find another breathtaking loop drive through wonders seldom seen by the average tourist—like the place to which migrating monarch butterflies flock in Los Osos and a lagoon and natural bay habitat at Morro Bay.

The twists, turns, and grades of the highway north of Morro Bay mimic the tortured contours of the land as it meets the sea. Only quaint seaside communities and delightful landscapes of rolling hills interrupt miles of scenic vistas.

One manmade attraction not to be overlooked in this portion of the drive is the Hearst San Simeon State Historical Monument near San Simeon. Built with profits from the expansive Hearst publishing empire, La Casa Grande, known as the Hearst castle, easily equals the grandest palaces of Europe. Set amid lavish gardens and terraces, the twin-towered home is the centerpiece of the 123-acre La Cuesta Encantada (The Enchanted Hill) estate. Built with materials imported from throughout the world, the main house features thirty-eight bedrooms, a movie theater, two libraries, a billiard room, and a medieval dining hall with ornate carved panels. Some of the rooms were even brought whole from centuries-old castles and taverns.

The guesthouses are mansions unto themselves. Each one features fountains, marble balustrades, and a garden filled with classical statuary. The main houses, as well as the smaller guesthouses, are furnished with art treasures and antiques imported from Europe and Asia.

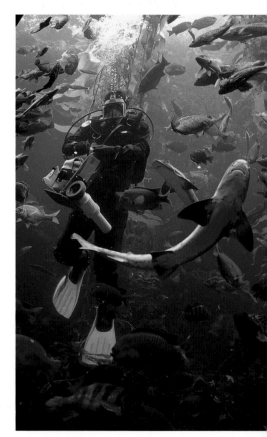

There is a huge outdoor swimming pool that mimics those of ancient Rome with its tile mosaics, statuary, and Etruscan-style colonnade. A second, indoor pool continues with this theme.

Imported wildlife fills the surrounding hills. So do not think you have spent too many hours on the road when you see zebras or tahr goats grazing in the meadows.

This section of Highway 1, suspended high above the ocean on a shelf of rock one moment and just above the beach the next, is designated the Big Sur Coast National Scenic Byway.

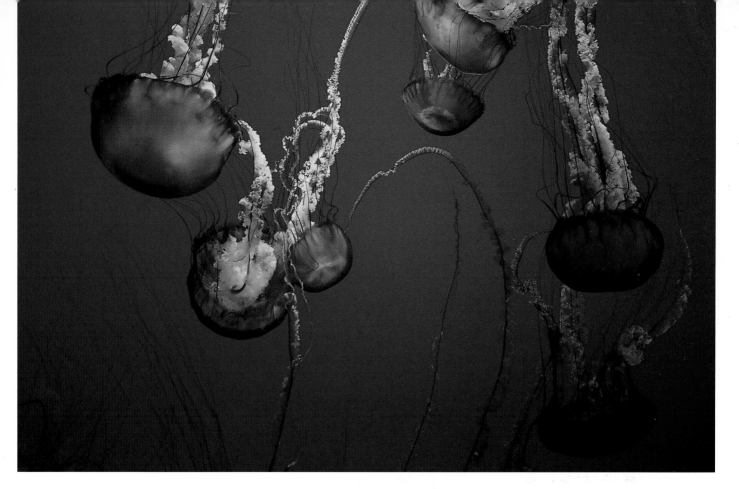

Without reservation, I can say this is one of the most beautiful drives undertaken in all my travels.

The capstone of this stunning landscape is Big Sur and the Pfeiffer–Big Sur State Park. Miles of hiking trails provide access to unbelievable vistas, gorges, waterfalls, and a large variety of native wildlife.

If driving along Highway 1 is like experiencing the beauty of a rainbow up close, then Monterey is finding the pot of gold at the rainbow's end. This beautiful city has great coastal state parks, havens for surfers as well as tide-pool watchers, wildlife refuges, award-winning golf courses, and fine dining with priceless views.

It is also home to probably the best aquarium in the United States, the Monterey Bay Aquarium, located on historic Cannery Row. Another place of interest is the The Monterey State Historic Park. Here you can see the state's first theater, as well as the Monterey Customs House, where the American flag was first raised over California.

Museums of note include the Colton Hall Museum, a public building in continuous use since 1840; the Monterey Museum of Art; Monterey County Youth Museum; and John Steinbeck's Spirit of Monterey Wax Museum. Walking tours offer opportunities to experience the hidden treasures of this area. Perhaps the most notable of these is the Monterey Path of History. It leads you through downtown Monterey past historic adobes that date back to the time this city was the Spanish capital of old California.

Jelly fish at the Monterey Bay Aquarium are one of the many exhibits that led the *Zagat U.S. Family Travel Guide* to rate this as the number one aquarium in the United States. KERRICK JAMES

INDEX

SUGGESTED READINGS

Belasco, Warren. *Americans on the Road.* Cambridge, MA: MIT Press, 1979.

DeLano, Patti. *Missouri Off the Beaten Path.* Guilford, CT: Globe Pequot Press, 2007.

Miner, Carrie, and Jill Bean Florio. *Arizona Off the Beaten Path.* Guilford, CT: Globe Pequot Press, 2005.

Parent, Laurence. *Official Guide to Texas State Parks.* Austin: University of Texas Press, 2002.

Post, Emily. *By Motor to the Golden Gate.* New York: D. Appleton & Company, 1916.

Robinson, Jon. *Route 66: Lives on the Road.* St. Paul, MN: MBI Publishing Company, 2001.

Trimble, Marshall. *Arizona: A Cavalcade of History.* Tucson: Rio Nuevo Publishers, 2003.

Trimble, Marshall. *Roadside History of Arizona.* Missoula, MT: Mountain Press Publishing, 1986.

ABOUT THE AUTHOR AND PHOTOGRAPHERS

From childhood, **Jim Hinckley** dreamed of being an author. After numerous detours into truck driving, mining, ranching, and a variety of other endeavors, he turned to writing a weekly column on automotive history for his local newspaper, the *Kingman Daily Miner*, in his adopted hometown of Kingman, Arizona.

From that initial endeavor almost twenty years ago, Jim has written extensively on his two primary passions: automotive history and travel. *Route 66*, *American Road*, *Hemmings Classic Car*, and *Old Cars Weekly* are but a few of the publications that have featured his work. He is currently a regular contributor to and an associate editor at *Cars & Parts*. Book reviews and original features on automotive history and travel can be found on his internationally acclaimed blog, Route 66 Chronicles (www.route66chronicles.blogspot.com).

The books Jim's written include *The Big Book of Car Culture*, *Checker: An Illustrated History*, and *Backroads of Arizona*.

Kerrick James has been a professional photographer for more than twenty years. He moved to Arizona in 1990, and since that time he has specialized in travel imagery. He is a regular contributor to Getty Images; *Arizona Highways*, *Sunset*, and *National Geographic Adventure* magazines; and the magazine for Alaska Airlines. He provided the color photography for *Backroads of Arizona* (Voyageur Press, 2006) and *Our Arizona* (Voyageur Press, 2007). Kerrick lives in Mesa with his wife, Theresa, and their three sons.

Rick Bowers and **Nora Mays Bowers** are professional wildlife and nature photographers and writers. Rick, who has a degree in wildlife ecology from the University of Arizona, has been photographing wildlife for more than twenty-five years. Before that, he led nature tours to exotic locales from Alaska to Antarctica for Victor Emanuel Nature Tours and photographed many of these beautiful places. Nora, who has degrees in ecology and evolutionary biology from the University of Arizona in Tucson, spent many years as a nurse before pursuing her passion for nature and photography full time. Rick and Nora's photographs have been featured in numerous publications, including *National Geographic*, *Audubon Magazine*, *Scientific American*, and *Birder's World*.

Nora and Rick also coauthored *Cacti of Arizona*, *Wildflowers of Arizona*, *Wildflowers of the Carolinas*, and *Kaufman Focus Guides: Mammals of North America*. Rick and Nora live in Tucson, Arizona, with their cat, Beau, Dreamer the horse, and their donkey, Buddy. They can be reached through their web page at www.bowersphoto.com.